# WRITTEN ON THE CITY

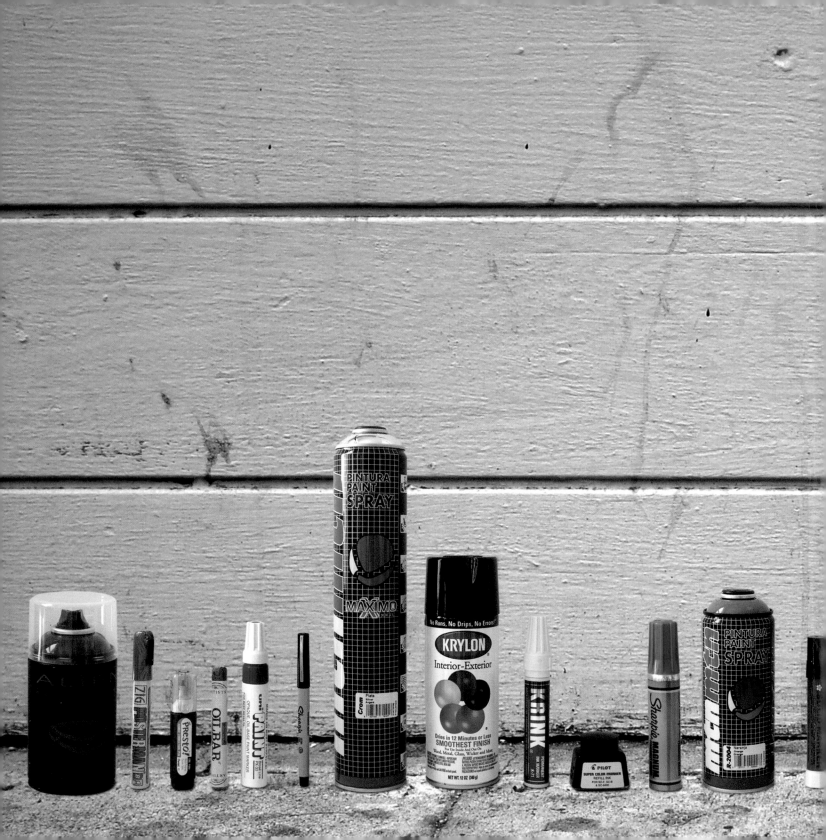

# WRITTEN ON THE CITY

## GRAFFITI MESSAGES WORLDWIDE

AXEL ALBIN & JOSH KAMLER

**HOW BOOKS**
CINCINNATI, OHIO
WWW.HOWDESIGN.COM

12 11 10 09 08    5 4 3 2 1

Distributed in Canada by Fraser Direct, 100 Armstrong Avenue, Georgetown, Ontario, Canada  L7G 5S4, Tel: (905) 877-4411. Distributed in the U.K. and Europe by David & Charles, Brunel House, Newton Abbot, Devon, TQ12 4PU, England, Tel: (+44) 1626-323200, Fax: (+44) 1626-323319, E-mail: postmaster@ davidandcharles.co.uk. Distributed in Australia by Capricorn Link, P.O. Box 704, Windsor, NSW 2756 Australia, Tel: (02) 4577-3555.

Library of Congress Cataloging-in-Publication Data

Albin, Axel.

Written on the city : graffiti messages worldwide / Axel Albin & Josh Kamler.

p. cm.

ISBN 978-1-60061-077-6 (hardcover : alk. paper)

1. Graffiti. 2. Sociology. I. Kamler, Josh. II. Title.

GT3912.A26 2008

306.4--dc22

2008015488

Edited by Amy Schell
Initial design by Audrey Kallander, Dana Steffe
Art direction and final design by Claudean Wheeler
Production coordinated by Greg Nock

# ACKNOWLEDGMENTS

It's a funny thing that designers aren't considered authors. Because there are three designers out there who deserve an author credit:

Audrey Kallander, without whom we may never have been able to get started. Dana Steffe, who designed the shit out of this book, and endured our constant backseat driving with a smile. And Claudean Wheeler, who took the reins when we fell off the horse.

Audrey, Dana, and Claudean, this is your book too. Thank you.

Also, big thanks to:

Megan Patrick, Jane Friedman, Amy Schell, Grace Ring, Shawn Feeney, Patti Silver, Pat Kujava, Skip Evans, Wooster Collective, and Liz Franklin.

And of course, thanks to our families.

*Written on the City* came alive because of the people out there with cameras who have chosen to record the messages written on their cities. We'd like to thank them for sharing those photos with us:

a1one, aa, Adam, Al M., André Carvalho, Anne Petrimoulx, aphex, Bob, Bod, Breezy, Breezy f. Baby, Bryony, CAROL ANDERSON, cbarth, Chris Holden, clare haggarty, Cyn, Damian, Dan, dan piassick, Dana, danger, Darren Shaun Mann, David, derekb, dwight, Edwin van Slingerlandt, Elise, elle, emily, esther, Ethan Kanat, evaberry, Gretchen Duffin, guy de lotz, Heather, indigenteandrajoso, isadub, Jack Margines, James Donaldson, jck, jennybelle, JN, John Doe, John Zappas, Kanat, Katherine Kelley, Kayaburkut, kevin, Kevin M Jackson, Lauren Bansemer, Lauren Elder, Leah, Lee Brozgol, lieutenant dan, Lili, Liza, Loren Cox, Louis, M J Gonzalez, Marcus Irwin, Martijn, Mary Pumphrey, mightyamanda, mightymanda, Mimicry, mind, mona, mr10, Naama, nagash, Nicole, Pamala, Paul Inman, Per Olav, purita, Ramone, Renee Griffin, Richard Kamler, Russell, Santanu Vasant, Sarah, shea M gauer, sma, Summer, Tabu, talithakumi, Thursday, Timothy Fargus, Trevor Spangle, Vegard, walt opie, Will, zen sutherland

# ABOUT THE AUTHORS

**Axel Albin** & **Josh Kamler** are the owners of Language in Common, a communication design studio in San Francisco. They would like to give due credit to **Jonathan Waldman**, whose research and writing made this book come alive. When he's not collaborating with Language in Common, Jonathan runs a bike-friendly company called Zero Per Gallon.

## www.WrittenOnTheCity.com

In the summer of 2006, there were some prolific graffiti artists at work in San Francisco, but rather than tagging or painting murals, they were writing messages. And people were writing back. We thought that was cool, so we started taking pictures. Pretty soon, we had a huge collection of images of messages from all over the city. And seeing all those messages collected in one place made us realize that we were looking at an important human conversation that wasn't being heard.

So we built writtenonthecity.com, and invited people to look at our images, share their own, and comment on the messages there. People started to take notice. Blogs and newspapers picked up the story. BBC World News covered the project on TV. And just six months after we launched the site, we'd logged over a million page views. Every day, the conversation grows with new images and new comments. We hope you'll take part.

—Axel Albin & Josh Kamler

# SOMEONE IS TRYING TO TELL YOU SOMETHING

All over the world, people are staying up late, venturing into the night, and breaking the law to say this thing to you. You don't know them and they don't know you. And it doesn't matter. They just want to be heard. So they're writing on the walls and sidewalks of the places we live.

You don't have to listen if you don't want to. You can walk past the words and mistake them for nothing more than vandalism. And that's what most of us do most of the time. But if you pay attention, you'll find a conversation worth celebrating, worth taking part in. You'll find a conversation about things that matter. Things like love, and shit, and incest, and war. Things like monkeys, and drugs, and cheese, and toilet seats. Things like fucking, and loss, and ducks, and revenge, and theft, and Arabs, and Chinese people. Things like science, and fame, and god, and pianos, and politics, and aliens, and Jesus, and pigeons, and pancakes.

Written on the city, there is signal amidst the noise. There is conversation between intimate strangers. This graffiti is good.

Axel Albin & Josh Kamler

San Francisco, 2008

1

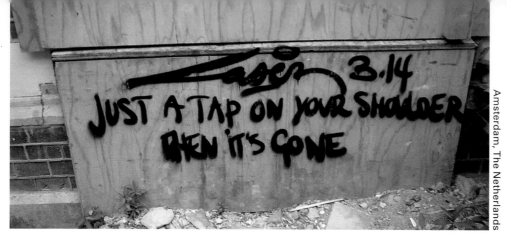

# AN IMPERIAL MESSAGE

**translation:** send a letter to someone you don't know

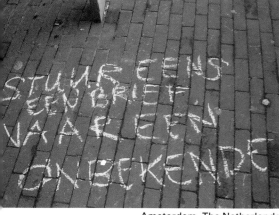

Amsterdam, The Netherlands

"The Emperor, so a parable runs, has sent a message to you, the humble subject, the insignificant shadow cowering in the remotest distance before the imperial sun; the Emperor from his deathbed has sent a message to you alone. He has commanded the messenger to kneel down by the bed, and has whispered the message to him; so much store did he lay on it that he ordered the messenger to whisper it back into his ear again. Then by a nod of the head he has confirmed that it is right. Yes, before the assembled spectators of his death—all the obstructing walls have been broken down, and on the spacious and loftily mounting open staircases stand in a ring the great princes of the Empire—before all these he has delivered his message. The messenger immediately sets out on his journey; a powerful, an indefatigable man; now pushing with his right arm, now with his left, he cleaves a way for himself through the throng; if he encounters resistance he points to his breast, where the symbol of the sun glitters; the way is made easier for him than it would be for any other man. But the multitudes are so vast; their numbers have no end. If he could reach the open fields how fast he would fly, and soon doubtless you would hear the welcoming hammering of his fists on your door. But instead how vainly does he wear out his strength; still he is only making his way through the chambers of the innermost palace; never will he get to the end of them; and if he succeeded in that nothing would be gained; he must next fight his way down the stair; and if he succeeded in that nothing would be gained; the courts would still have to be crossed; and after the courts the second outer palace; and once more stairs and courts; and once more another palace; and so on for thousands of years; and if at last he should burst through the outermost gate—but never, never can that happen—the imperial capital would lie before him, the center of the world, crammed to bursting with its own sediment. Nobody could fight his way through here even with a message from a dead man. But you sit at your window when evening falls and dream it to yourself."

*Franz Kafka, 1919*

**translation:** he said good morning and his neighboor didn't answer him

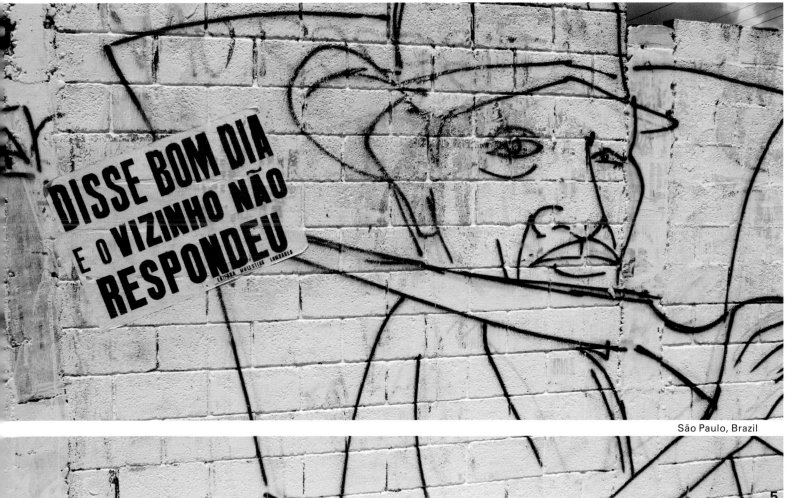

São Paulo, Brazil

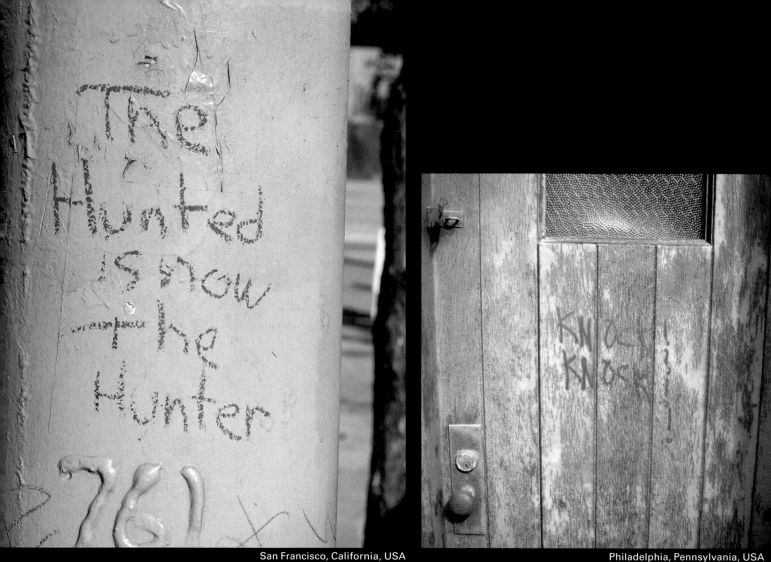

San Francisco, California, USA

Philadelphia, Pennsylvania, USA

6

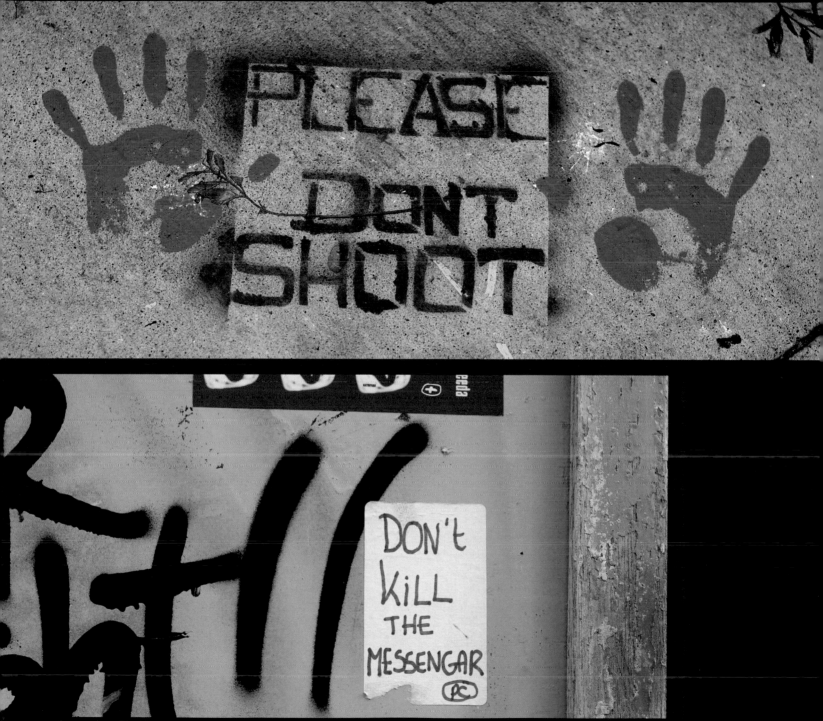

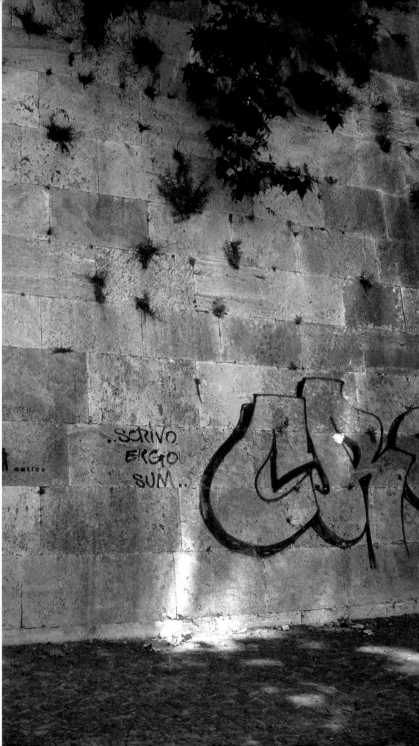

Rome, Italy

## EGO GRAFFITI

Like a marketing campaign, like a dog pissing on hydrants and trees, graffiti of the ego aims to spread the name of its creator throughout the community by tagging as many surfaces as possible. It says no more than its name, repeating itself in every place it's found. It's about me, not you.

## AESTHETIC GRAFFITI

The piece, the burner, the throw up, the mural: This is graffiti for aesthetic consumption. More than anything else, it is beautiful first. The impulse behind this kind of graffiti is a generous one. It is a gift to the eyes, to the visual world we share.

## MESSAGE GRAFFITI

Meant to be legible and accessible to anyone passing by, message graffiti is trying to tell you something. Whoever wrote it doesn't know you and you don't know them, and it doesn't matter. It's what's being said, it's the message, that matters.

**8**          **translation:** I write therefore I am

# TAGGING, MESSAGES AND MESSENGERS

The proliferation of tagging is widely attributed to Taki 183, a New York City tagger who became famous in the late 1960s and early 1970s. Taki was the nickname of a Greek-American foot messenger who lived on 183rd Street in Washington Heights. His job took him all over the city, and he wrote his nickname everywhere he went. Soon his tag was so pervasive that the *New York Times* was compelled to write an article about him. After that article was published, tagging became a widespread practice. Tags, like names, carry little or no semantic meaning. They are not messages. But Taki the messenger did have a message for the city, whether he knew it or not. He showed New York that the city was a blank canvas, an empty page. The medium was his message.

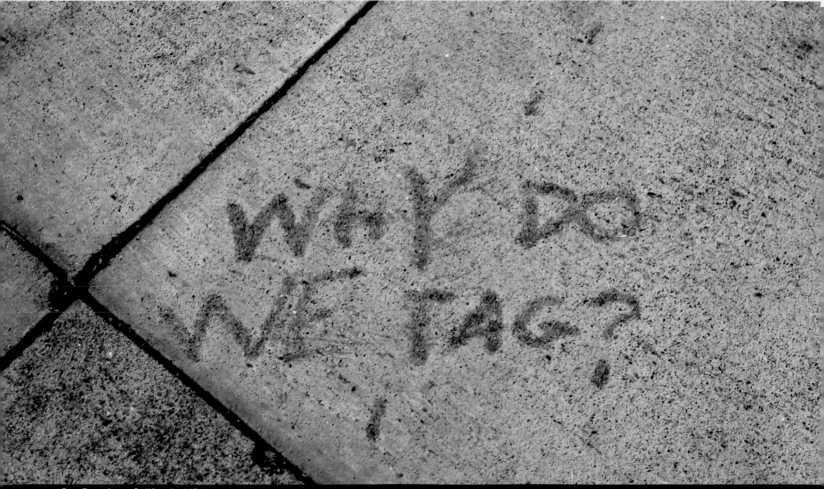

San Francisco, California, USA

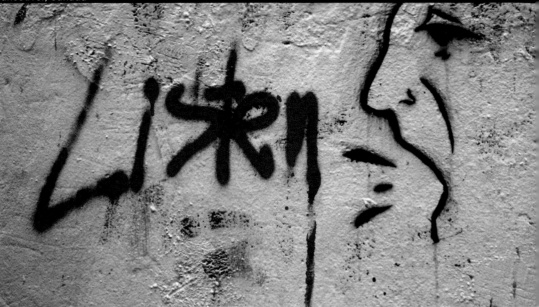

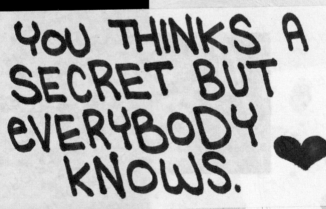

YOU THINKS A SECRET BUT EVERYBODY KNOWS.

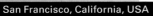

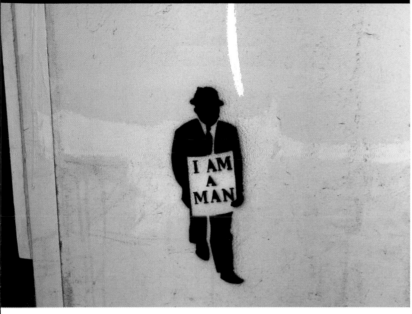

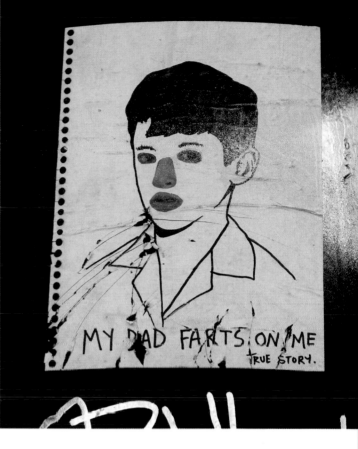

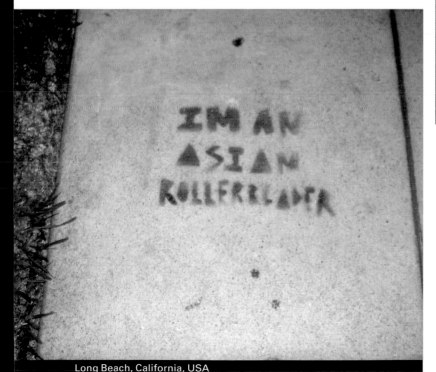

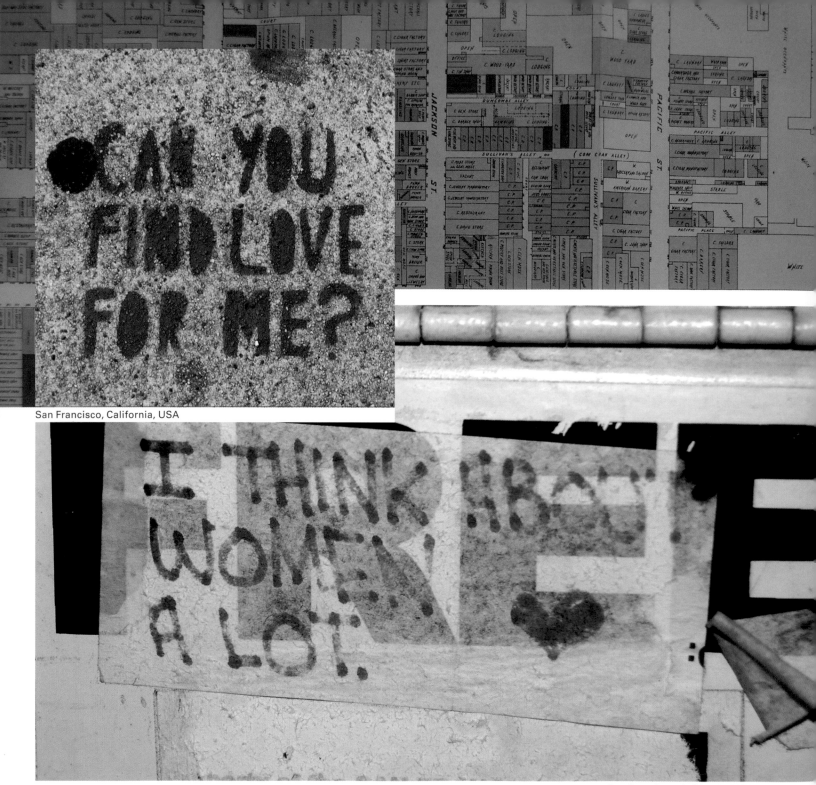

CAN YOU FIND LOVE FOR ME?

San Francisco, California, USA

I THINK ABOUT WOMEN A LOT.

San Francisco, California, USA

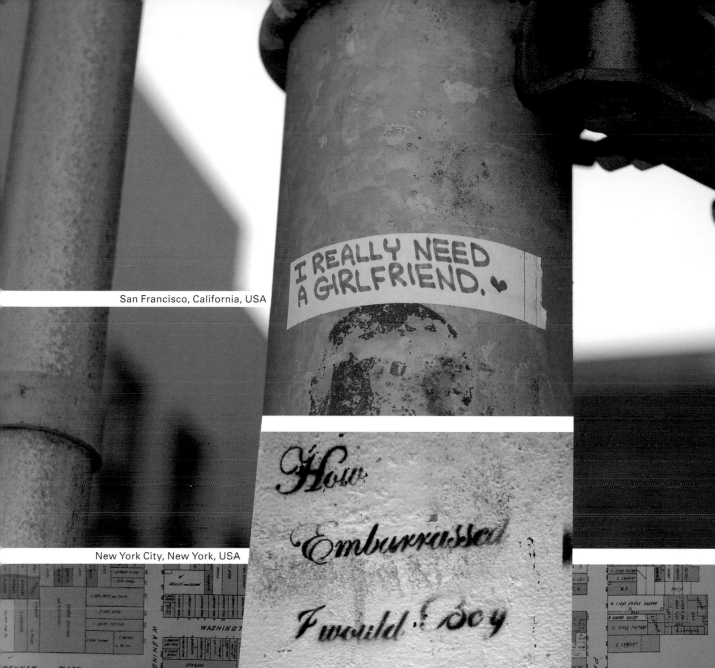

San Francisco, California, USA

New York City, New York, USA

13

Some cities use ivy to deter graffiti. Community groups in Chicago recently used 40,000 gallons of paint to cover the graffiti up.

15

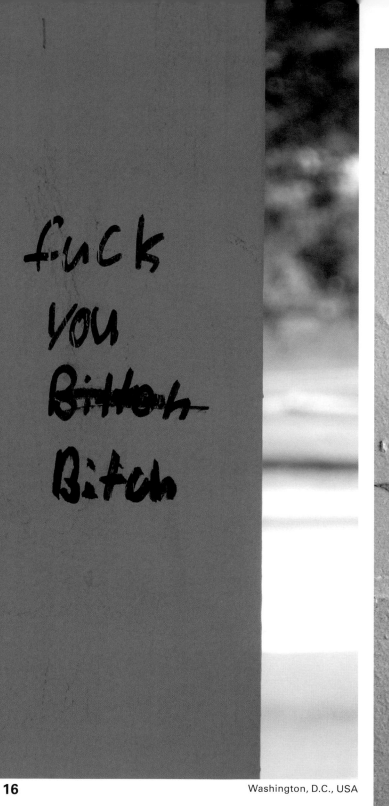

**16**          Washington, D.C., USA

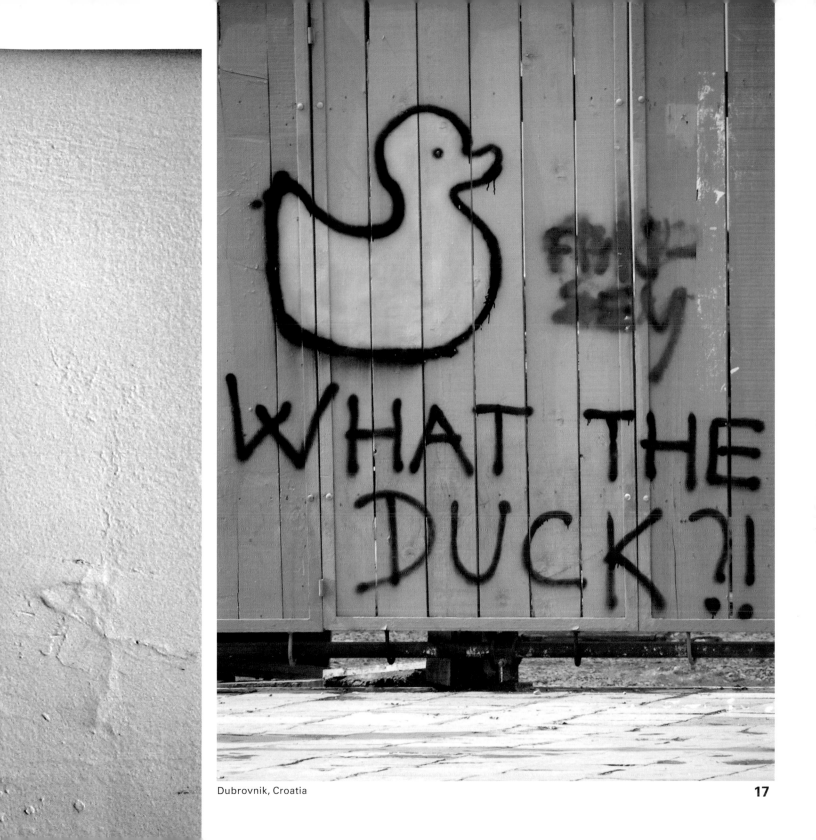

Dubrovnik, Croatia

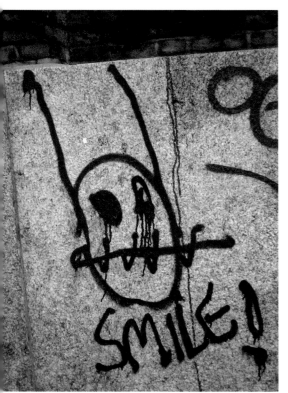

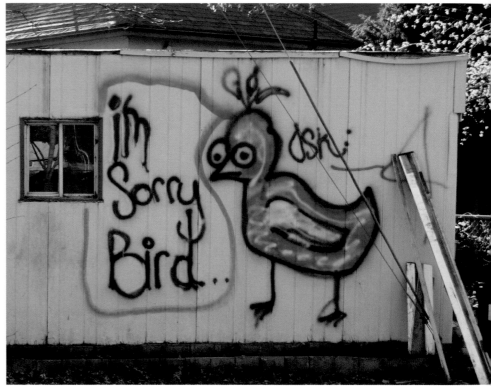

Amsterdam, The Netherlands    Boise, Idaho, USA

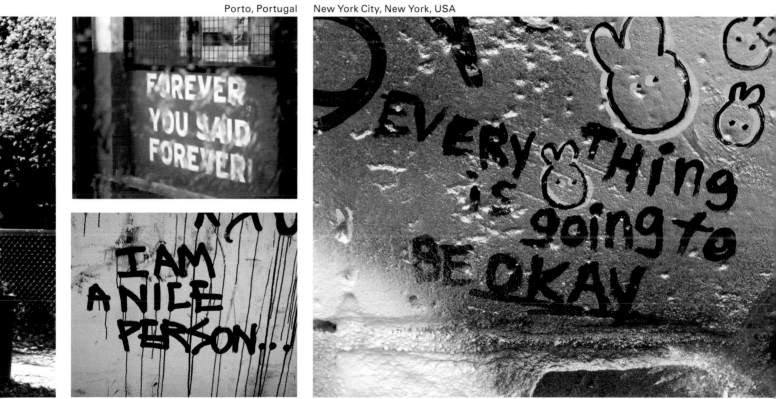

Porto, Portugal

New York City, New York, USA

Philadelphia, Pennsylvania, USA

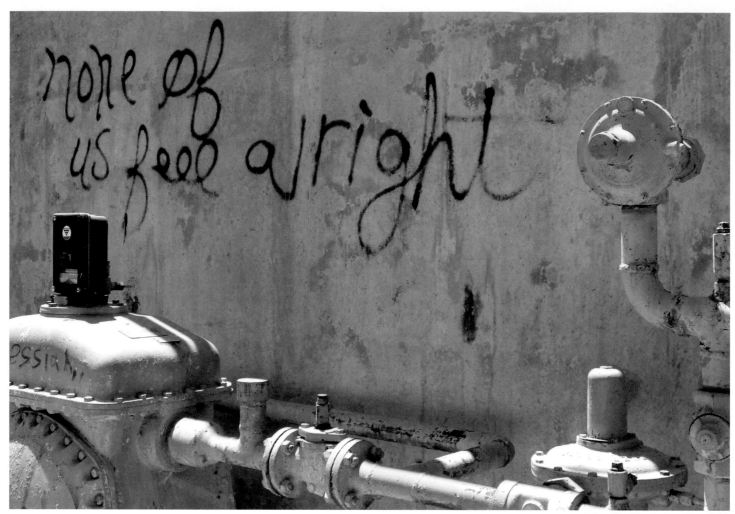

Asheville, North Carolina, USA

# NO ONE WISHES
# TO BE A WINDBAG

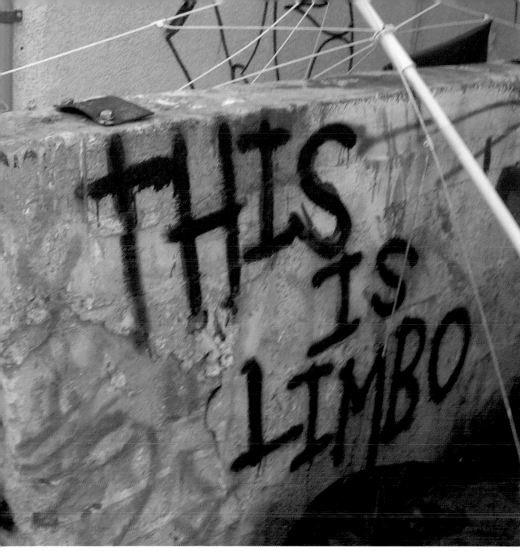

Tel Aviv, Israel

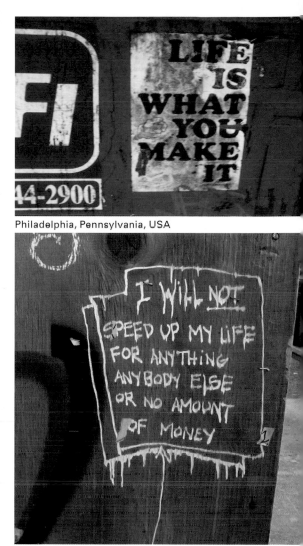

Philadelphia, Pennsylvania, USA

San Francisco, California, USA

"It is one thing to have interesting and worthwhile ideas about which to talk to others. It is another matter to express the ideas concisely. All of us know people who talk too much. Frequently it is due to enthusiasm, and we can excuse it if the enthusiasm is over something of sufficient value to warrant the expenditure of so many words. Sometimes wordiness and talkativeness are due to conceit. These persons feel they have many things of importance to discuss, and that what they have to say is much more worthwhile than what others may have to contribute. Not infrequently they are show-offs. They like to monopolize the conversation, to be in the center of it, to have all attention directed to them."

*From* 1001 Ways to Improve Your Conversation and Speeches, *by Herbert V. Prochnow, 1952*

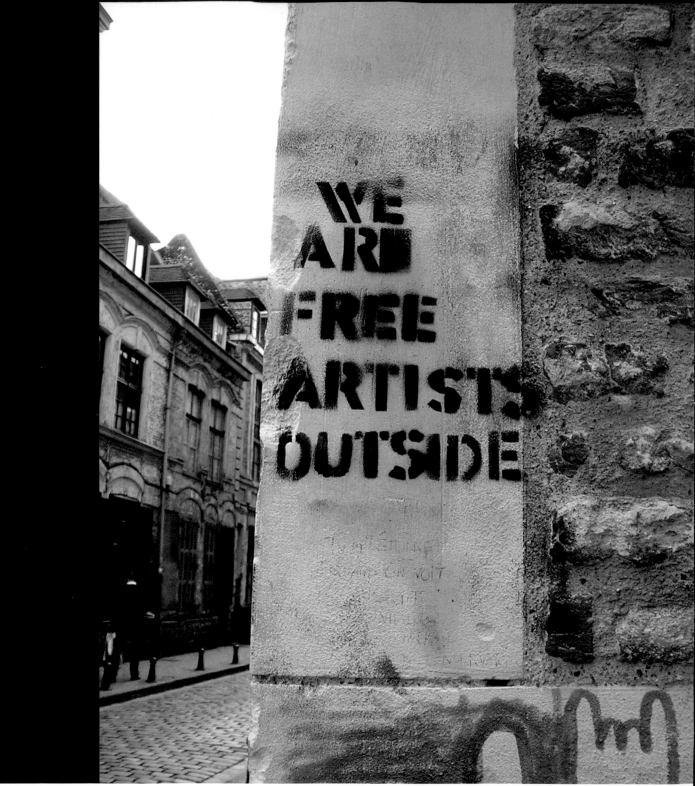

Lille, France

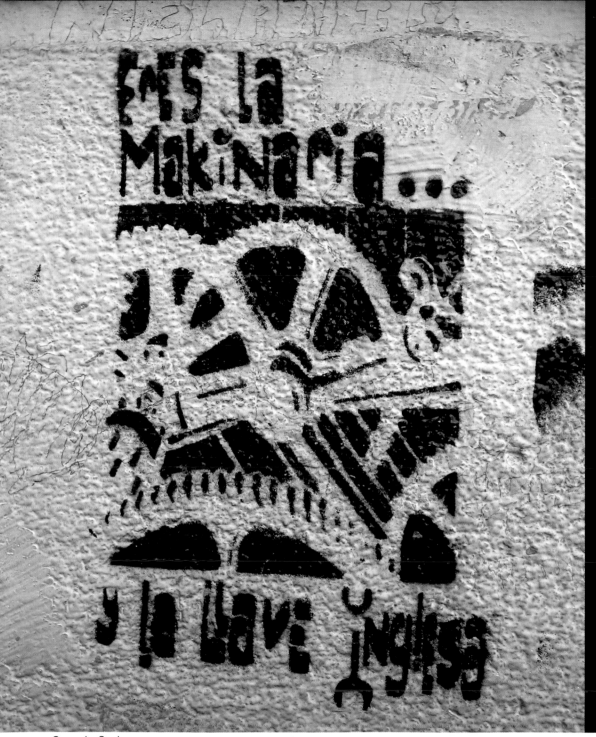

Granada, Spain

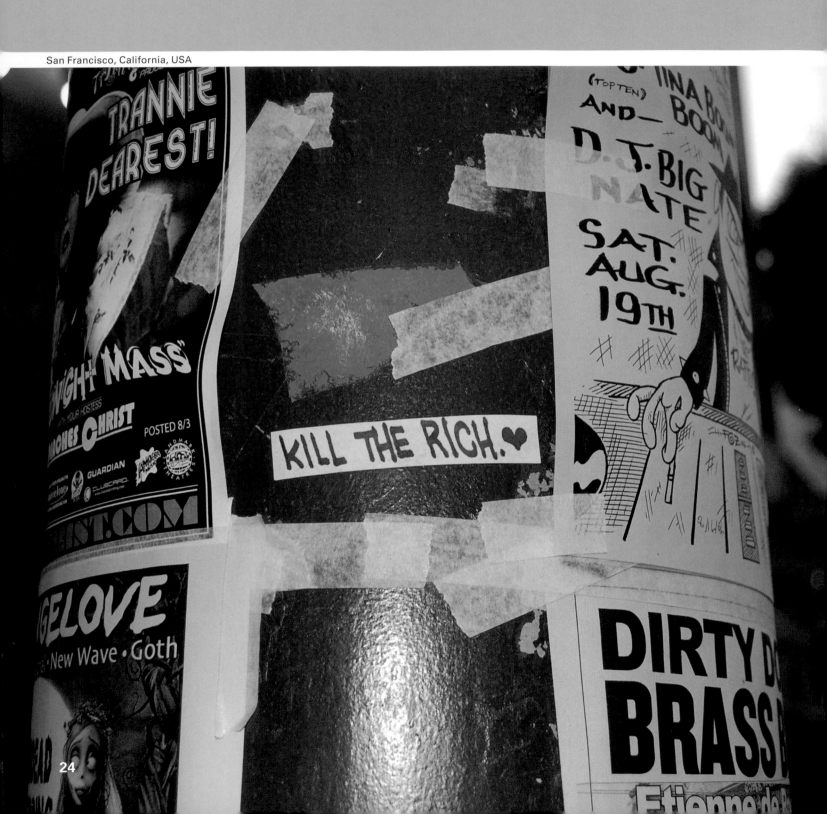

24

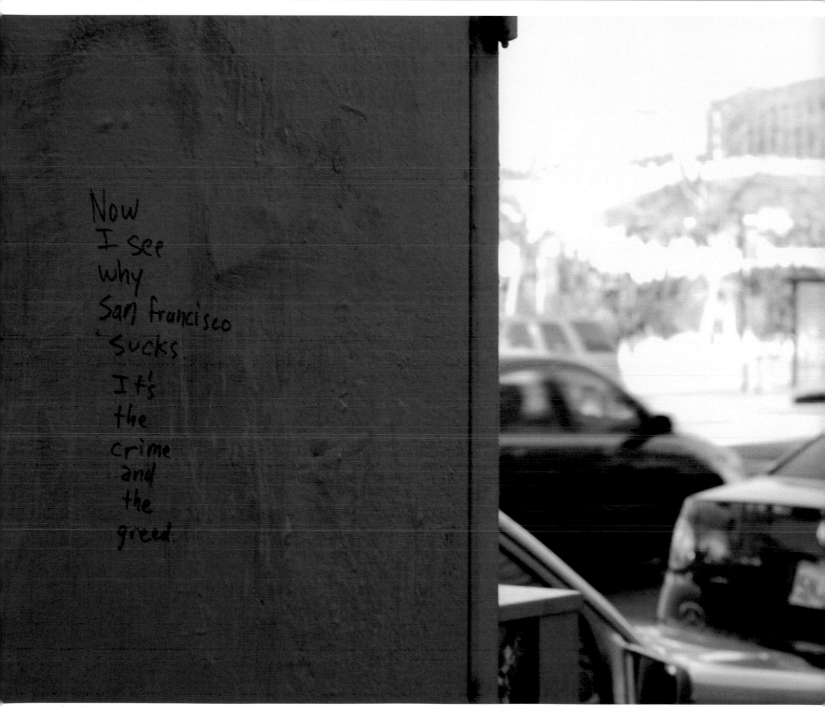

Now
I see
why
San francisco
sucks.
It's
the
crime
and
the
greed.

San Francisco, California, USA

RELIGION IS WHAT KEEPS
THE POOR FRUM
MURDERING THE RICH

— NAPOLEON —

San Francisco, California, USA

Amsterdam, The Netherlands

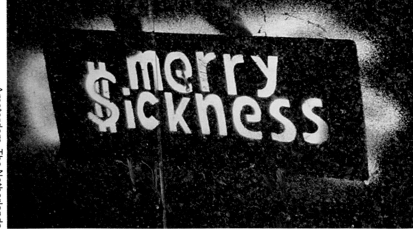

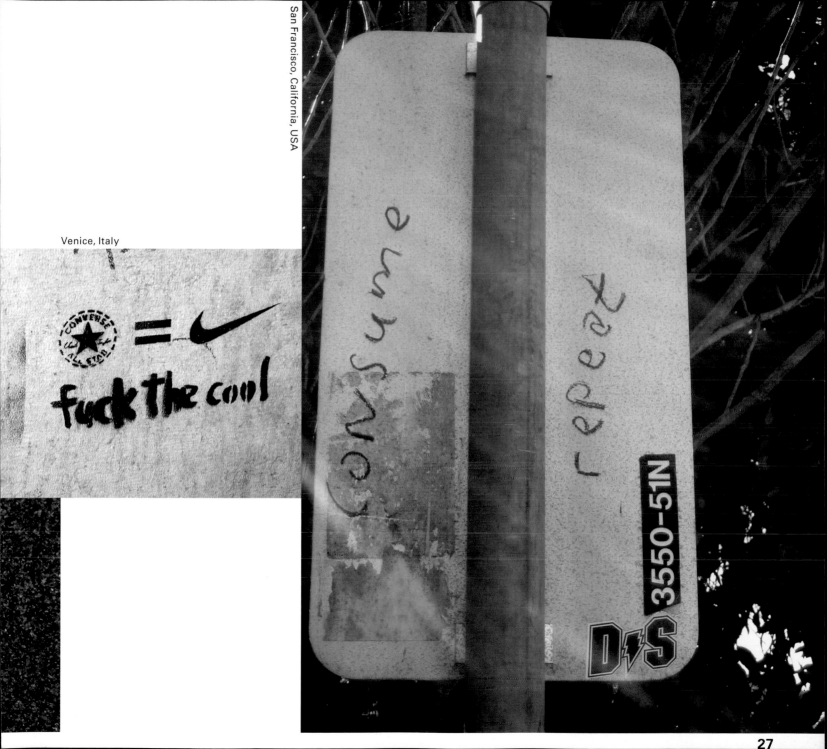

Venice, Italy

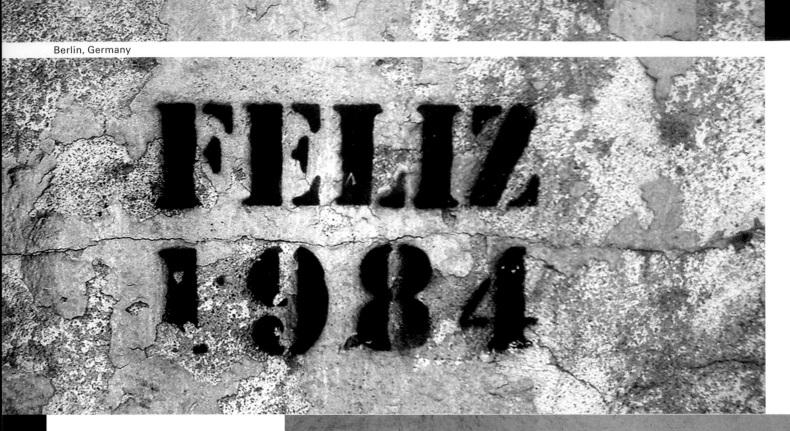

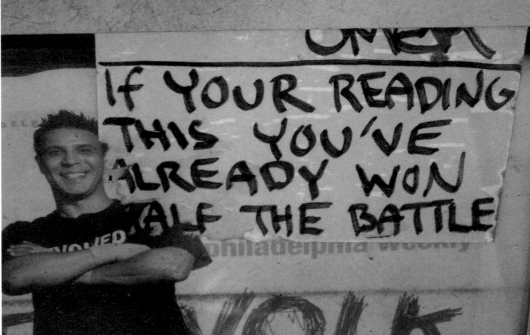

If YOUR READING THIS YOU'VE ALREADY WON HALF THE BATTLE

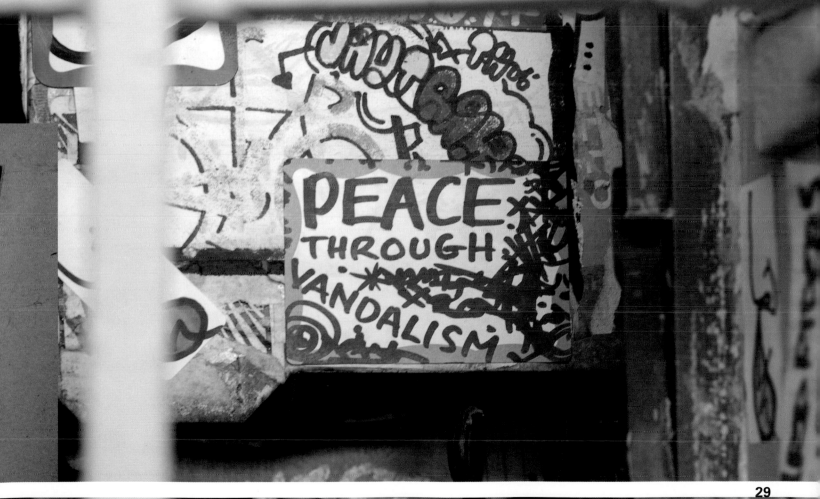

Philadelphia, Pennsylvania, USA

# WHERE GRAFFITI COMES FROM

**GREECE**
*Graphein* (v.) to write, draw, or paint

*and/or*

**ITALY**
*Graffiare* (v.) to carve, engrave, scratch

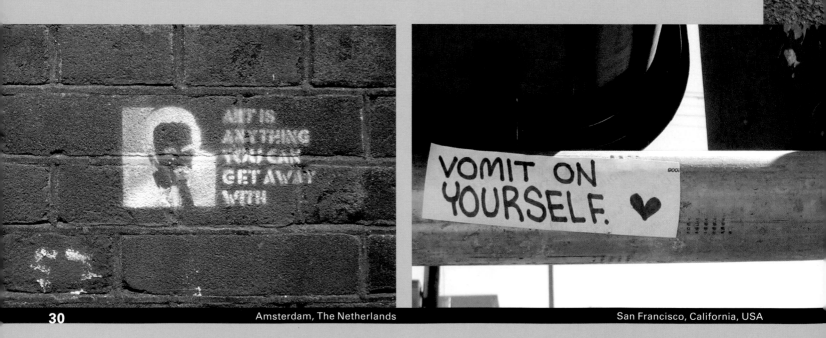

Amsterdam, The Netherlands

San Francisco, California, USA

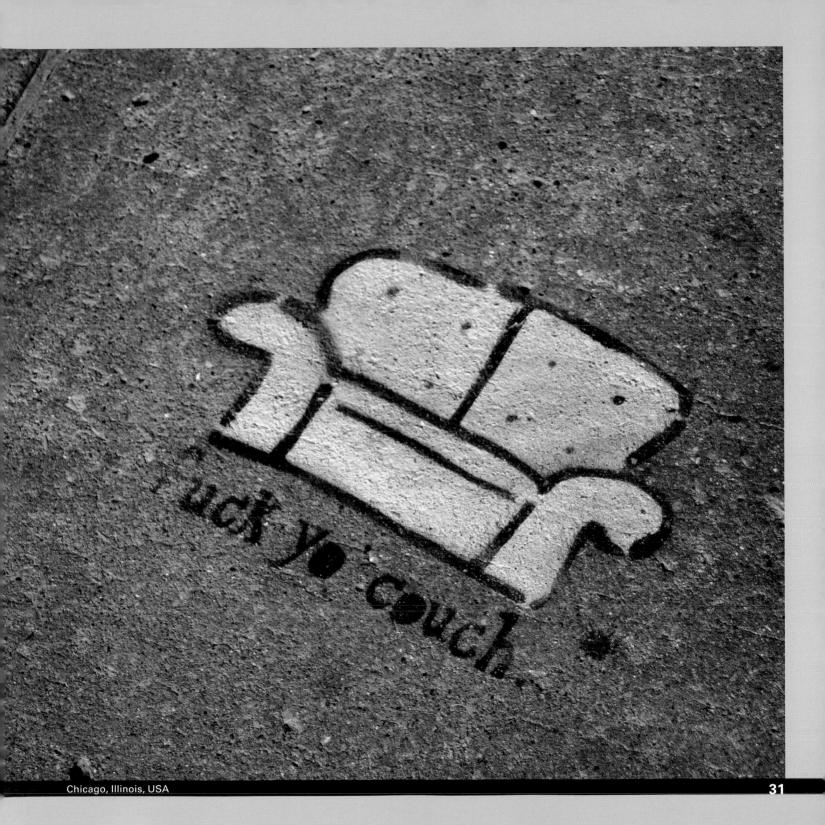

ay bridge fuck my broken hamstring fuck driving to la fuck cubicles fuck windowlessness fuck loud-talking swivelchair fatties fuck strategic interface concre
hes fuck exploiting profanity fuck please fuck the exgirl fuck the fucking fuck a fuck your coke habit fuck yo couch fuck the grind fuck no fuck death fuck mone
ob fuck traffic fuck michael vick fuck it on a silver platter fuck looking for job fuck having 5 jobs fuck talents fuck fossil fuel fuck a model fuck global warming
but fuck the wind fuck this fuck your own hand fuck anything when you drink too much fuck sandals with socks fuck cheeto salad fuck everything fuck housto
herman fuck my confiscated chapstick, tsa fuck dick cheney fuck your deadlines fuck your work/life balance fuck your meetings fuck your process fuck your p
groups fuck conference calls fuck cowardice fuck fear fuck fear fuck fear fuck my fear fuck your fear fuck greed fuck squandered liberty fuck shopping therapy f
as texture fuck me (again) fuck "edgy" fuck cool fuck repetition fuck repetition fuck repetition fuck here now fuck the news fuck the corporate media fuck hov
essionalism fuck cussing fuck prayer fuck meditation fuck mindfulness fuck intention fuck dogma fuck fanatics fuck fanaticism fuck extremists fuck black and v
y fuck laziness fuck this riff fuck not having fun fuck preaching all the time fuck the person you were yesterday fuck positive outlook fuck depression fuck leavi
ng for permission fuck fear fuck fear fuck fear fuck me (again and again) fuck my face fuck my ass fuck my mind fuck my heart fuck me where it hurts fuck des
nstinct fuck your symbolism fuck your neckbone connected to your headbone fuck you for pretending to try fuck your fancy yoga bag fuck wearing other cu
ed fuck the open waters fuck the endless sky fuck having to find your way fuck being sick fuck being tired fuck being sick and tired and cold and hungry and lo
the new black fuck the old guard fuck obsolete laws fuck tradition fuck vision fuck positive outlook fuck two birds with one stone fuck clowns fuck twenty of th
the idea that something's wrong fuck a better tomorrow fuck choosing your battles fuck art fuck street art fuck urban cool fuck the underground fuck artists f
fuck getting away from it all fuck fancy spas fuck bodywork fuck lifestyle fuck fancy anything fuck ugly too fuck artificial sweeteners fuck refined sugar fuck foo
monkeys fuck donkeys fuck your butt fuck your sister fuck your uncle fuck your peanut butter fuck now or forever hold your piece fuck marriage fuck loneline
your neighbors fuck your hometown fuck being from any one place fuck globalization fuck responsibility fuck citizenship fuck vandalism fuck breaking the law
anarchy fuck nationhood fuck the grid fuck living off the grid fuck waffle irons fuck a spoonful of sugar fuck drinking it black fuck spitting fuck swallowing fuc
fuck shy people fuck big personalities fuck steamrollers fuck consolidated power fuck the power company fuck power fuck your political platform fuck your
y fuck yankee doodle dandy fuck baloo fuck the jungle book fuck hybrid cars fuck potatoes fuck tacos and taco salad fuck the poo on our doorstep fuck music f
ionships fuck los angeles fuck your loud voice fuck cheese blankets and chicken fuck shoelaces fuck velcro fuck farming fuck grapes fuck persuasion fuck brar
looking for apartments in san francisco fuck my credit report fuck my debt fuck the irs fuck greenwashing fuck the green movement fuck hot flashes and fever
fucking cell phone fuck underwire lingerie fuck titties fuck faded carpets fuck breakfast fuck food fuck health problems fuck the food pyramid fuck ethnograp
oo ha fuck version control fuck dank moldy carpets fuck old people who mean well fuck repression fuck exercise fuck my love handles fuck my baggy eyes fuc
ble fuck the homeless problem fuck getting a job fuck suits and ties fuck weddings fuck family obligation fuck grow and win fuck the language you use to man
your mission statement fuck your solid oak conference table fuck your arm chairs fuck craigslist fuck being angry and hungry fuck cantaloupe fuck file folders
esign fuck brand names fuck big box stores fuck smooth tan skin fuck comedy fuck design snobbery fuck design starfuckers fuck the projects on webster str
atpants fuck oversize sunglasses fuck silverlake fuck everyone who wants something from me fuck this hat fuck innovation fuck tattoos fuck the quest to be in
pany fuck belt loop doodads fuck style snobbery fuck burning man fuck never admitting faults fuck memes fuck haight street hippies fuck funny quote shirts fu
loctor fuck status fuck surfing fuck judgment fuck fat girls with too much makeup fuck perfume fuck spoiled college girls who live in their parents' house fuck c
being tired fuck sleep fuck this messy office fuck shit on the floor fuck the floor fuck hipster pastries fuck veganism fuck meat fuck everything outside your ov
fuck grad school fuck tricycles fuck hayes valley fuck expensive dinners fuck bread baskets fuck the long walk to work fuck saying goodbye fuck bile fuck win
aspirations of middle class fuck your fantasy fuck male pattern baldness fuck blind dates fuck activism fuck muay thai fuck getting fat fucking worrying abou
uck lockjaw fuck pretending to be engaged fuck trying so hard fuck sandwiches fuck high-end malls fuck reality tv fuck flying across the country fuck expensi
oodily fluids fuck money transfers fuck purchase orders fuck drugstores fuck standup comedy fuck being in the now fuck intentionality fuck lunch decisions f
high heels fuck piercings fuck clock hands fuck patience fuck phone calls fuck outsourcing fuck international politics fuck the whole world fuck the polar ice
oard fuck hitting refresh ten times a day fuck being polite fuck the social good fuck brown nosing fuck magazines fuck swear words fuck positive change fuc
conferences fuck feature articles fuck left-hand turns fuck coffee cups fuck amoebic dysentery fuck the runs fuck bleached hair fuck me me me fuck the podiu
estate market fuck traveling across the country fuck being cold fuck breaking your lease fuck burritos fuck video games fuck random mailing lists fuck breakfa
ors' appointments fuck public transportation fuck plastic bags fuck environmental consciousness fuck lucifer jones fuck hippie laws fuck obvious logo choices
b fuck hiding fuck tortilla chips fuck independent accounting fuck accounts payable fuck online banking fuck diy fuck art school fuck beggars being choosers fu
rt scene fuck couples fuck big fat and sweaty fuck vaginas fuck juicebox scorpions fuck the copy deck fuck your big vision and lack of courage fuck your real
ury maps fuck the ice age fuck australopithecus man fuck the ancient scroll fuck the holy grail fuck your yellow shirt fuck you for being my future brother-in-la
uck the ex-wife fuck indecision fuck garbage fuck trees fuck going to seed fuck hotel room rates fuck the caravan fuck every bad song you've ever heard fuck t
vinyl seats fuck moon over my hammy fuck talking barnyard animals fuck totalitarian fantasies fuck being an authority fuck not knowing fuck moving to oakla
uck compassion fuck your empathy fuck your need for security fuck the shit out of that melon fuck a toilet paper tube covered in moisturizer fuck three stripe
ch for something better fuck the airlines fuck paying for your own drinks fuck photo alteration fuck miscategorized posts fuck megaphones fuck speaker's cor
ol fuck established shops fuck vines and ivy and iceplant fuck e-mail fuck planning fuck the jump to lightspeed fuck walking carpets fuck your highness fuck tr
d stunts fuck late night television fuck mail order movies fuck two year contracts fuck my headache fuck a little more fuck hunh fuck misdirected anger fuck c

32

h paper fuck ceramic bowls fuck printers that cost a lot but don't work fuck lower back pain fuck restless leg syndrome fuck the white bar fuck hanging sungl
et fuck these waves man fuck commercials about sex and food fuck stupidity fuck this week fuck the first half of next week fuck waiting two years to see my gi
r conditioned theater fuck your handkerchief fuck your fixie fuck your skinny jeans fuck your dirty style fuck north beach on the weekends fuck italian barl

s fuck yes fuck god fuck all y'all fuck yo' mama fuck apos-
ck bush fuckin a-hole fuck this for a game of soldiers fuck
k coldplay fuck the world fuck a duck fuck wind cold your
tt fuck clowns fuck harry potter fuck yo low pressures, mr
ect managers fuck your powerpoint presentations fuck fo-
voting with your dollar fuck money fuck me fuck lists fuck
blishing fuck language in common fuck boardrooms fuck
e fuck ambiguity fuck nuance fuck shades of gray fuck pas-
t in someone else's hands fuck asking for permission fuck
fuck branding fuck pigeonholes of any size fuck your nest-
es as ornament fuck tourism fuck traveling without being
and hopeless and tired, tired, tired fuck it all fuck nothing
in the backseat of a clowncar fuck not knowing what to do
job descriptions fuck fitting in fuck doing fuck being fuck
omas fuck staring into the fridge, not knowing what to eat
uck partnership fuck solitude fuck family fuck community
dutiful sons fuck the spirit of the law fuck legal precedent
ur local delicacy fuck fucking fuck talking fuck verbal diar-
ty fuck your agenda fuck your love of power fuck my ego
my upset stomach fuck this dirty office fuck long distance
trategy fuck identity fuck the chocolate starfish fuck maps
lls fuck blankets fuck being the boss fuck the workers fuck
uck wine week fuck cool style and lame organization fuck
y big nose fuck angels on the head of a pin fuck homeless
ate people fuck train wrecks fuck your core competencies
k ergonomic workstations fuck office furniture fuck swed-
fuck graffiti in my garage fuck cow tipping fuck red velour
sting fuck flat screen monitors fuck your new snowboard
ur local pride fuck team spirit fuck having to be right fuck
king my credit fuck santa barbara fuck the eight hour drive
ead fuck trance music fuck rock and roll fuck college drop-
g fuck shadow puppets fuck two dogs instead of kids fuck
it fuck random jury selection fuck nonviolent communica-
otels fuck the diggity doo da day fuck cartoons fuck virus
new shoes fuck the status quo fuck cute little black books
s fuck the latest awareness campaign fuck crumbs on my
ur fancy cowboy boots fuck blogging fuck virtual worlds
uck control fuck sitting on the floor fuck paranoia fuck the
uck gourmet chocolate fuck rocket science fuck canceling
k radioactive iodine fuck the final frontier fuck feeling like
ur sun deck fuck the hair on my back fuck your angst fuck
te moguls fuck big beautiful coffee table books fuck early
uck your ping pong skills fuck my weed smoking father-in-
orth star fuck aurora borealis fuck in the heat of the night
uck the east bay fuck automatic formatting fuck capitaliza-
es fuck traction fuck sore shoulders fuck the never ending
fuck graffiti and everything associated with it fuck design
compactors fuck incestuous movie plots fuck aerobic key-
king searching my name on the internet fuck high school

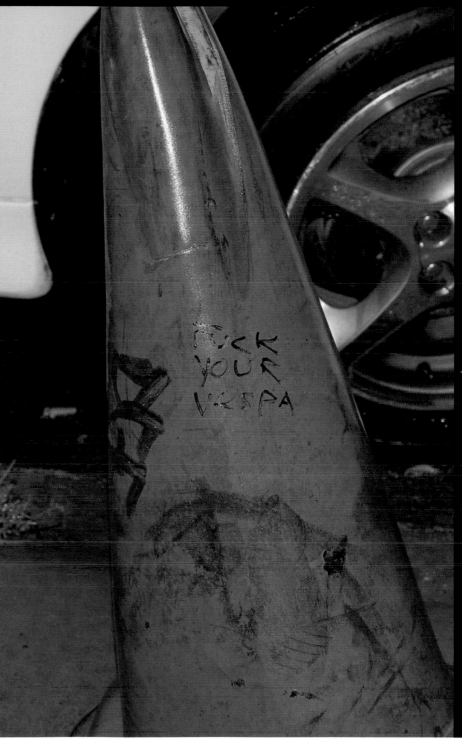

San Francisco, California, USA

33

es from your collar fuck camouflage pants fuck the honey
end again fuck the big blue bus fuck asking for blankets in
and their mock turtlenecks fuck garbage trucks fuck that

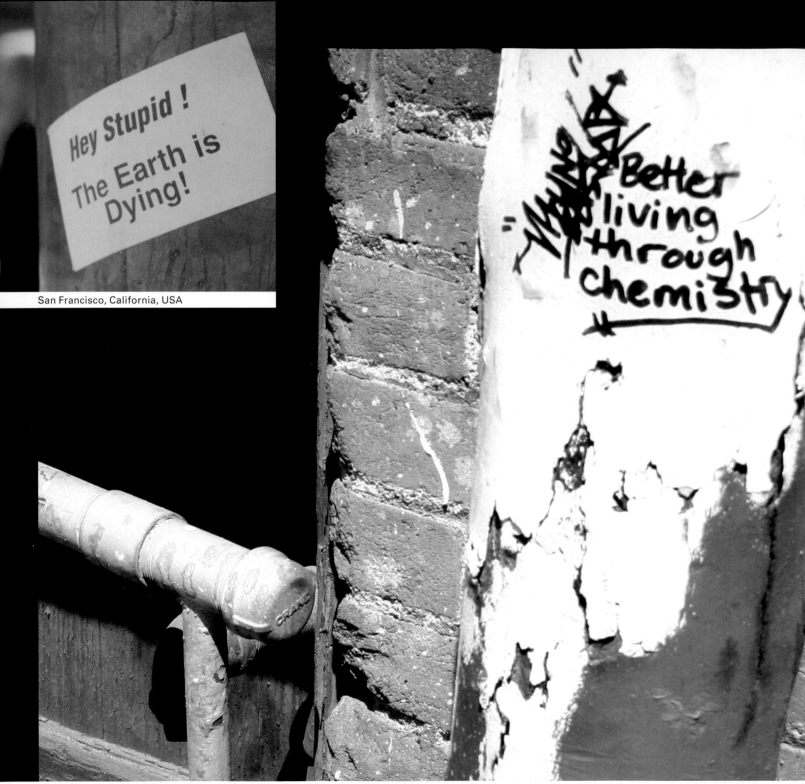

San Francisco, California, USA

**34**

Boise, Idaho, USA

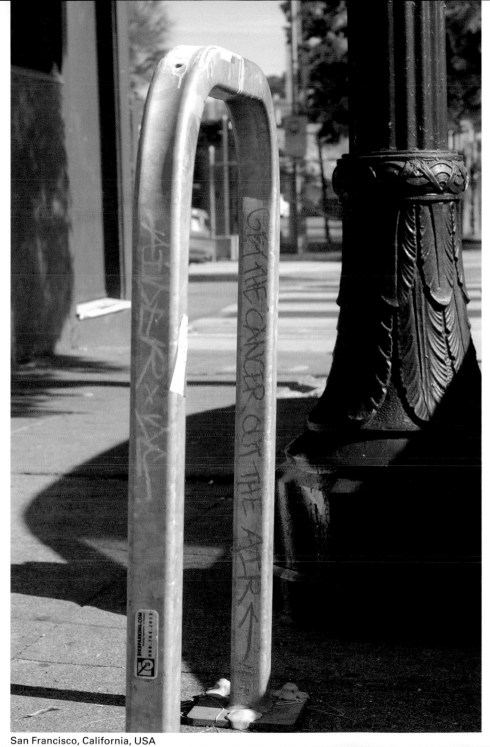

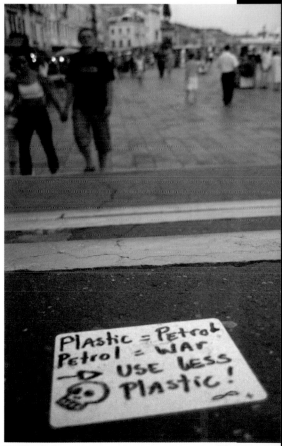

San Francisco, California, USA

Venice, Italy

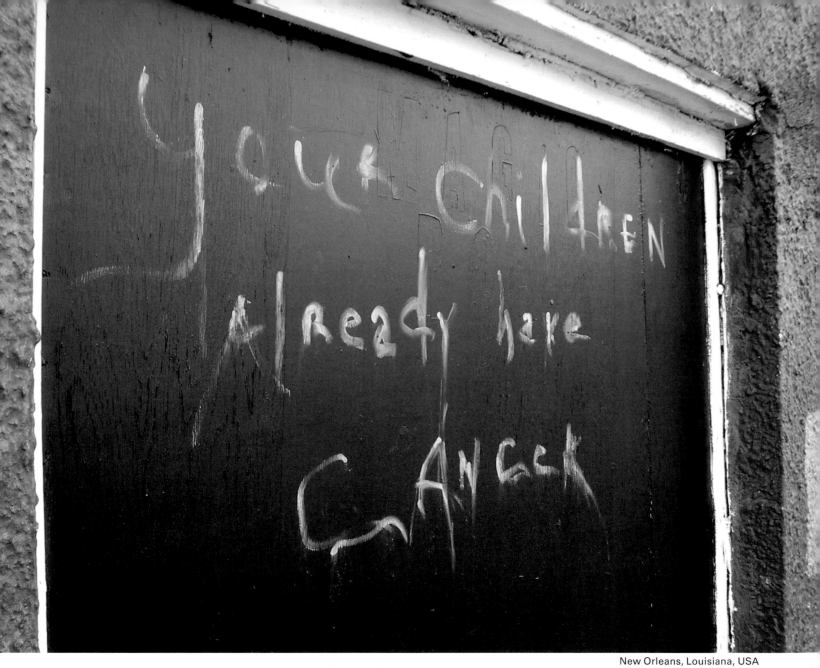

New Orleans, Louisiana, USA

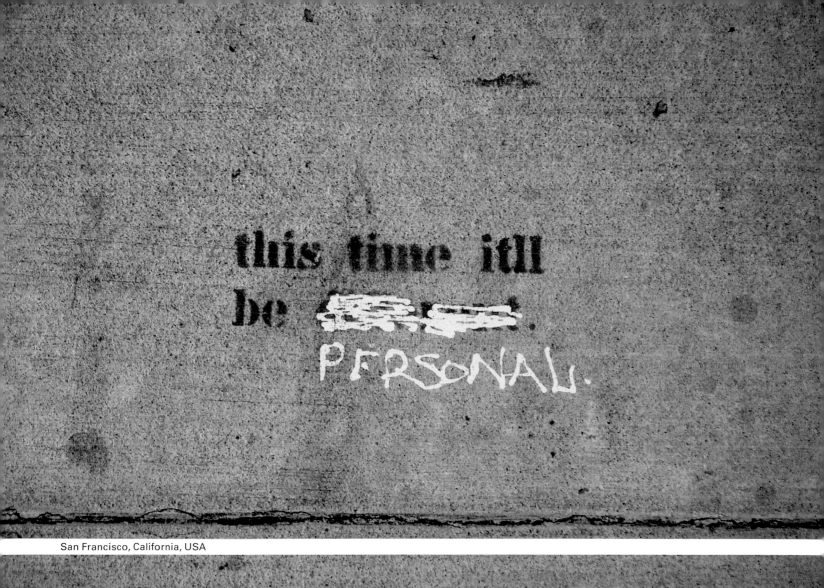

this time itll
be ~~personal~~.
PERSONAL.

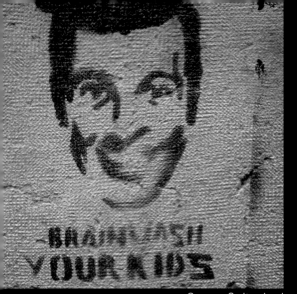

BRAINWASH YOUR KIDS

Geneva, Switzerland

I CAN'T TAKE CARE OF MYSELF. ♥

de banda

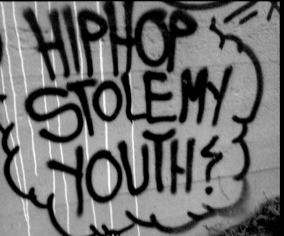

HIPHOP STOLE MY YOUTH?

Moss, Norway

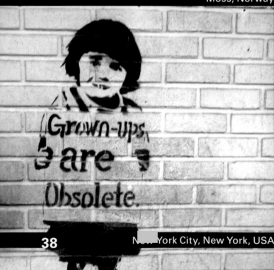

Grown-ups are Obsolete.

New York City, New York, USA

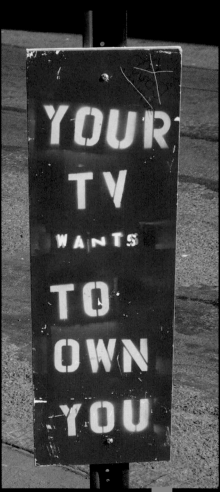

YOUR TV WANTS TO OWN YOU

New York City, New York, USA

net
ancha

San Francisco, California, USA

NO
More
Children

San Francisco, California, USA

**translation:** don't abandon your grandparents

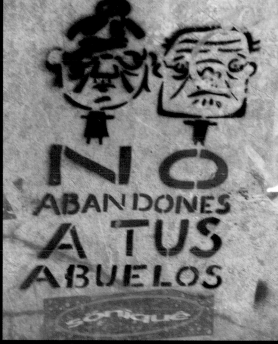

NO
ABANDONES
A TUS
ABUELOS

Granada, Spain

Estimated number of ad messages
seen per day by city dwellers in 1976:

# 2,000

Estimated number of ad messages
seen per day by city dwellers in 2006:

# 5,000

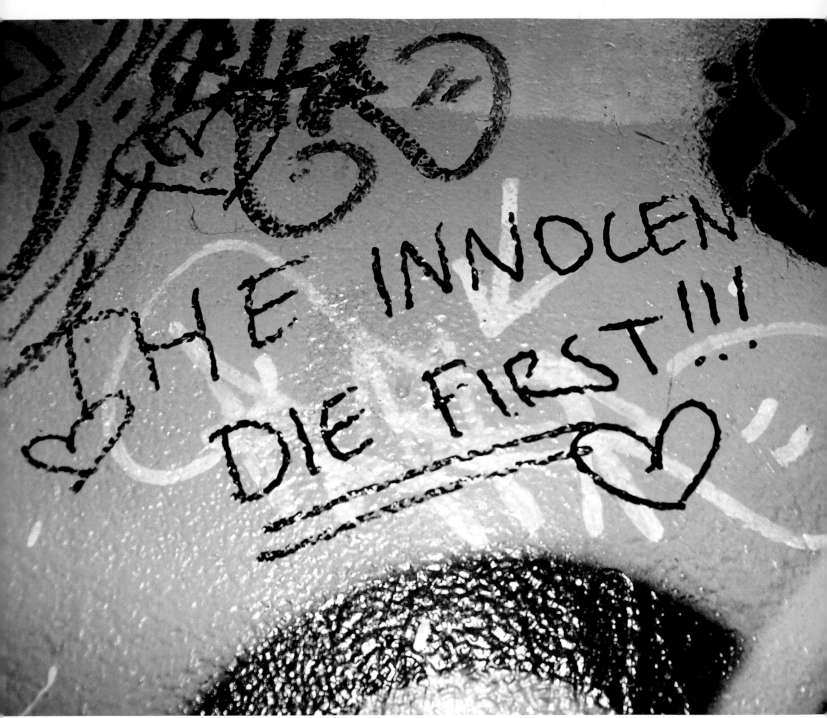

Melbourne, Australia

**40**

I WOULD LIKE TO RETRACT MY LAST COMMENT

San Francisco, California, USA

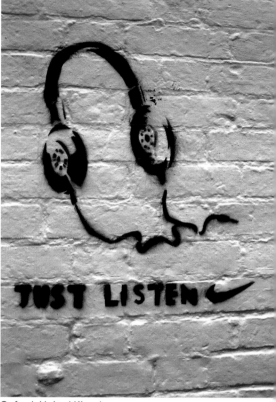

JUST LISTEN

Oxford, United Kingdom

LIFE AND DEATH ARE A STUPID SELLING SHOW

Dresden, Germany

The most prized brand of spray paint for graffiti is called Montana (a.k.a. MTN), made in Spain.

44

# TYBURN GALLOWS, SPEAKERS' CORNER

If you were a Londoner 400 years ago, and you'd been sentenced to be executed, you could go to one of five places, depending on what crime you'd committed:

If you were a traitor, you'd be hanged or beheaded at the Tower of London. If you were a pirate, you'd be hanged at the execution dock at Wapping. If you were a servant and you'd killed your master, or a woman and you'd killed your husband, you'd be burnt, beheaded, or boiled at West Smithfield. If you were a thief, you'd hang at East Smithfield. And if you were a plain old felon, you'd be taken to the Tyburn gallows.

But, consider this: If you were "taking a ride to Tyburn," or, as they say, if you were off "to fetch a Tyburn stretch," you could call yourself lucky, because your day would go more or less like this:

You'd put on your finest clothes and make your way out of Newgate prison, as the great bell of St. Sepulchre—which only tolls on execution days—rang through the town. You'd climb into an oxcart with the hangman and the prison chaplain, stopping for one drink at every ale house and inn along the way. By the time you reached the gallows, you'd be good and drunk, and you'd speak your mind in front of a crowd of up to 200,000 people who'd paid to watch the spectacle of your death. Then you would hang until you died. (Unless you were already dead: In an act of posthumous revenge, Charles II hanged three dead men, including Oliver Cromwell, at Tyburn, after digging them up from their graves.)

Now, keep in mind, that little speech part would have made you pretty special. You couldn't just open your mouth and speak you mind whenever/wherever you wanted. Back then, you could get arrested and/or executed for saying certain things. And if you got executed anywhere else, you didn't get the chance to make a speech like you did at Tyburn.

But here's the thing: The people loved that speech part. Sure, by hanging you (and up to twenty-three others at the same time) the King or Queen of England was demonstrating the state's power, not-so-subtly suggesting that you stay within the law. But people detected, nonetheless, a glimmer of hope in your defiance, in your insouciance. They grew to love it. They craved it as much as any other part of the execution spectacle.

So, when the gallows were removed from Tyburn in 1783, and the spot became a park, there remained an emptiness. A yearning. An unmet need. A hundred years later, when the Reform League urged Parliament to designate a corner of that park as a spot for free speech, it brought up that history, and those executions. To this day, Speakers' Corner, in Hyde Park, London, is a place where free speech—on any subject—is protected.

Australia (Hyde Park Sydney) followed suit in 1878, Canada followed along in 1966, and the Netherlands, in response to Theo van Gogh's murder, created a Speakers' Corner in 2005.

(Singapore's not quite playing the game: the Speakers' Corner there is next to a police station, where you gotta register. You also have to be a citizen of Singapore, and speak in one of the four official languages of Singapore. Also, you can't talk about race or religion or bring up anything else too controversial for the government.)

WHERE IS
MISERY? MAY
WHAT! Some times
I DONT see the
Exist of life. Have
you seen it, yes or
NO! WHERE IS IT?
NEVER get me wrong
I LOVE you. SOME WHERE
OVER THE RIANBOW, SHE
MUST PEEPER to be SURROUNDED

San Francisco, California, USA

46

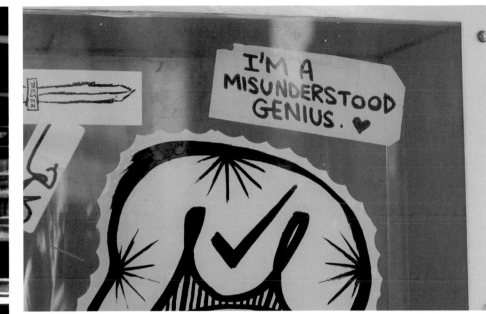

San Francisco, California, USA

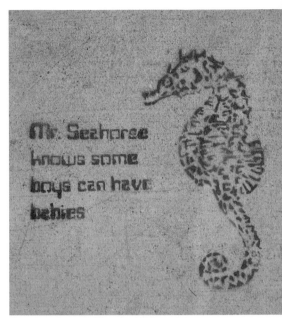

San Francisco, California, USA

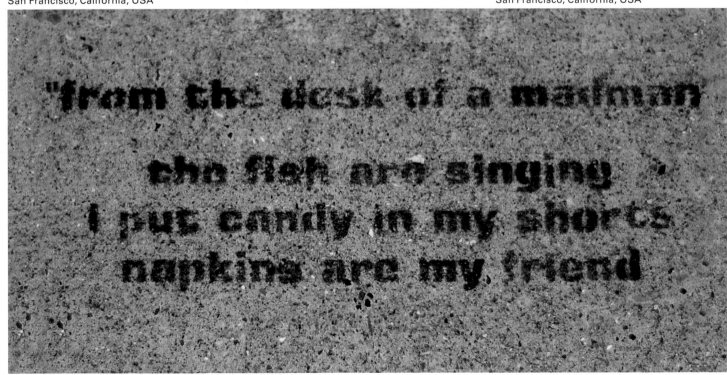

San Francisco, California, USA

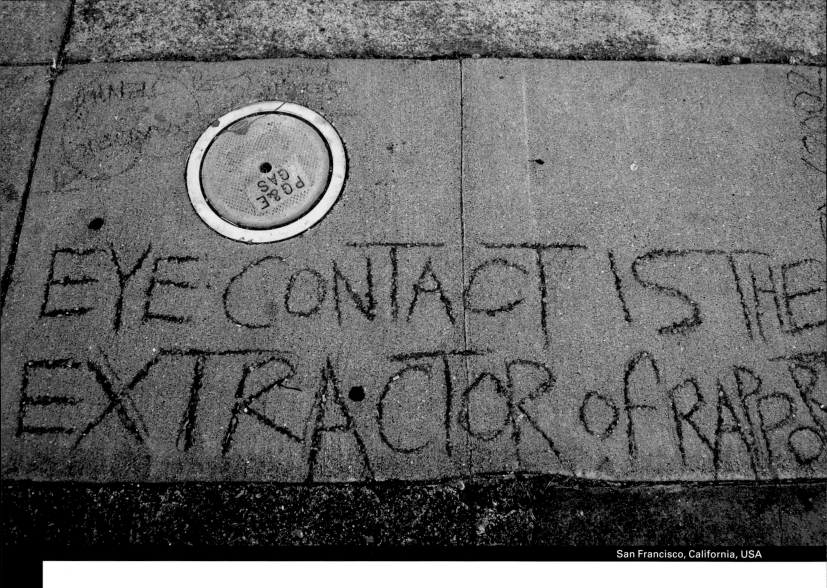

San Francisco, California, USA

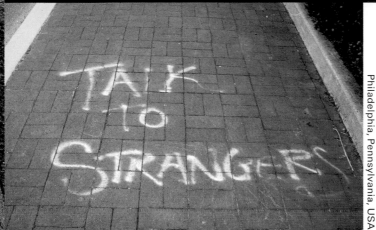

TALK
TO
STRANGERS

TELL ME THE
BAD THINGS
YOU SAY ABOUT ME
WHENEVER I'M NOT AROUND

OK, STRANGER
I SAID YOU WERE WORTHLESS
SHALLOW, PREDICTABLE
THAT I DIDN'T CARE ANYMORE
BUT I'M DONE LYING
NOW TELL ME
SOMETHING TRUE.

49

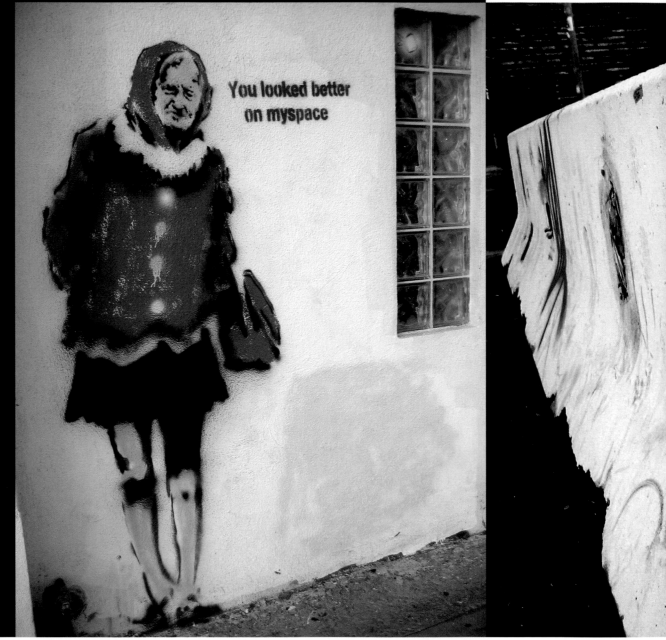

Los Angeles, California, USA

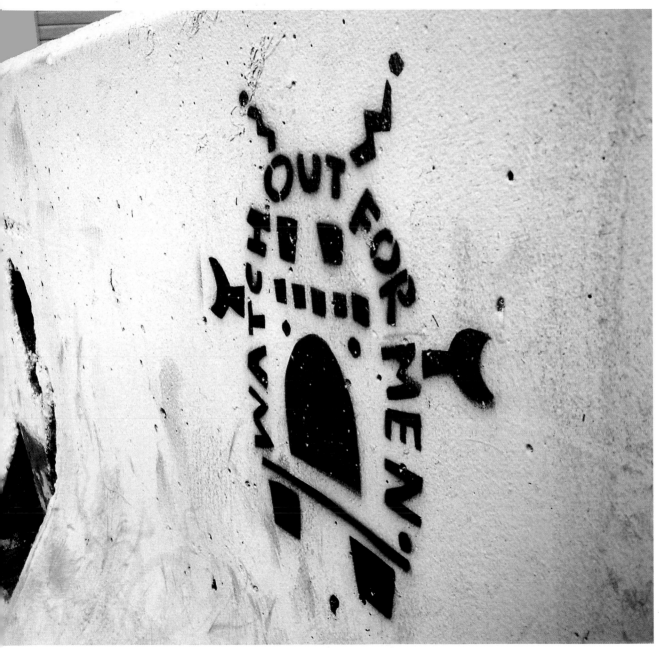

Sacramento, California, USA

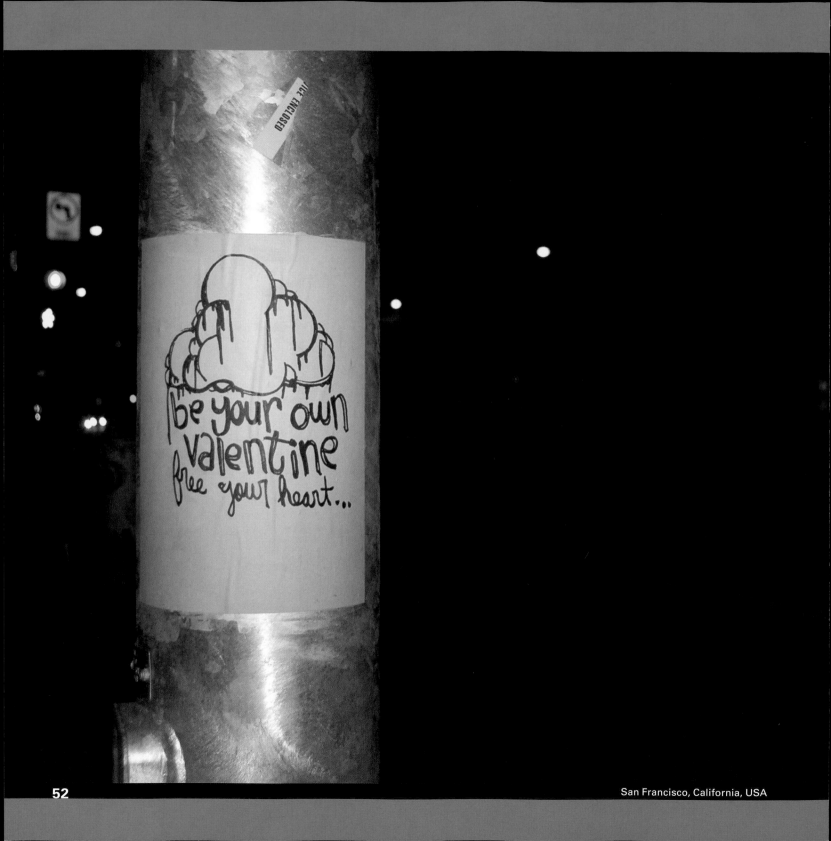

San Francisco, California, USA

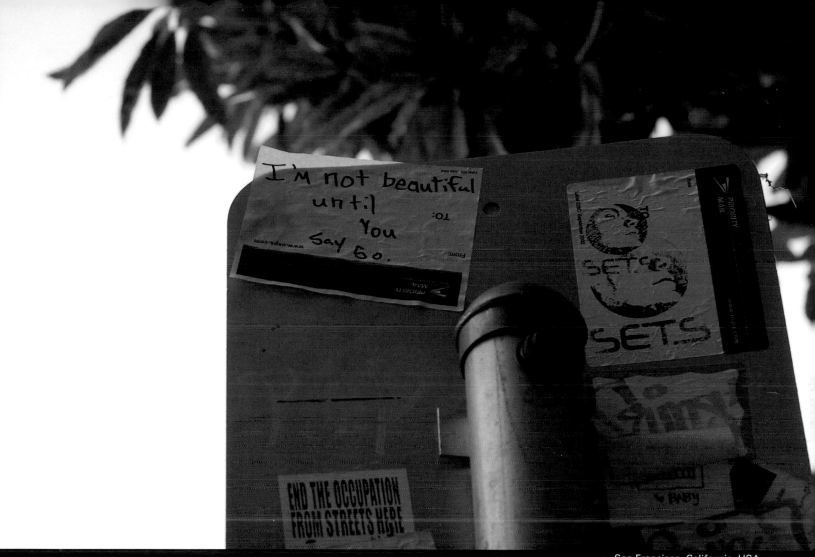

San Francisco, California, USA

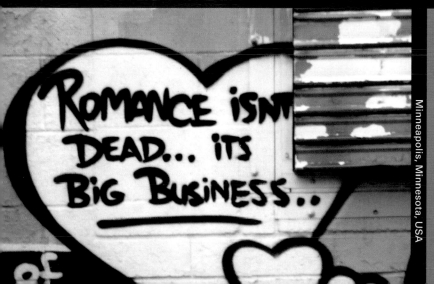

Minneapolis, Minnesota, USA

53

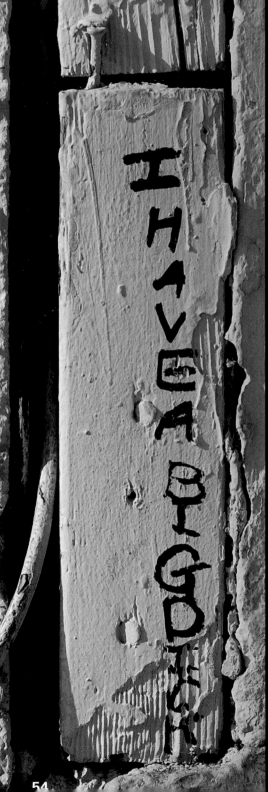

I HAVE A BIG DICK

San Francisco, California, USA

Asheville, North Carolina, USA

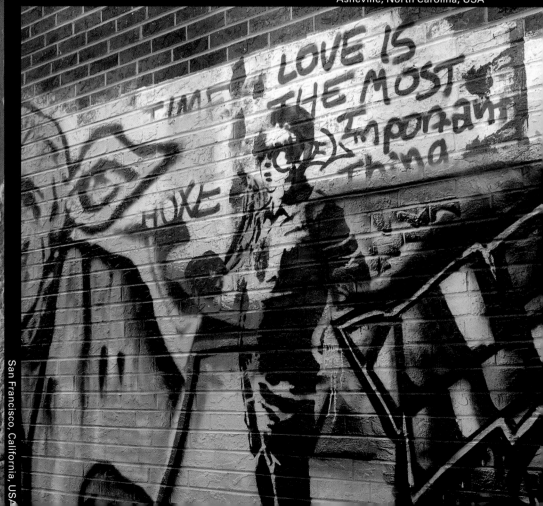

LOVE IS THE MOST (imporan) thing

Granada, Spain

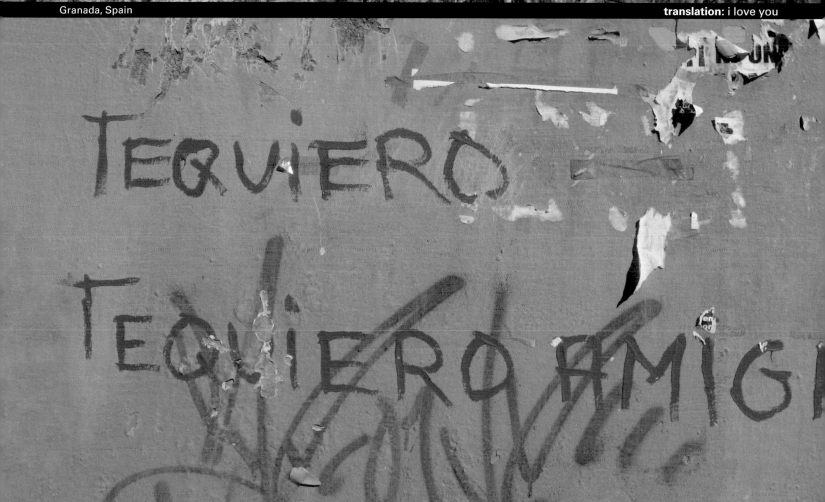

TEQUIERO

TEQUIERO AMIG

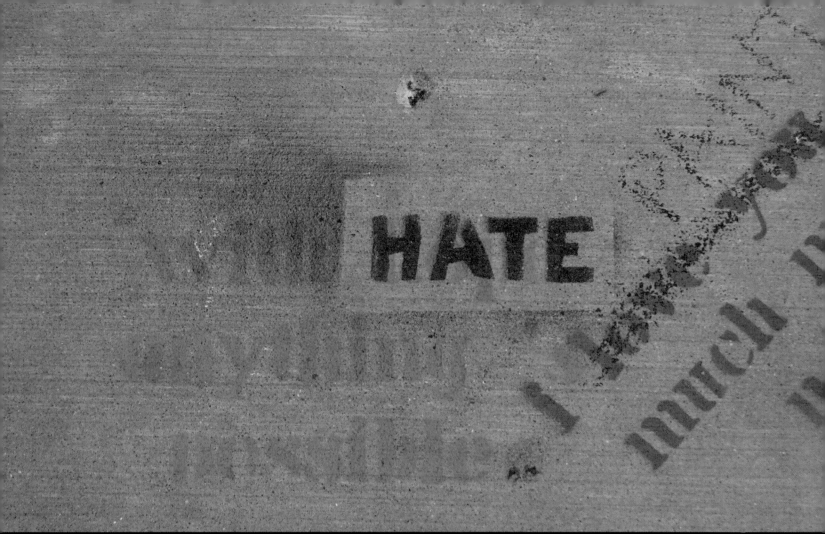

San Francisco, California, USA

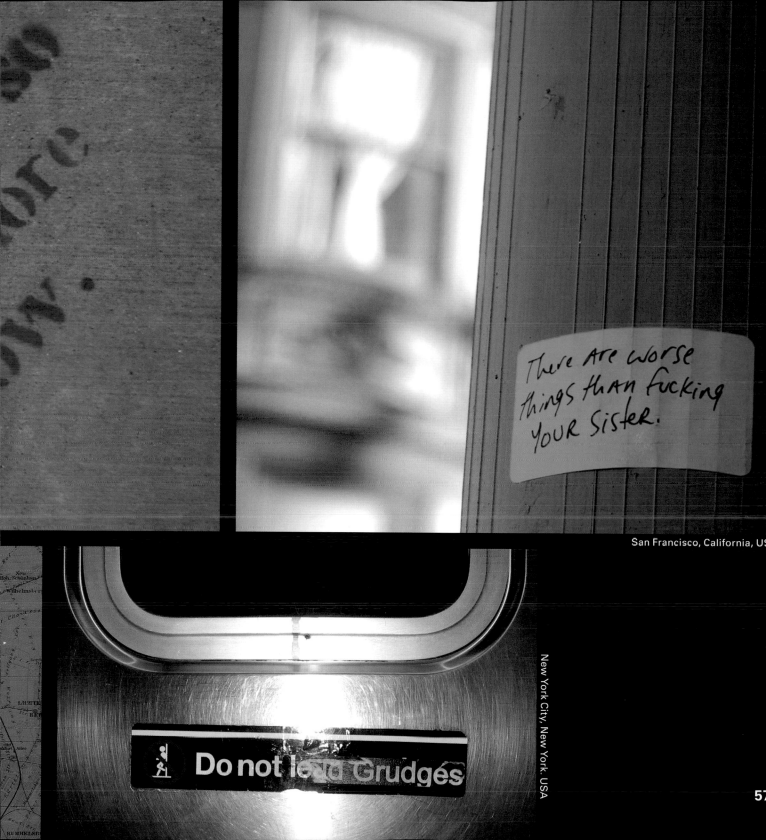

There Are worse things than fucking YOUR Sister.

San Francisco, California, US

Do not lend Grudges

New York City, New York, USA

5

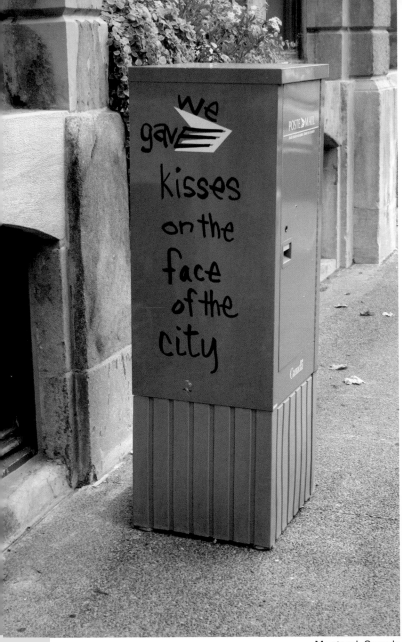

Montreal, Canada

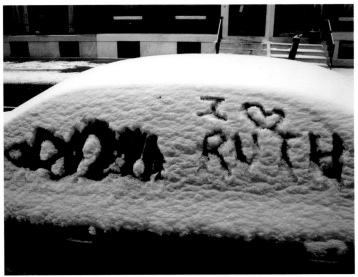

Philadelphia, Pennsylvania, USA

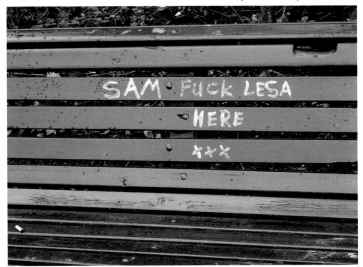

Amsterdam, The Netherlands

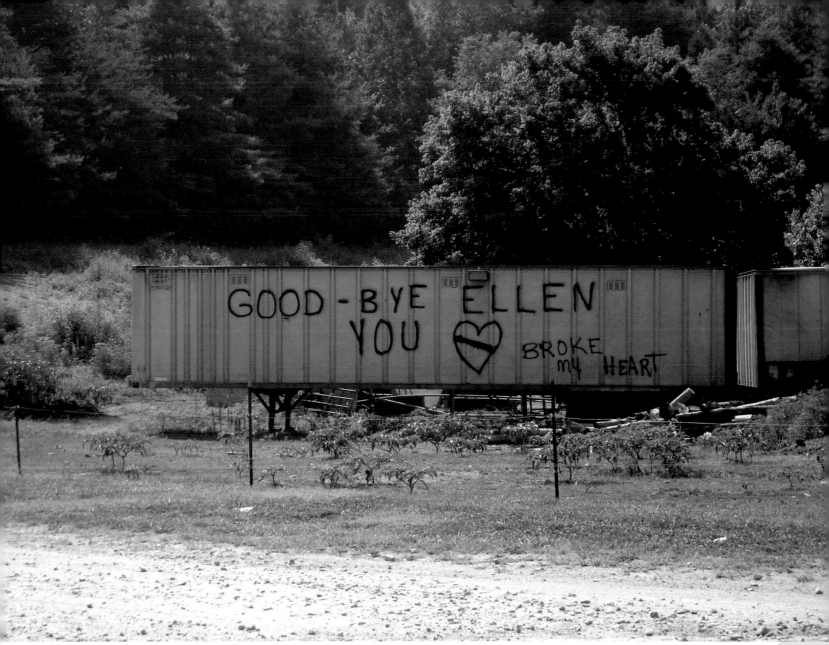

Asheville, North Carolina, USA

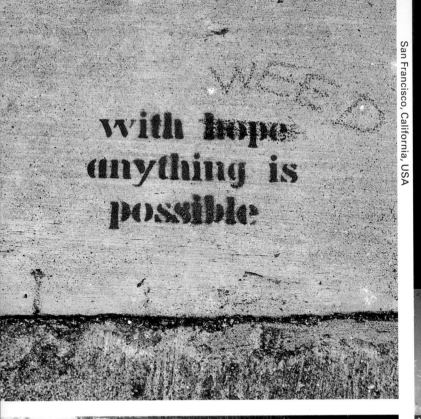

with hope
anything is
possible

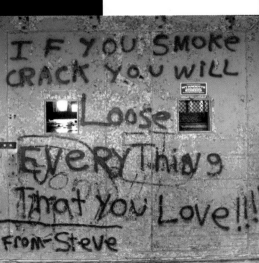

IF YOU SMOKE
CRACK YOU WILL
Loose
EVERYThing
That you Love!!!!
From Steve

# APATHY AND PILLS

## MAKE A DANGEROUS COCKTAIL

PEOPLE ARE DYING EVERYDAY, BEING
EVICTED FROM HOUSING, LOSING THEIR BASIC
RIGHTS, SOCIAL SERVICES AND
BEING FORCED TO PAY RIDICULOUS
PRICES
JUST TO
LIVE
ANOTHER DAY.

WHATEVER
60
HAPPENED TO OUR OUTRAGE OVER AN
EXPLOITATIVE MEDICAL INDUSTRY AND A

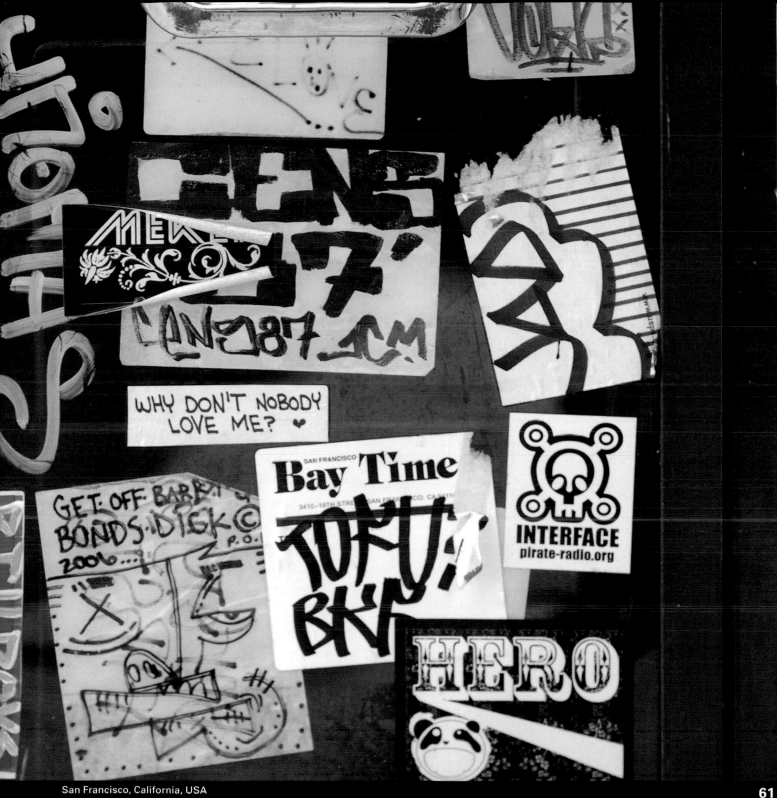

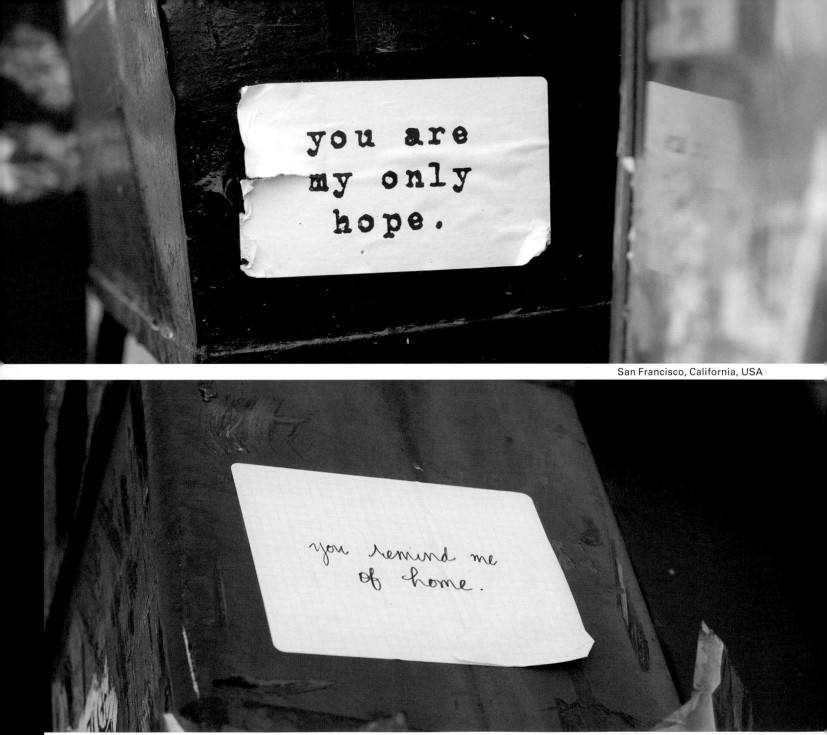

San Francisco, California, USA

San Francisco, California, USA

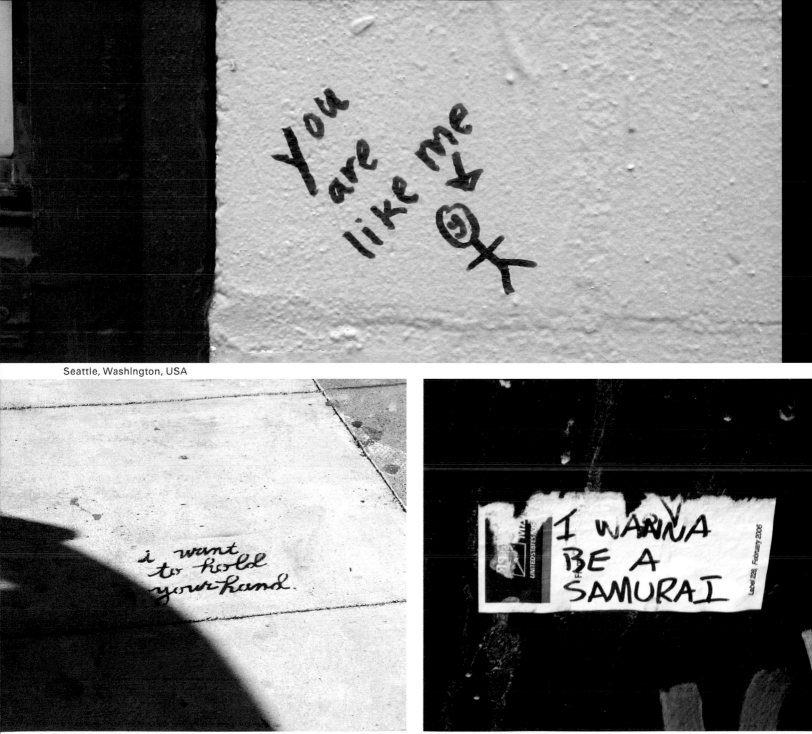

Seattle, Washington, USA

San Francisco, California, USA

Philadelphia, Pennsylvania, USA

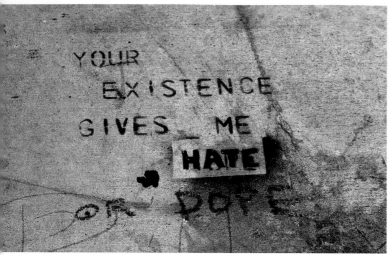

San Francisco, California, USA

Crack For Sale.
Hotel Vigilante.
370 8th Avenue.
4th Floor. #426.

See Mister Garfield.

New York City, New York, USA

Richmond, Virginia, USA

64

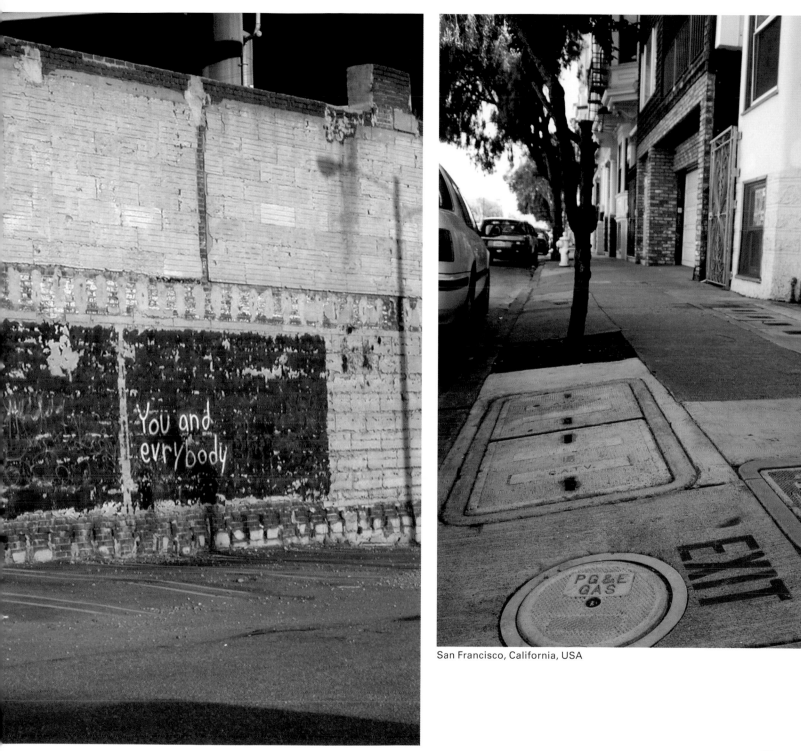

San Francisco, California, USA

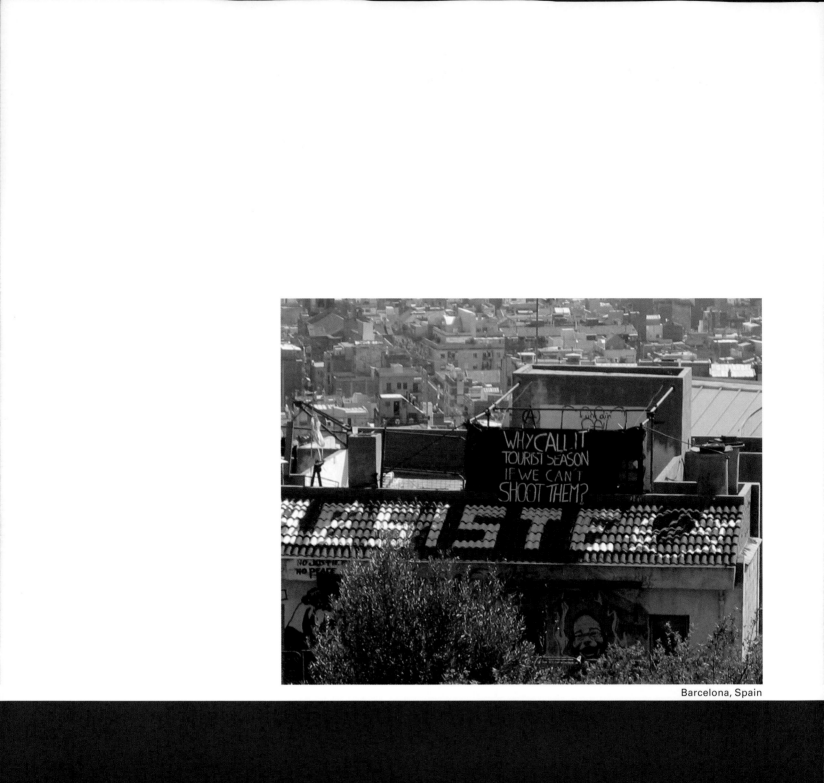

Barcelona, Spain

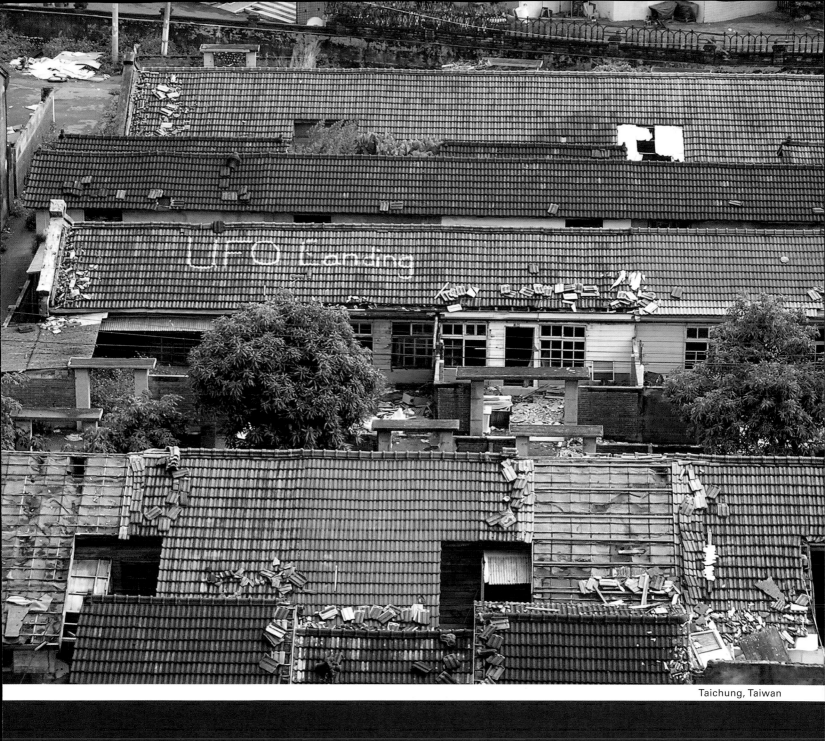

Taichung, Taiwan

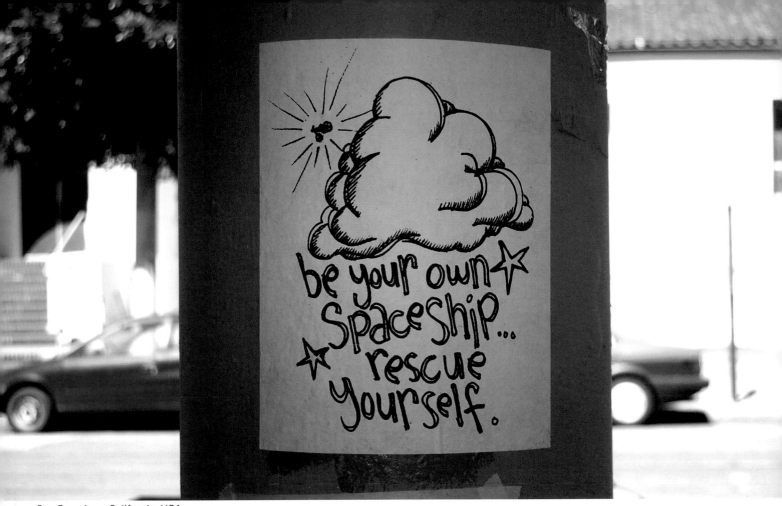

be your own ☆ Spaceship... ☆ rescue yourself.

San Francisco, California, USA

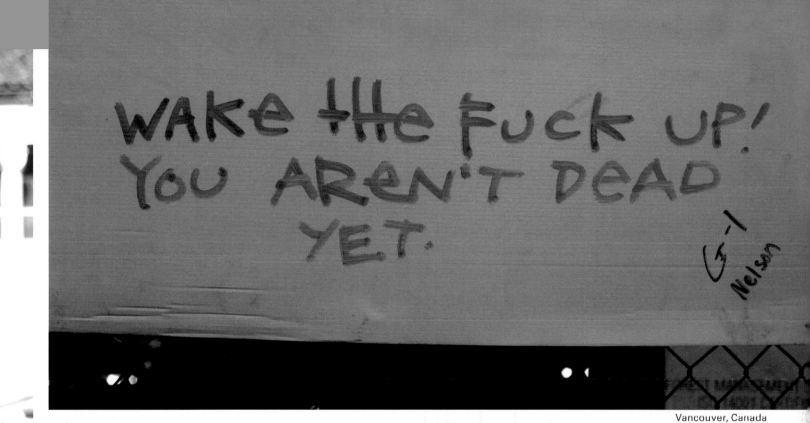

WAKE tHe FUCK UP!
YOU AREN'T DEAD
YET.
G-1
Nelson

Vancouver, Canada

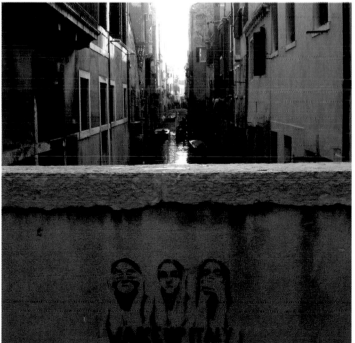

Venice, Italy

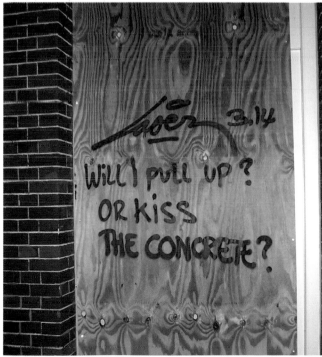

Laser 3.14
WILL I PULL UP?
OR KISS
THE CONCRETE?

Amsterdam, The Netherlands

In 1989, New York City spent $55,000,000 on graffiti cleanup efforts.

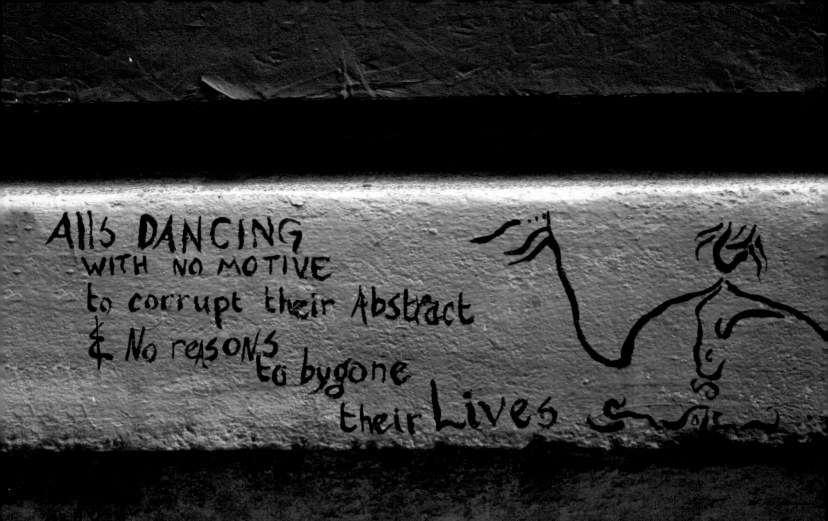

AIIs DANCING
WITH NO MOTIVE
to corrupt their Abstract
& No reasons
to bygone
their Lives

Boise, Idaho, USA

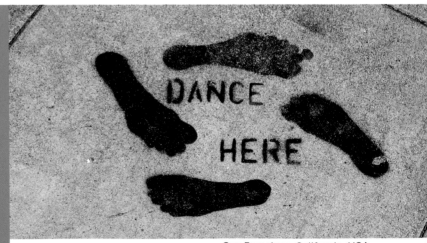

DANCE

HERE

San Francisco, California, USA

72

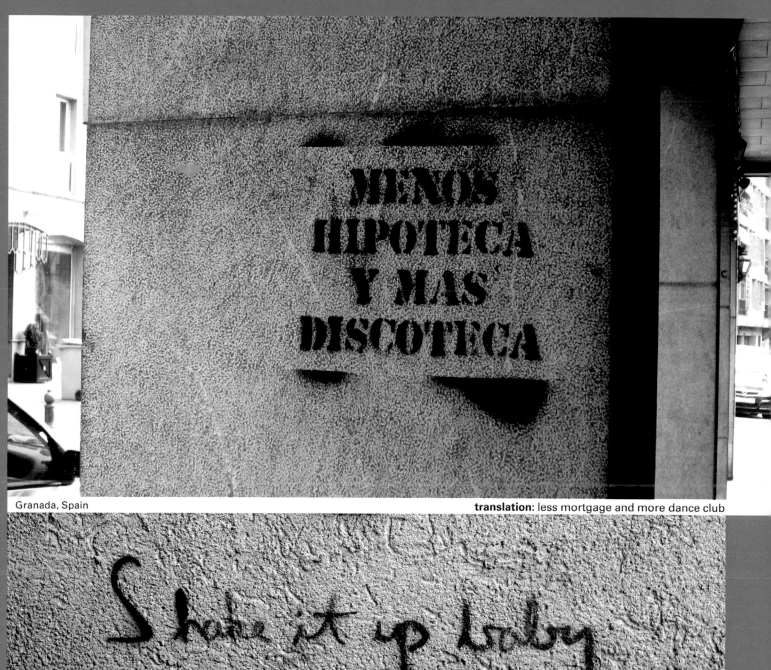

Granada, Spain

**translation:** less mortgage and more dance club

Charlottesville, Virginia, USA

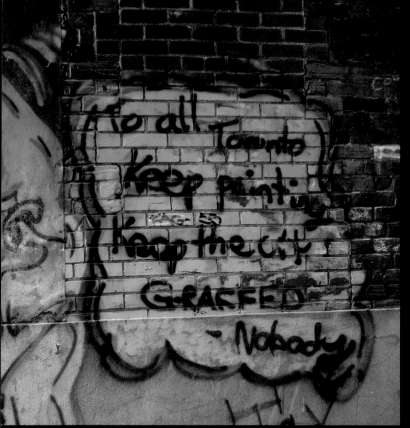

Toronto, Canada

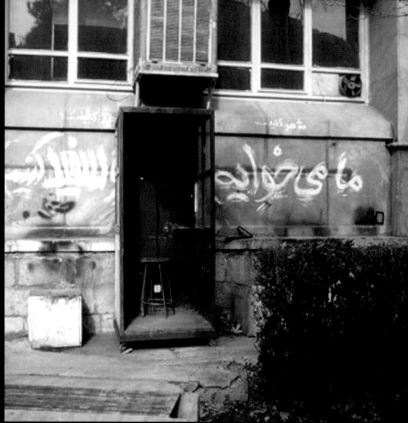

Tehran, Iran    **translation:** we want to paint all the city in white

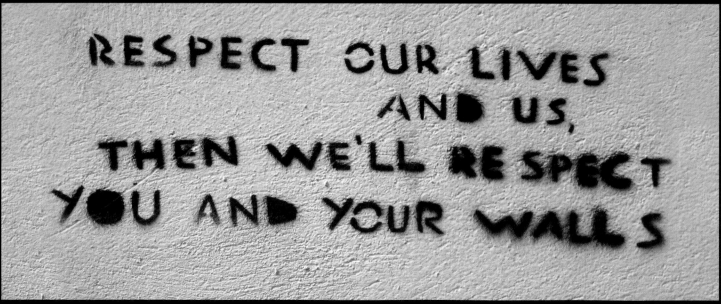

Vilinius, Lithuania

# HOW TO "PAINT THE TOWN RED"

1. Be a Roman soldier in 200 A.D., or thereabouts.

2. Ravage the countryside claiming all territories for Rome.

3. Pillage.

4. Rape.

5. Burn.

6. Roast a goat and drink for free at the town tavern.

7. Rape some more.

8. Take a stroll in the night air, being careful not to trip over the vanquished.

9. Think to self: This is our town now.

10. Grab a handful of blood and guts and paint the walls of the town with it.

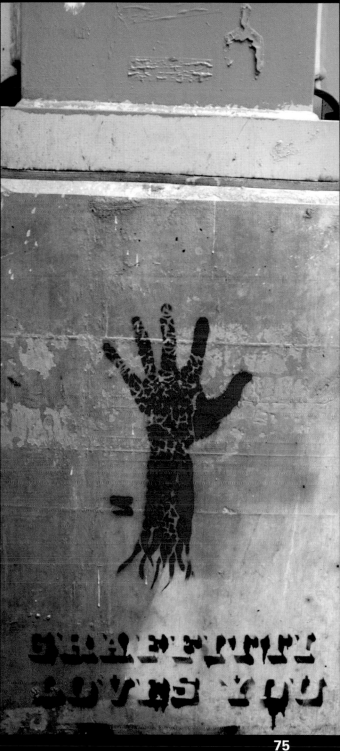

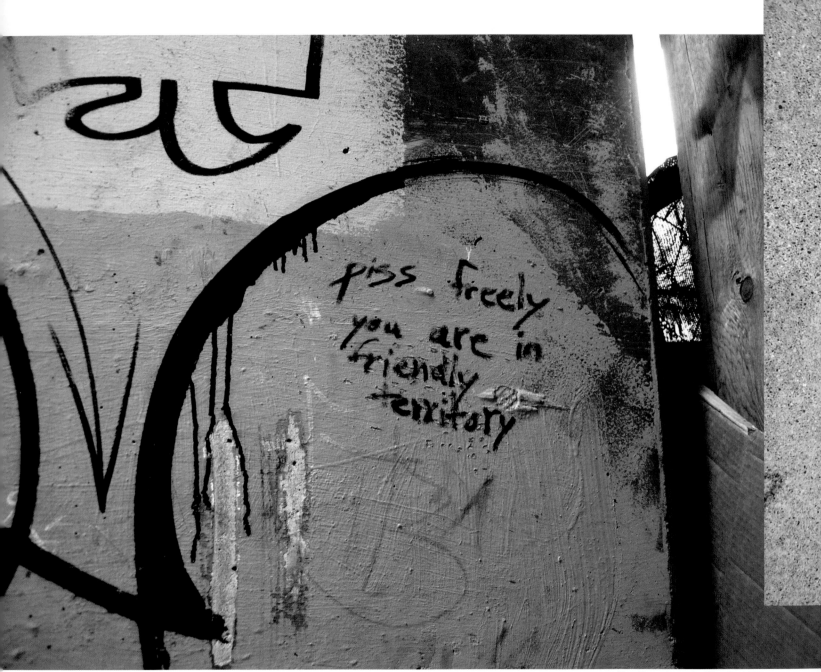

San Francisco, California, USA

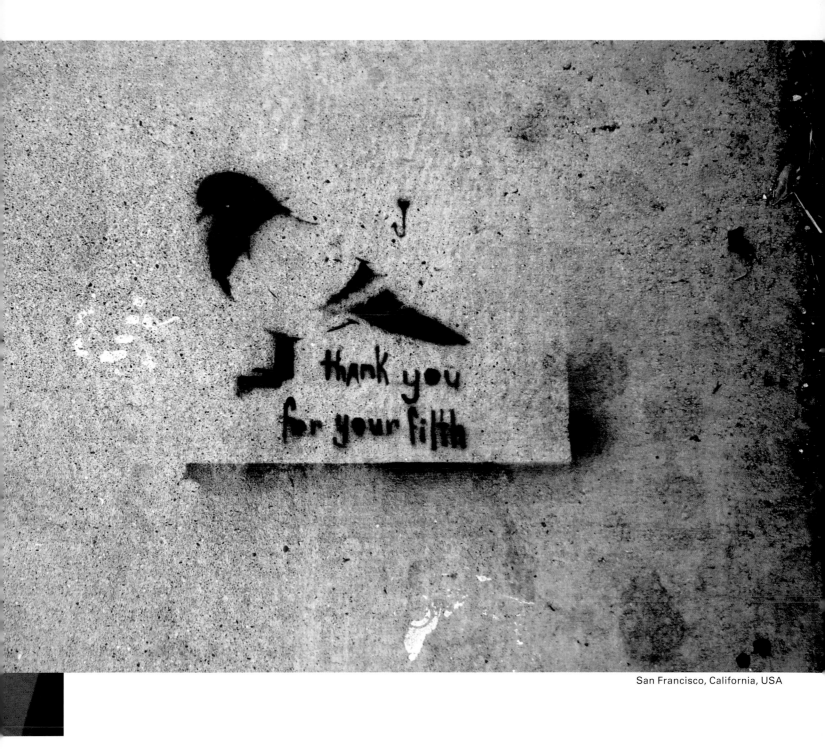

San Francisco, California, USA

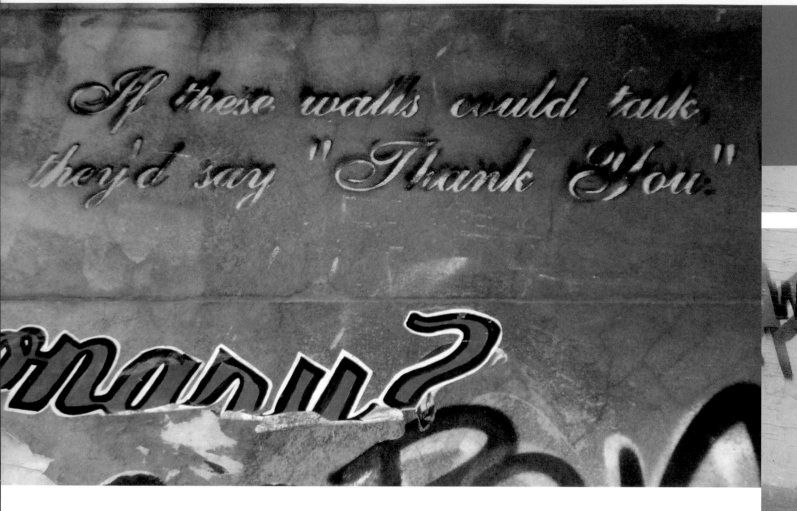

Amsterdam, The Netherlands

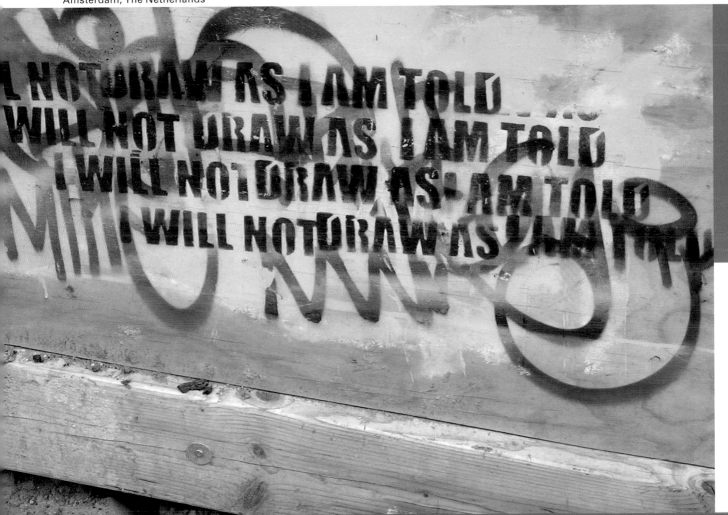

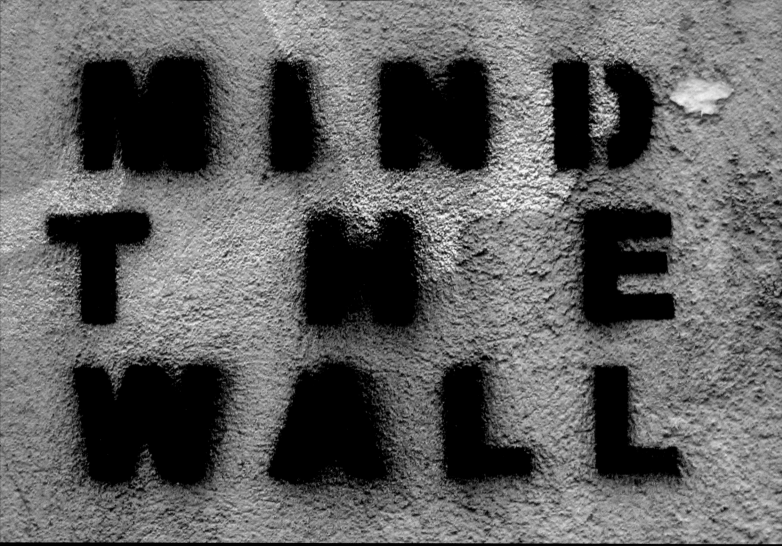

Vilnius, Lithuania

# NEW YORK CITY ADMINISTRATIVE CODE

**TITLE 10-117** Defacement of property, possession, sale and display of aerosol spray paint cans, broad tipped markers and etching acid prohibited in certain instances.

a. No person shall write, paint or draw any inscription, figure or mark or affix, attach or place by what-ever means a sticker or decal of any type on any public or private building or other structure or any other real or personal property owned, operated or maintained by a public benefit corporation, the city of New York or any agency or instrumentality thereof or by any person, firm, or corporation, or any personal property maintained on a city street or other city-owned property pursuant to a franchise, concession or revocable consent granted by the city, unless the express permission of the owner or operator of the property has been obtained.

b. No person shall possess an aerosol spray paint can, broad tipped indelible marker or etching acid in any public place, any public building or any public facility with the intent to violate the provisions of subdivision a of this section. No person shall possess an aerosol spray paint can, broad tipped indelible marker or etching acid in or upon any motor vehicle with the intent to violate the provisions of subdivision a of this section. For purposes of this subdivision only, "public place" means a place to which the public or a substantial group of persons has access, and includes, but is not limited to, any highway, street, road, parking lot, plaza, sidewalk, playground, park, beach, or transportation facility.

c. No person shall sell or offer to sell an aerosol spray paint can, broad tipped indelible marker or etching acid to any person under twenty-one years of age.

   1. No person under twenty-one years of age shall possess an aerosol spray paint can, broad tipped indelible marker or etching acid on the property of another or in any public building or upon any public facility.

   2. When a person is found to possess an aerosol spray paint can, broad tipped indelible marker or etching acid while on the property of another or in any public building or upon any public facility in violation of subdivision c-1 of this section, and it is an affirmative defense that: facility consented to the presence of the aerosol spray paint can, broad tipped indelible marker or etching acid; or (2) such person is traveling to or from his or her place of employment, where it was or will be used during the course of such employment and used only under the supervision of his or her employer or such employer's agent.

d. All persons who sell or offer for sale aerosol spray paint cans, broad tipped indelible

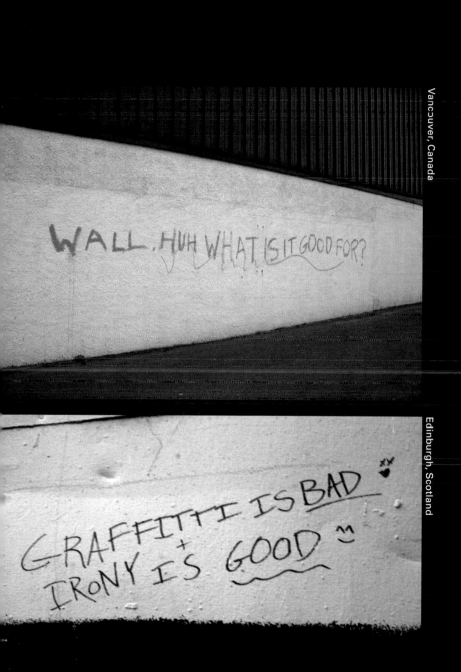

Vancouver, Canada

Edinburgh, Scotland

markers or etching acid shall not place such cans, markers or etching acid on display and may display only facsimiles of such cans, markers or etching acid containing no paint, ink or etching acid.

e. For the purpose of this section, the term "broad tipped indelible marker" shall mean any felt tip marker or similar implement containing a fluid that is not water soluble and which has a flat or angled writing surface one-half inch or greater. For the purpose of this section, the term "etching acid" shall mean any liquid, cream, paste or similar chemical substance that can be used to etch, draw, carve, sketch, engrave, or otherwise alter, change or impair the physical integrity of glass or metal.

f. Any person who violates the provisions of paragraph a of this section shall be guilty of a class A misdemeanor punishable by a fine of not more than one thousand dollars or imprisonment of not more than one year, or both. Any person who violates the provisions of paragraph b of this section shall be guilty of a class b misdemeanor punishable by a fine of not more than five hundred dollars or a term of imprisonment of not more than three months, or both. Any person who violates the provisions of paragraphs c or d of this section shall be guilty of a misdemeanor punishable by a fine of not more than five hundred dollars or imprisonment of not more than three months, or both. Any person who has been previously convicted of violating the provisions of paragraphs c or d of this section shall be guilty of a class A misdemeanor punishable by a fine of not more than one thousand dollars or imprisonment of not more than one year, or both. Any person who violates the provisions of paragraph c-1 of this section shall be guilty of a violation punishable by a fine of not more than two hundred fifty dollars or imprisonment of not more than fifteen days, or both. When a person is convicted of an offense defined in subdivision a or b of this section, or of an attempt to commit such offense, and the sentence imposed by the court for such conviction includes a sentence of probation or conditional discharge, the court shall, where appropriate, include as a condition of such sentence the defendant's successful participation in a graffiti removal program pursuant to paragraph (h) of subdivision two of section 65.10 of the penal law.

g. In addition to the criminal penalties imposed pursuant to subdivision f of this section, a person who violates the provisions of subdivision a, b, c or d of this section shall be liable for a civil penalty of not more than five hundred dollars for each violation which may be recovered in a proceeding before the environmental control board. Any person who has been previously convicted of violating the provisions of subdivision a, b, c or d of this

section shall be liable for a civil penalty of not more than one thousand dollars for each violation which may be recovered in a proceeding before the environmental control board. Such proceeding shall be commenced by the service of a notice of violation returnable before such board. Anyone found to have violated the provisions of subdivision a of this section, by affixing, attaching or placing by whatever means a sticker or decal, in addition to any penalty imposed, shall be responsible for the cost of the removal of the unauthorized stickers or decals.

h. In addition to police officers, officers and employees of the department of consumer affairs, sanitation, environmental protection and transportation shall have the power to enforce the provisions of this section and may issue notices of violation, appearance tickets or summonses for violations thereof.

i. There shall be a rebuttable presumption that the person whose name, telephone number, or other identifying information appears on any sticker or decal affixed, attached or placed by whatever means in violation of subdivision a of this section violated this section by either (i) affixing, attaching or placing by whatever means such sticker or decal or (ii) directing, suffering or permitting a servant, agent, employee or other individual under such person's control to engage in such activity.

j. There shall be a rebuttable presumption that if a telephone number that appears on any sticker or decal affixed, attached or placed by whatever means in violation of subdivision a of this section belongs to a telephone answering service and no other telephone number or address is readily obtainable to locate the person or business advertised therein, such telephone answering service shall be held liable for a violation of subdivision a in accordance with the provisions of this section.

k. The commissioner of the department of sanitation shall be authorized to issue subpoenas to obtain official telephone records for the purpose of determining the identity and location of any person or entity reasonably believed by the commissioner to have violated subdivision a of this section by affixing, attaching or placing by whatever means a sticker or decal.

l. For the purposes of imposing a criminal fine or civil penalty pursuant to this section, every sticker or decal affixed, attached or placed by whatever means in violation of subdivision a of this section, shall be deemed to be the subject of a separate violation for which a separate criminal fine or civil penalty shall be imposed.

**10-117.1** Anti-graffiti task force.

a. There is hereby established an anti-graffiti task force consisting of at least seven members. The speaker of the council

shall appoint three members, and the mayor shall appoint the balance of the members, one of whom shall serve as chairperson. The members of the task force shall be appointed within thirty days of the effective date of this section and shall serve without compensation. The task force shall have a duration of twelve months.

b. The task force shall:

1. Assess the scope and nature of the city's graffiti problem, including geographical concentration, perpetrator profile and future trends.

2. Examine the effectiveness of existing provisions of law aimed at curbing graffiti vandalism, and propose amendments to strengthen such legislation.

3. Review current law enforcement activity, clarify enforcement responsibility and suggest ways to augment enforcement capability.

4. Identify all existing public and private anti-graffiti programs citywide and in each borough.

5. Survey efforts to combat graffiti in other jurisdictions, consider the replication of such programs in New York city and recommend further programmatic initiatives.

6. Propose a coordinated, comprehensive anti-graffiti program encompassing prevention, education, removal and enforcement.

7. Maintain regular and systematic contact with civic associations, community boards and other concerned groups and individuals.

8. Assist in the establishment of borough and community anti-graffiti task forces.

c. The task force shall meet at least quarterly and shall issue a final report to the mayor and the council detailing its activities and recommendations.

**10-117.2** Rewards for providing information leading to apprehension, prosecution or conviction of a person for crimes involving graffiti vandalism. The mayor, upon the recommendation of the police commissioner, shall be authorized to offer and pay a reward in an amount not exceeding five hundred dollars to any person who provides information leading to the apprehension, prosecution or conviction of any person who may have violated the provisions of subdivision a or b of section 10-117 of this chapter, or who may have committed any other crime where the unlawful conduct included the conduct described in subdivision a or b of such section. No police officer, peace officer or any other law enforcement officer, and no officer, official or employee of the city of New York shall be entitled, directly or indirectly, to collect or receive any such reward.

**10-117.3 Remedies for failure to remove graffiti from certain premises.**

a. Definitions. For purposes of this section, the following terms shall have the following meanings:

1. "Graffiti" means any letter, word, name, number, symbol, slogan, message, drawing, picture, writing or other mark of any kind visible to the public from a public place that is drawn, painted, chiseled, scratched, or etched on a commercial building or residential building, or any portion thereof, including fencing, that is not consented to by the owner of the commercial building or residential building. There shall be a rebuttable presumption that such letter, word, name, number, symbol, slogan, message, drawing, picture, writing or other mark of any kind is not consented to by the owner. Such presumption may be rebutted in any proceeding pursuant to this section.

2. "Commercial building" means any building that is used, or any building a portion of which is used, for buying, selling or otherwise providing goods or services, or for other lawful business, commercial, professional services or manufacturing activities.

3. "Residential building" means any building containing one or more dwelling units.

4. "Public place" means a place to which the public or a substantial group of persons has access including, but not limited to, any highway, street, road, sidewalk, parking area, plaza, shopping area, place of amusement, playground, park, beach or transportation facility.

b. Duty to keep property free of graffiti. The owner of every commercial building and residential building shall keep and cause to be kept such building free of all graffiti.

c. Availability of city funds; graffiti removal through written consent. Subject to the availability of annual appropriations, the mayor, through the community assistance unit, shall provide graffiti removal services to abate graffiti on commercial buildings and residential buildings without charge to the property owner if the property owner first executes a written consent and a waiver of liability in the form prescribed by the mayor.

d. Failure to remove graffiti from property. Notice to remove graffiti from a commercial or residential building shall be served by an agency designated by the mayor in the manner prescribed in paragraph two of subdivision d of section 1404 of the charter. Such written notice shall, at a minimum: (1) describe the city's graffiti abatement program and the resources available to the property owner to abate graffiti; (2) indicate that if the owner of a commercial or residential building fail to remove such graffiti within sixty days of receipt of such notice, then the city may cause such graffiti to be removed; and (3) for a written notice involving residential buildings containing six or more dwelling units or commercial buildings, further indicate that the failure to remove the graffiti within sixty days of receipt of the notice shall result in the imposition of a fine as set forth in subdivision e of this section.

e. Penalty for failure to remove graffiti from residential buildings containing six or more dwelling units or commercial buildings. The owner of a residential building of six or more units or a commercial building who has been given written notice to remove graffiti from such building, and who fails to remove such graffiti within sixty days of receipt of such notice, shall be liable for a civil penalty of not less than one hundred fifty dollars nor more than three hundred dollars. Such civil penalty may be recovered in a proceeding before the environmental control board. The owner of a residential building containing six or more dwelling units or a commercial building shall not be liable for a civil penalty if, within sixty days of receipt of such notice, such owner can demonstrate that the owner has contacted the mayor's community assistance unit, through a call to 311, with regard to providing graffiti removal services with respect to the graffiti that was the subject of the notice, and has executed a written consent and a waiver of liability in the form prescribed by the mayor with respect to such graffiti. Notwithstanding the foregoing, a property shall not be fined more than once in any six-month period, and summonses shall not be issued between November 1 and March 31.

f. Removal of graffiti from property through nuisance abatement proceedings.

1. Whenever the owner of a commercial building or a residential building fails to accept the city's graffiti removal services after the city has attempted in good faith to obtain written consent and a waiver of liability from the owner for such services, and the property owner fails to remove such graffiti within sixty days of receiving a notice to remove the graffiti, the city may serve the owner of the commercial building or residential building a notice of nuisance abatement. The notice shall be served on the owner by an agency designated by the mayor in the manner prescribed in paragraph two of subdivision d of section 1404 of the charter. The notice, at a minimum, shall indicate the following:

a. That the city of New York has determined that the property has become a nuisance because of graffiti on the property.

b. The address of the property and the location on the property that has become a nuisance.

c. That unless the property owner removes the graffiti, files a written consent and waiver of liability consenting to receive, without charge, graffiti removal services from the city, or submits to the city a written request for a hearing to contest the city's determination within thirty days of the date of the service of notice of nuisance abatement, the property owner will be deemed to have given permission to the city to enter or access the property and use the means it determines appropriate to remove or conceal the graffiti at the specified location.

d. That if a property owner requests a hearing, the property owner may contest the determination that the property has become a nuisance.

e. That this notice shall be deemed to provide the city with authority to work on as much of the property as necessary to remove or conceal the graffiti, and that the city is not responsible for removing or concealing the graffiti to the property owner's satisfaction.

2. Upon the property owner's failure to remove the graffiti, to file a written consent and a waiver of liability consenting to receive, without charge, graffiti removal services from the city, or to submit to the city a written request for a hearing to dispute the determination that the property identified in the notice has become a nuisance because of graffiti within thirty days of the date of the service of the notice of nuisance abatement, the city may enter or access the property specified in the notice and abate the nuisance by removing or concealing the graffiti.

3. Upon receipt of a timely request for a hearing, a hearing shall be held before the environmental control board within thirty days of receiving the request.

4. Upon a finding of a hearing officer of the environment control board that the property has become a nuisance because of graffiti the city may enter or access the property specified in the notice and abate the nuisance by removing or concealing the graffiti.

5. In no case shall the city be required to clean, paint, or repair any area more extensive than where the graffiti is located.

Chaos
ist die Ordnung
des Verursachers ....!

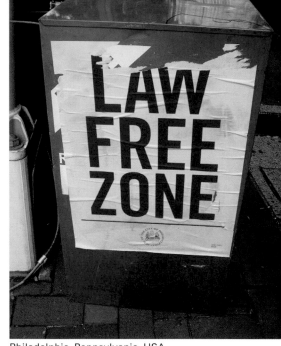

Philadelphia, Pennsylvania, USA

LAW FREE ZONE

Berlin, Germany

**translation:** chaos is the order of the cause...!

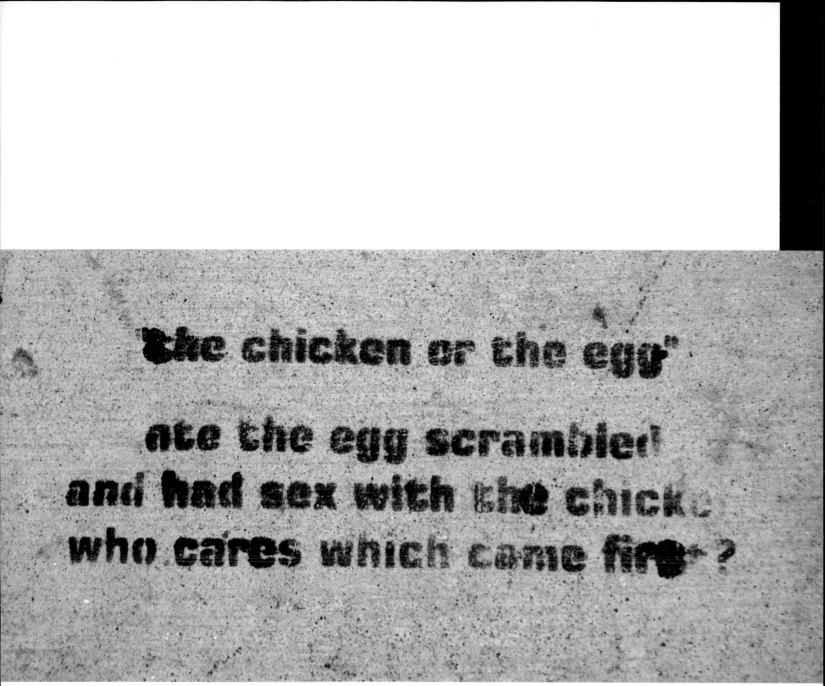

"the chicken or the egg"

ate the egg scrambled
and had sex with the chicke
who cares which came first?

San Francisco, California, USA

Portland, Oregon, USA

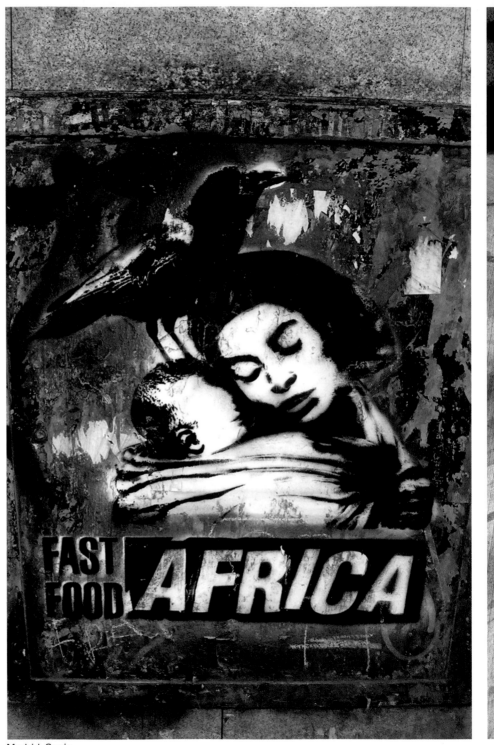

Madrid, Spain

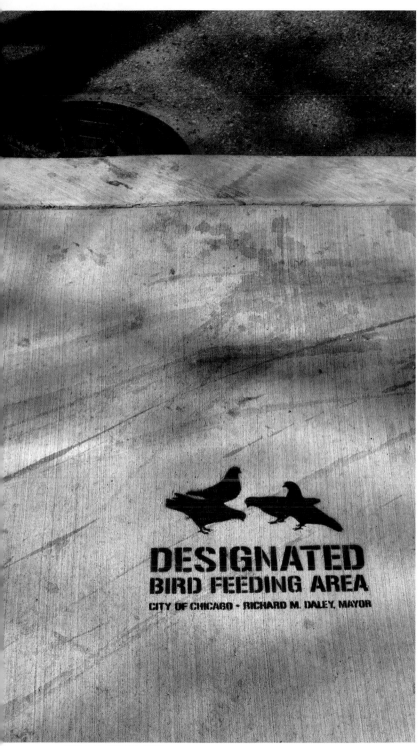

Chicago, Illinois, USA

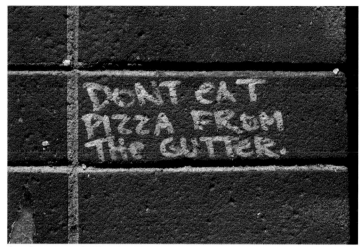

San Francisco, California, USA

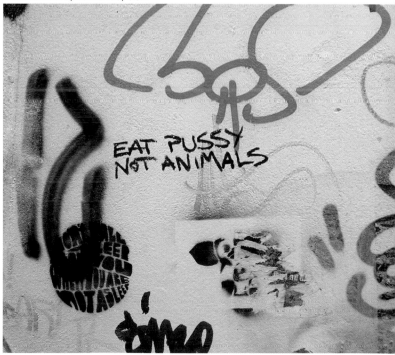

Reykjavik, Iceland

# NOT IN OUR NAME

When the image below was published on writtenonthecity.com, it immediately generated a comment thread filled with hate speech. And while we started the project to encourage conversation, this particular conversation wasn't one we felt comfortable hosting. So we shut it down. Would you have done the same?

Tel Aviv, Israel

CREATE
BEAUTIFUL
CHILDREN
MARRY
AN ARAB

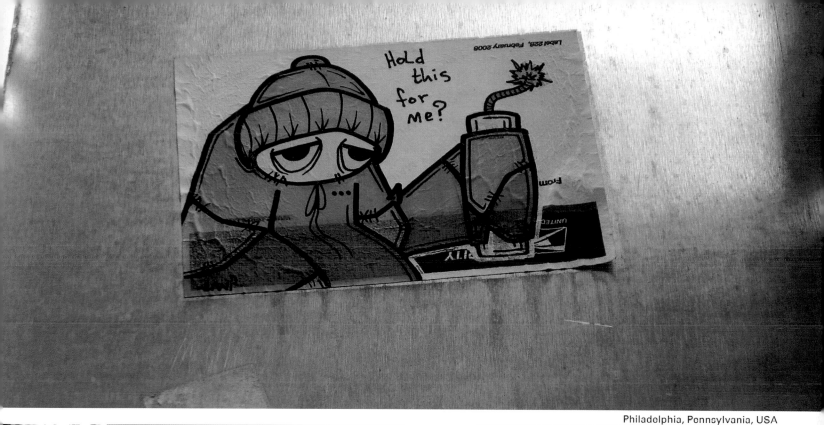

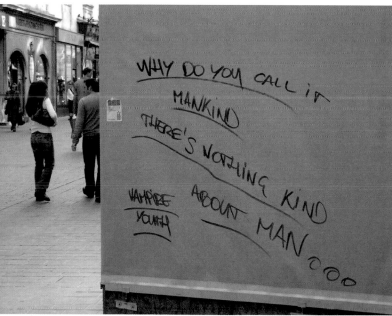

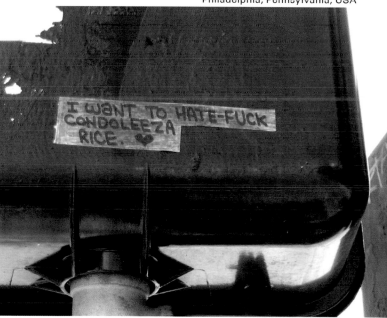

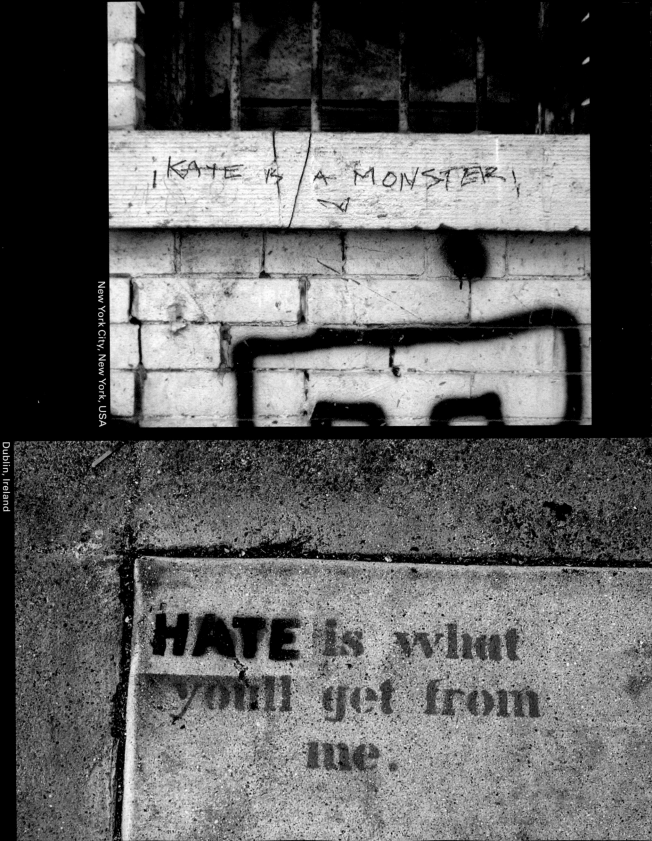

New York City, New York, USA

Dublin, Ireland

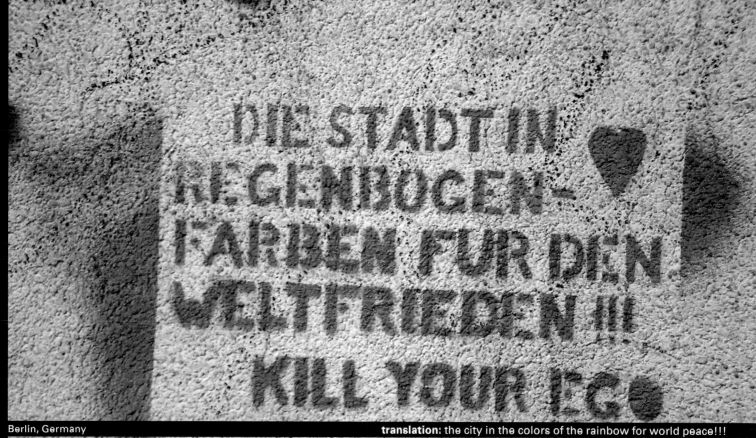

Berlin, Germany

**translation:** the city in the colors of the rainbow for world peace!!!

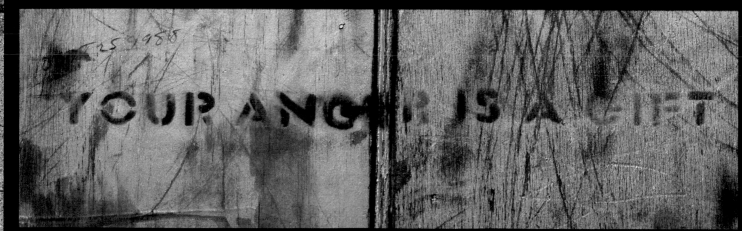

San Francisco, California, USA

San Francisco, California, USA

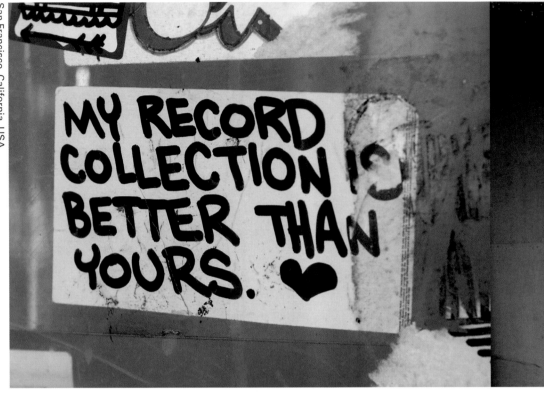

MY RECORD COLLECTION IS BETTER THAN YOURS. ♥

San Francisco, California, USA

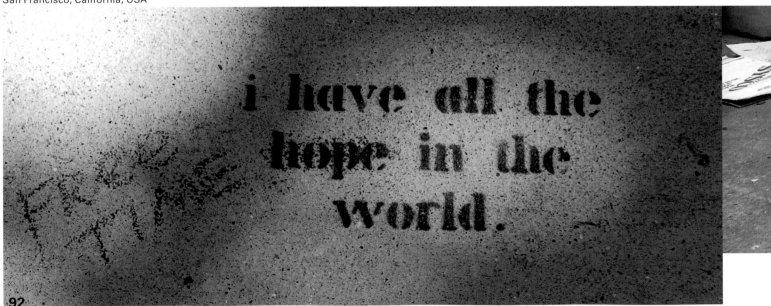

i have all the hope in the world.

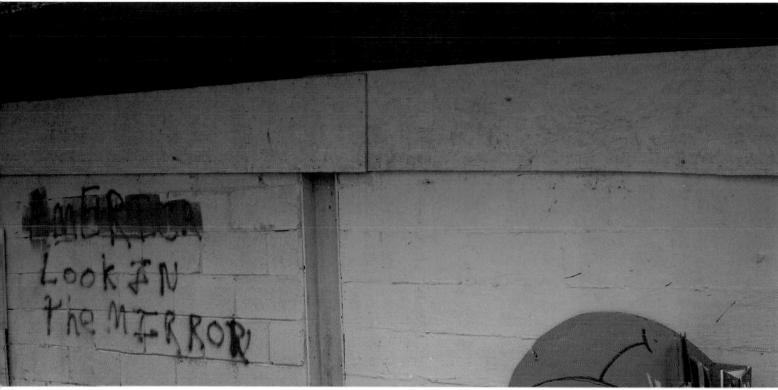

Asheville, North Carolina, USA

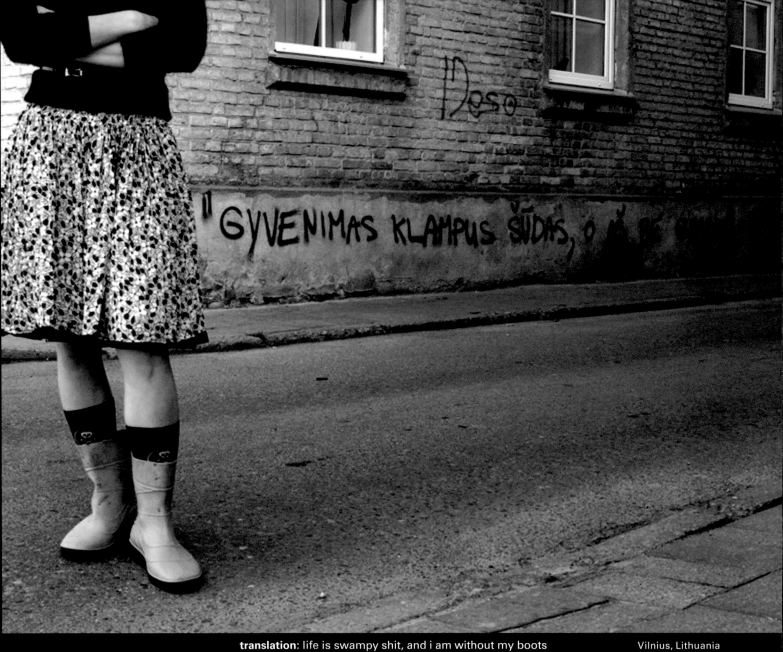

**translation:** life is swampy shit, and i am without my boots          Vilnius, Lithuania

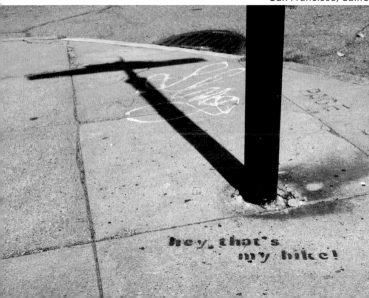

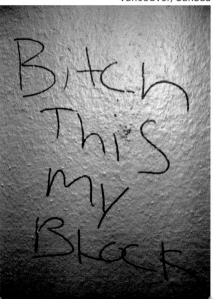

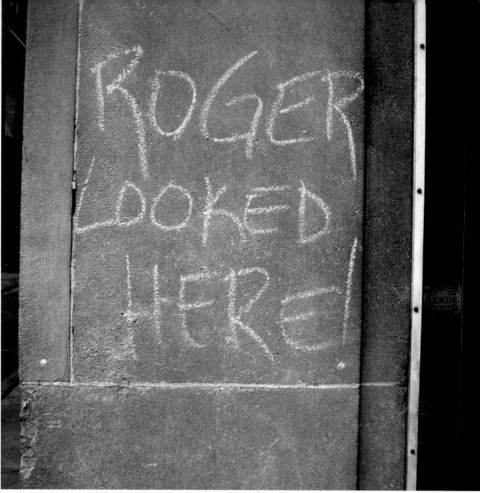

Philadelphia, Pennsylvania, USA

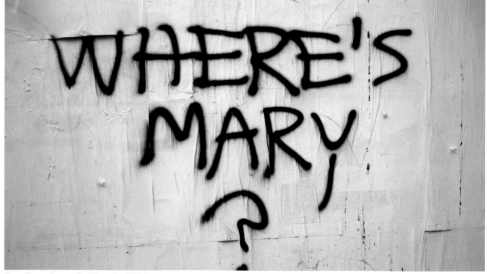

San Francisco, California, USA

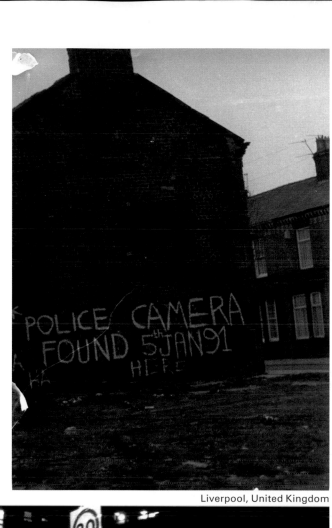

Marin City, California, USA

Liverpool, United Kingdom

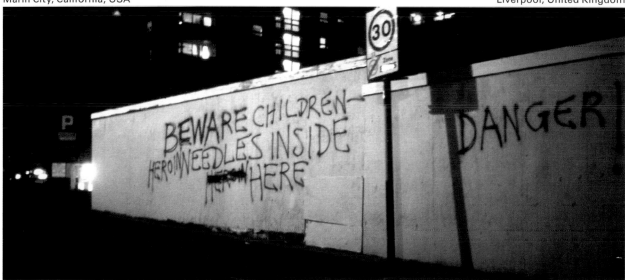

Brighton, United Kingdom

In Milan, Italy, 40 percent of buildings have at least one piece of graffiti.

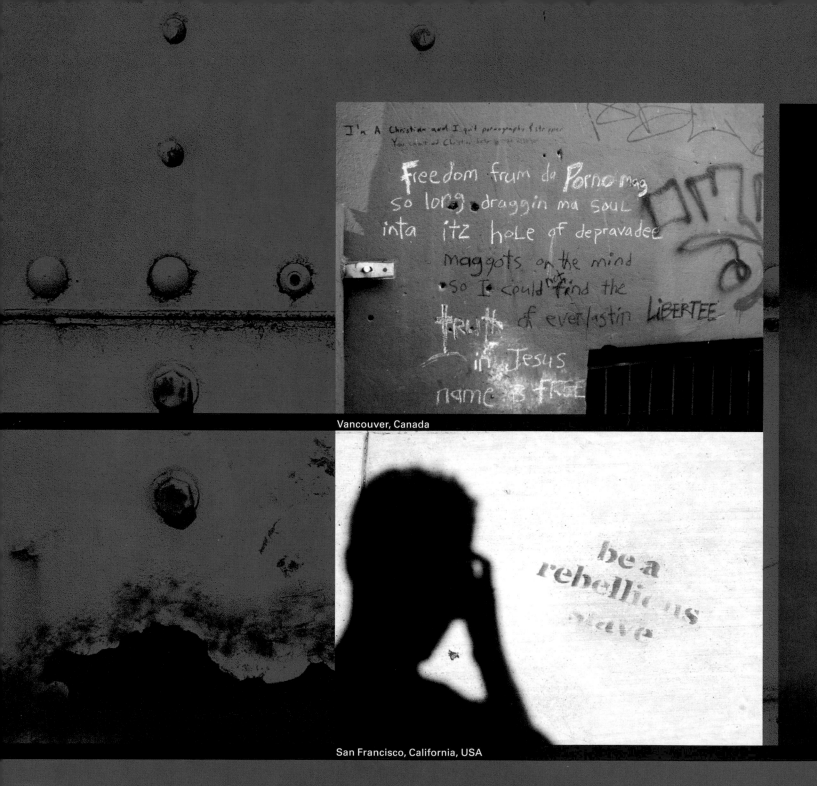

Vancouver, Canada

San Francisco, California, USA

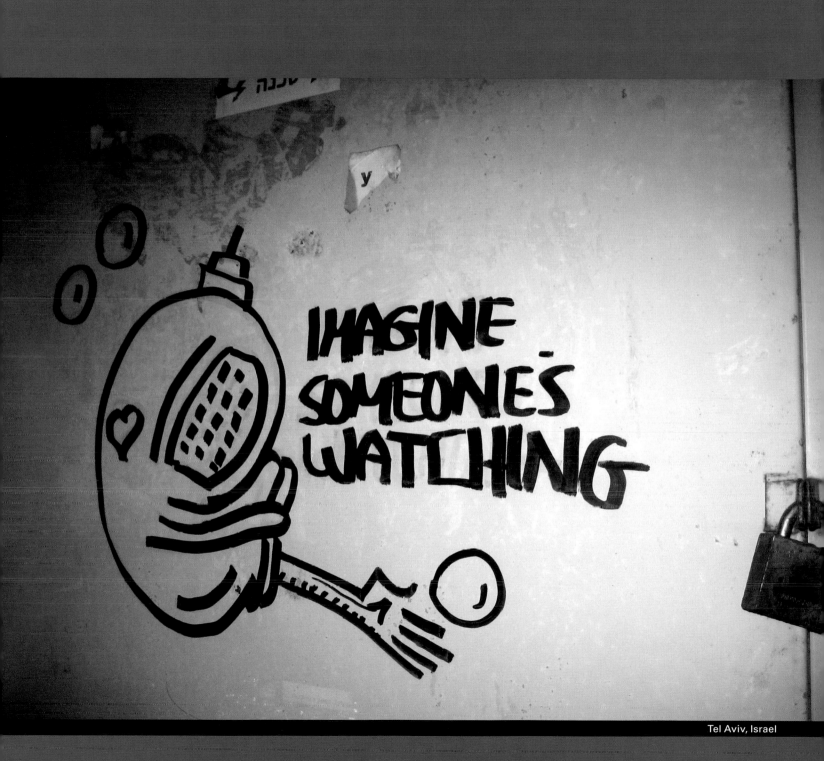

Tel Aviv, Israel

TOGETHER WE CAN PROFIT FROM THIS TRAGEDY. ♥

Label 228 June 2004

From:

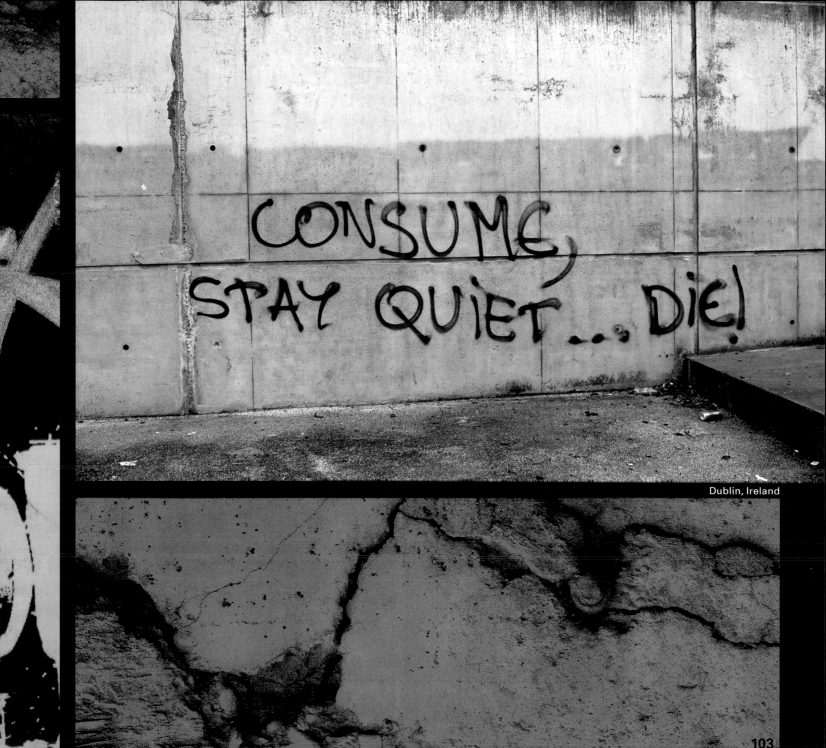

Dublin, Ireland

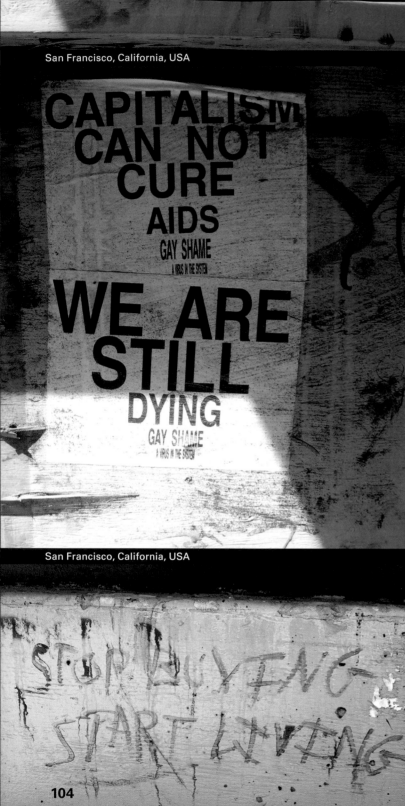

CAPITALISM
CAN NOT
CURE
AIDS
GAY SHAME
A VIRUS IN THE SYSTEM

WE ARE
STILL
DYING
GAY SHAME
A VIRUS IN THE SYSTEM

San Francisco, California, USA

STOP BUYING
START LIVING

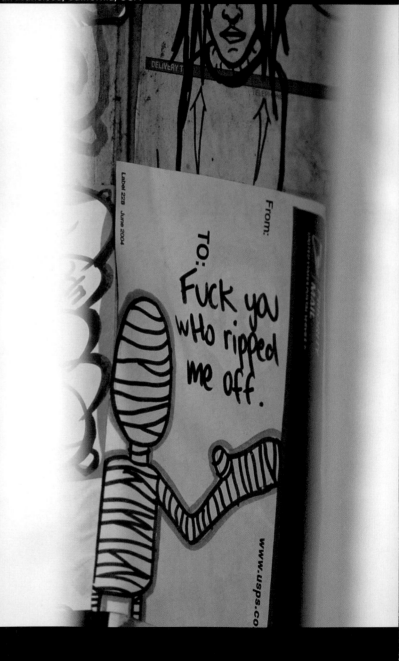

Label 228 June 2004

From:

TO: Fuck you
who ripped
me off.

www.usps.co

# BORF IS DEAD, LONG LIVE BORF

On February 9, 2006, 18-year-old graffiti artist John Tsombikos, a.k.a. Borf, was fined $12,000, sentenced to thirty days in jail, two hundred hours of community service, and banished from Washington, D.C.

This is what D.C. Superior Court Judge Lynn Leibovitz told him as she handed down his sentence:

"You profess to despise rich people. You profess to despise the faceless, nameless forms of government that oppress. That's what you've become. That's what you are. You're a rich kid who comes into Washington and defaces property because you feel like it. It's not fair. It's not right ... It's not about whether you want to express yourself. Washington, D.C., is not a playground that was built for your self-expression. It's a place where people, real people, live and care about their communities."

Shortly after Borf's arrest a flyer was seen posted all around D.C.:

"Borf is not caught. Borf is many. Borf is none. Borf is waiting for you in your car. Borf is in your pockets. Borf is running through your veins. Borf is naive. Borf is good for your liver. Borf is controlling your thoughts. Borf is everywhere. Borf is the war on boredom. Borf annihilates. Borf hates school. Borf is a four letter word for joy. Borf is quickly losing patience. Borf yells in the library. Borf eats pieces of shit like you for breakfast. Borf is digging a hole to China. Borf is bad at graffiti. Borf is ephemeral. Borf is invincible. Borf. Borf ruins everything. Borf runs near the swimming pool. Borf keeps it real. Borf writes you love letters. Ol' Dirty Bastard is Borf. Borf knows everything. Borf is in the water. Borf doesn't sleep. Borf systematically attacks the infrastructure of the totality. Borf is a foulmouth. Borf eats your homework. Borf brings you home for dinner. Borf is the dirt under your fingernails. Borf is the song that never ends. Borf gets down. Borf gets up. Borf is your baby. Borf is neither. Borf is good for your heart, the more you eat the more you. Borf is. Borf knows. Borf destroys. Borf is immortal. Borf pulls fire alarms. Borf scuffs the gym floor. Borf is looking through your mom's purse. Borf is M. Borf is the size of Alaska. Borf likes pizza. Borf is in general. Borf is X. Borf ain't nothin' to fuck with. Borf runs it. Borf has reflexes like a cat. Borf is immortal. Borf sticks gum under the desk. Borf is omnipotent. Borf is flawed. Borf is winning."

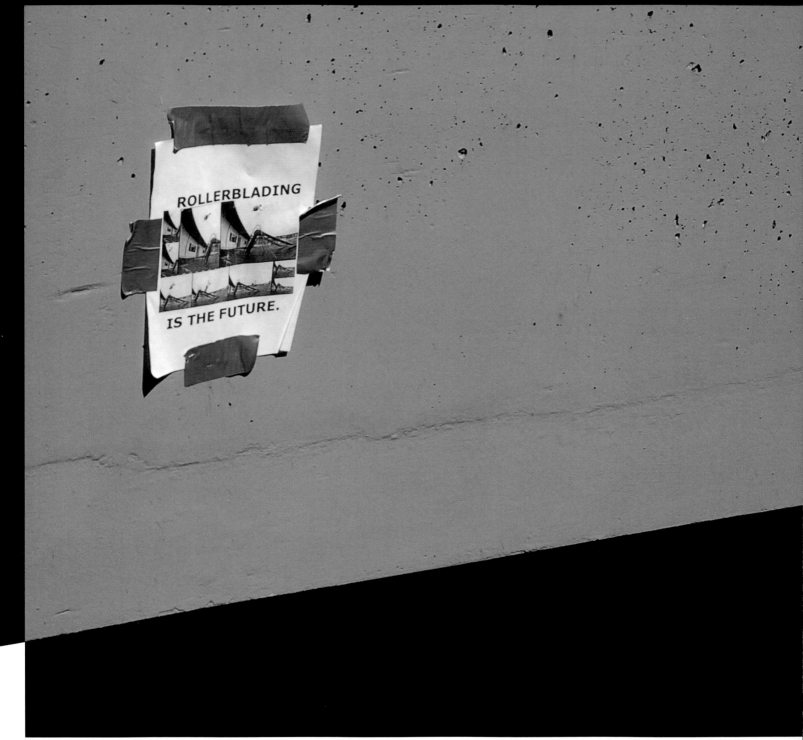

Toronto, Canada

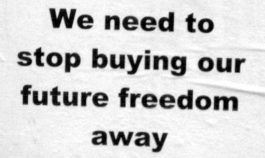

San Francisco, California, USA

San Francisco, California, USA

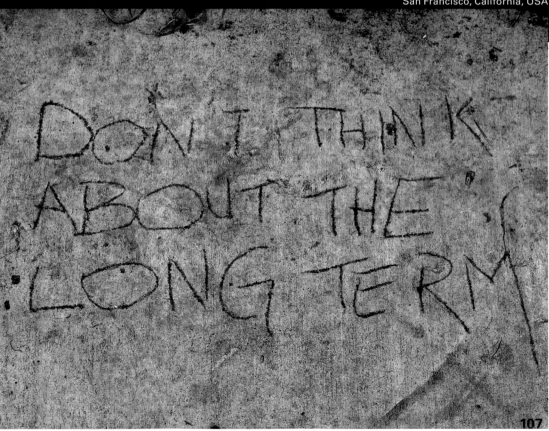

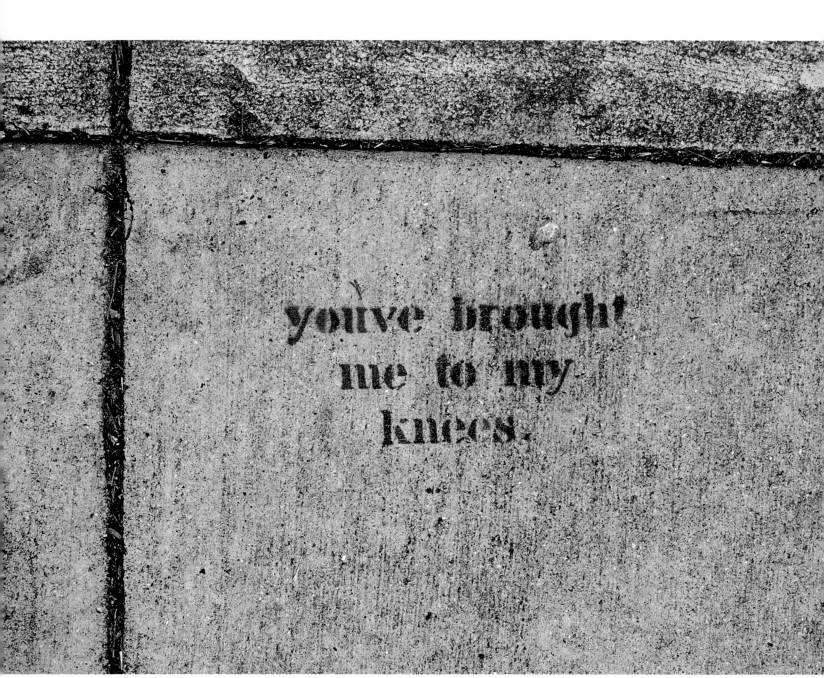

San Francisco, California, USA

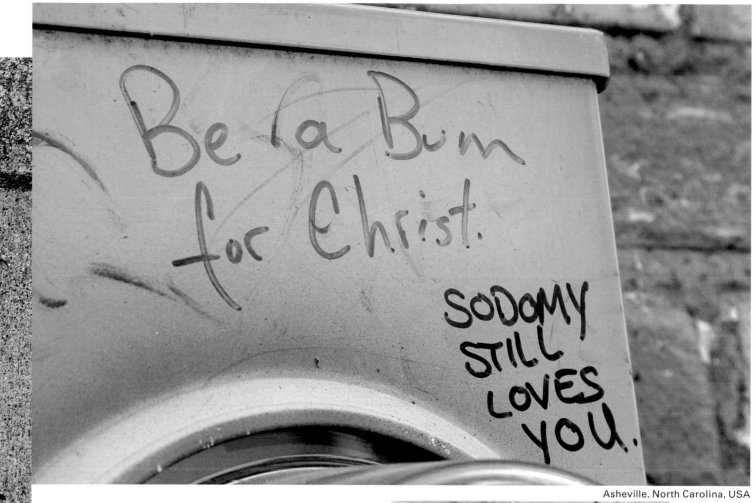

Be a Bum for Christ.

SODOMY STILL LOVES YOU.

Asheville, North Carolina, USA

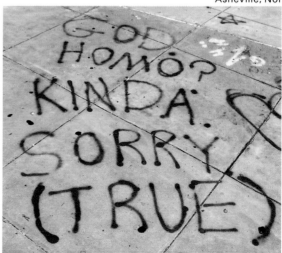

GOD HOMO? KINDA. SORRY (TRUE)

San Francisco, California, USA

YOU'RE THE ONE
I WANTED TO
FIND ,FUCKer,

San Francisco, California, USA

Too lost to find your way
life has led you astray
one your ws will be revealed
1-800-Jesus
exe LuV U

Asheville, North Carolina, USA

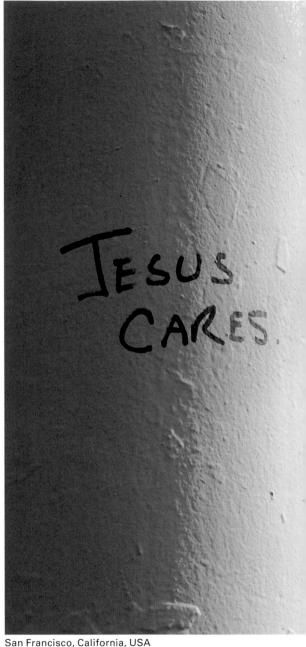

JESUS
CARES.

San Francisco, California, USA

110

Philadelphia, Pennsylvania, USA

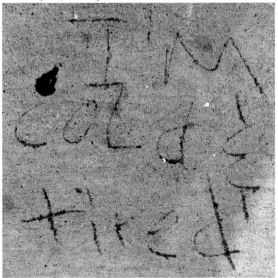

San Francisco, California, USA

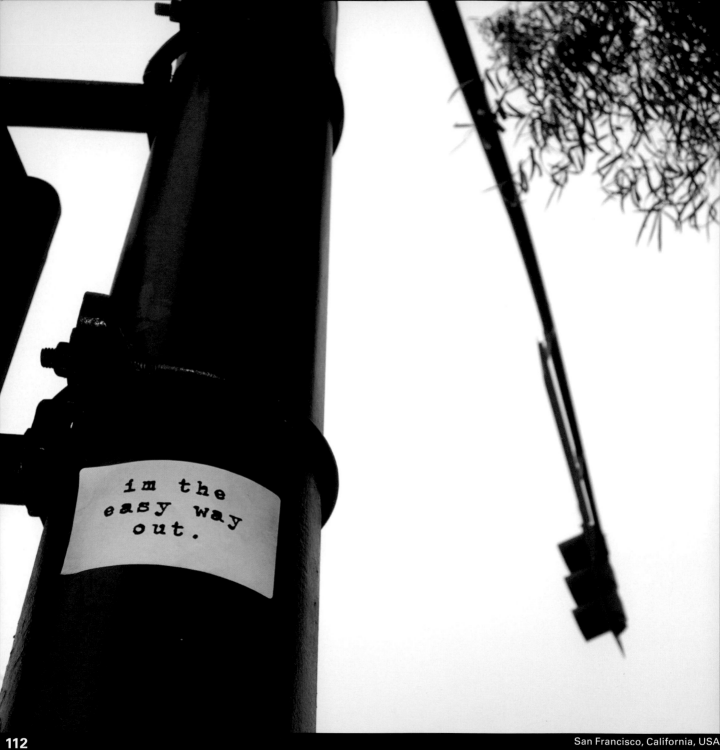

San Francisco, California, USA

DEATH
BE NOT PROUD,
THOUGH SOME HAVE CALLED THEE,
MIGHTY AND DREADFUL,
FOR THOU ART NOT SO!
UNKNOWN AUTHOR

Boise, Idaho, USA

ONCE YOU'VE BEEN
ENLIGHTEND
YOU'LL REALIZE YOU'VE BEEN
ENLIGHTED ALL ALONG

Marin City, California, USA

113

# A MESSAGE FROM THE SEA

"Anyone who should find this bottle will earn the dying blessing of three men, who do not expect to live an hour, by letting our friends and relations know our fate. We are sinking fast. All hands but us three were washed overboard last night. We were dismasted, and the binnacles and everything washed away by one sea. Every sea washes over the deck fore and aft. I don't know where we are, but by the skipper's reckoning at midday yesterday we were about 1000 miles from New Zealand. We have been sinking fast ever since the squall struck us. May God help us, for we may sink at any minute—George Wright.

The other men with me are Vincent Wallace and James King."

*Found and published on September 3, 1889, in the New Zealand publication* The Otago Witness *four months after it was written.*

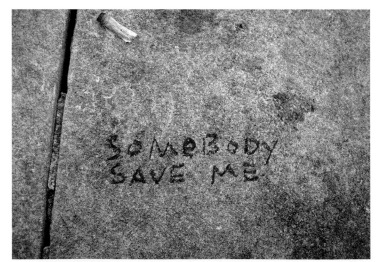

Philadelphia, Pennsylvania, USA

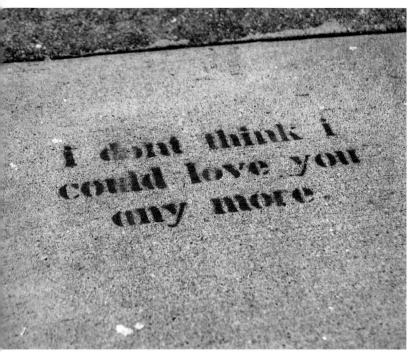

San Francisco, California, USA

San Francisco, California, USA

LOVE ME
TILL MY
HEART
STOPS

San Francisco, California, USA

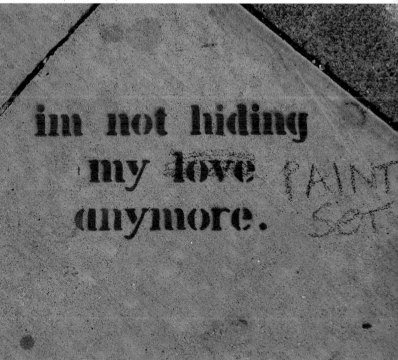

San Francisco, California, USA

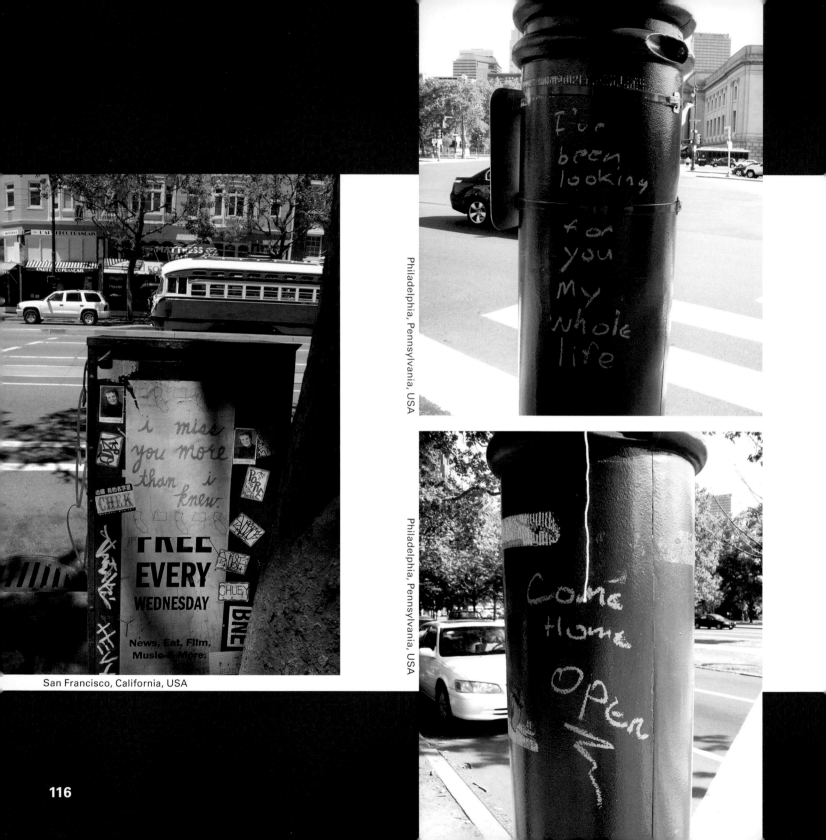

i miss you more than i knew.

San Francisco, California, USA

I've been looking for you my whole life

Philadelphia, Pennsylvania, USA

Come Home Open

Philadelphia, Pennsylvania, USA

116

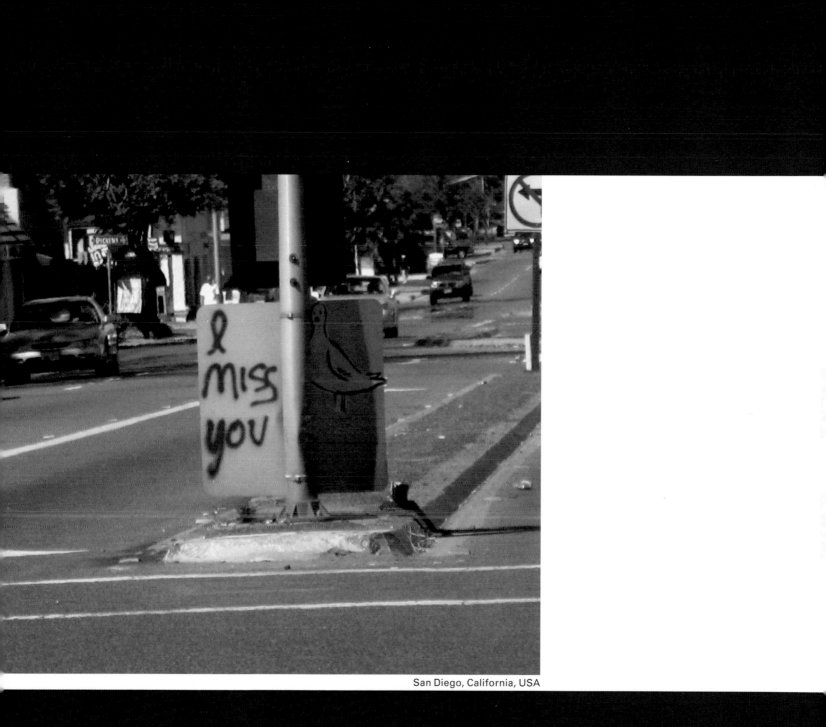

San Diego, California, USA

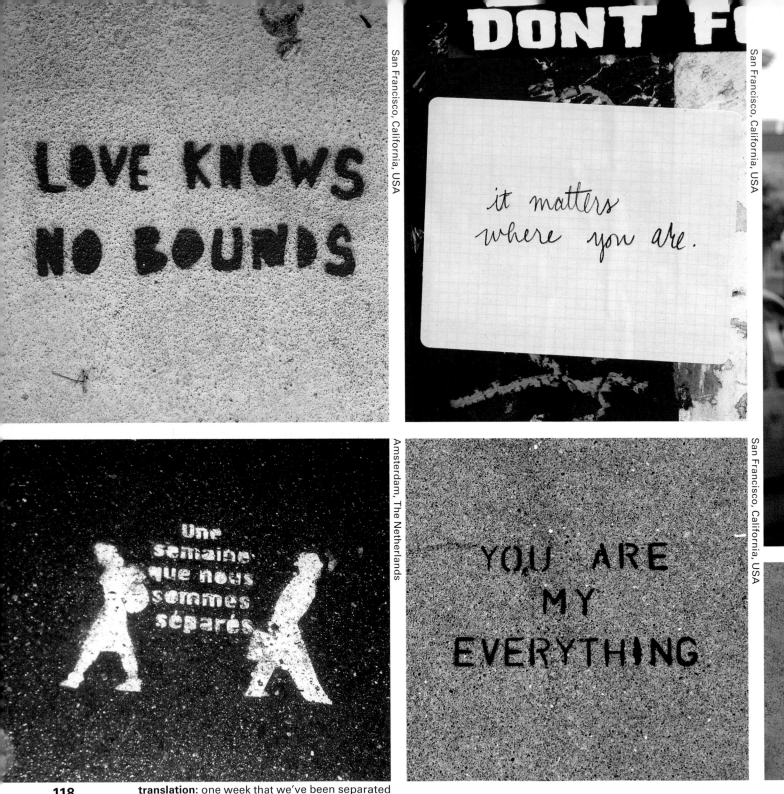

LOVE KNOWS NO BOUNDS

it matters where you are.

DONT F

Une semaine que nous sommes séparés

YOU ARE MY EVERYTHING

**translation:** one week that we've been separated

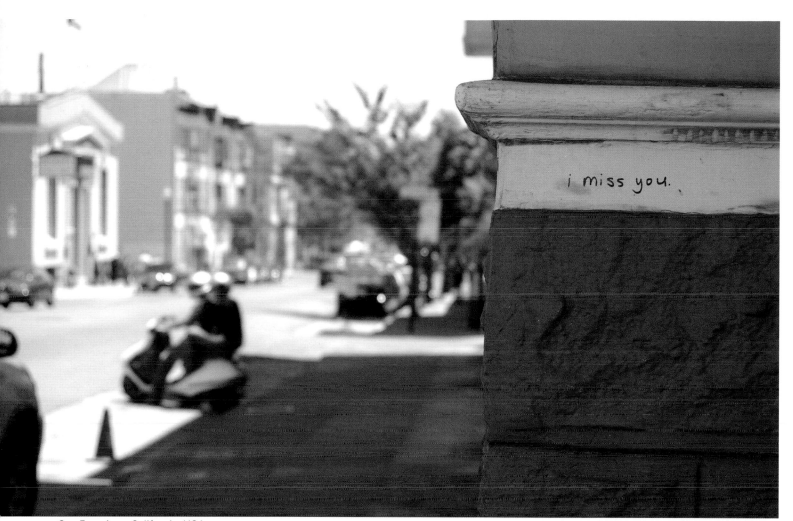

i miss you.

San Francisco, California, USA

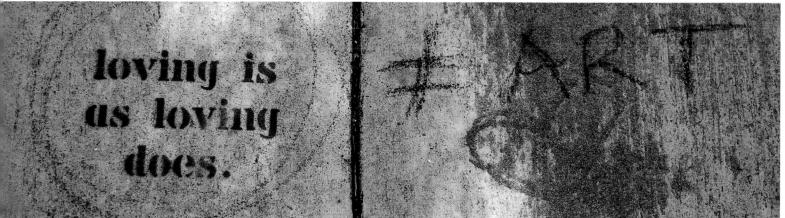

loving is as loving does.

≠ ART

San Francisco, California, USA

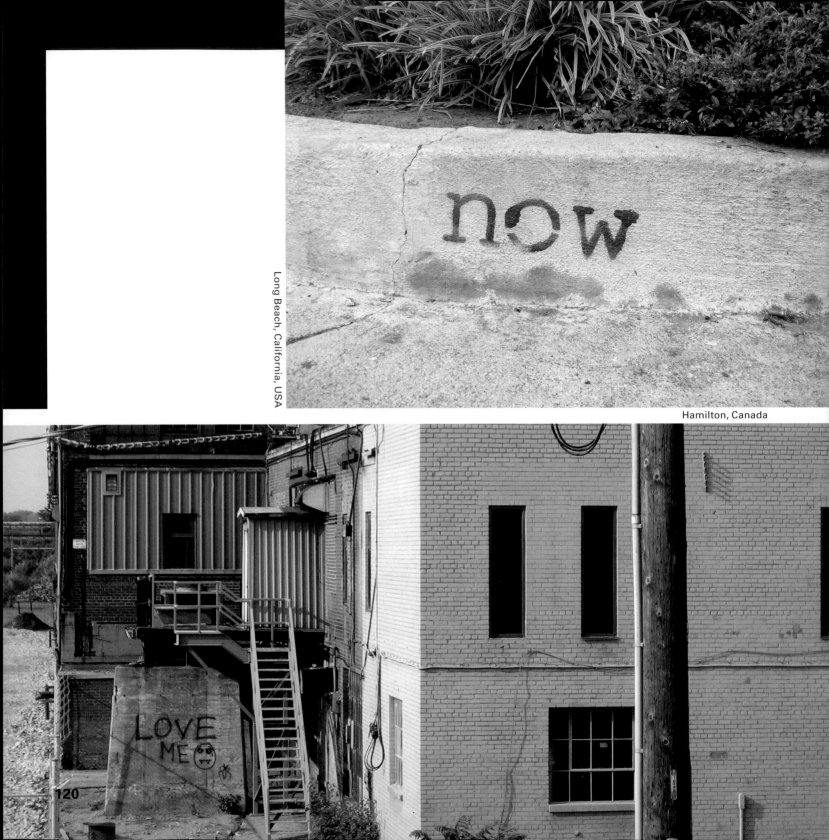

Long Beach, California, USA

Hamilton, Canada

LOVE ME

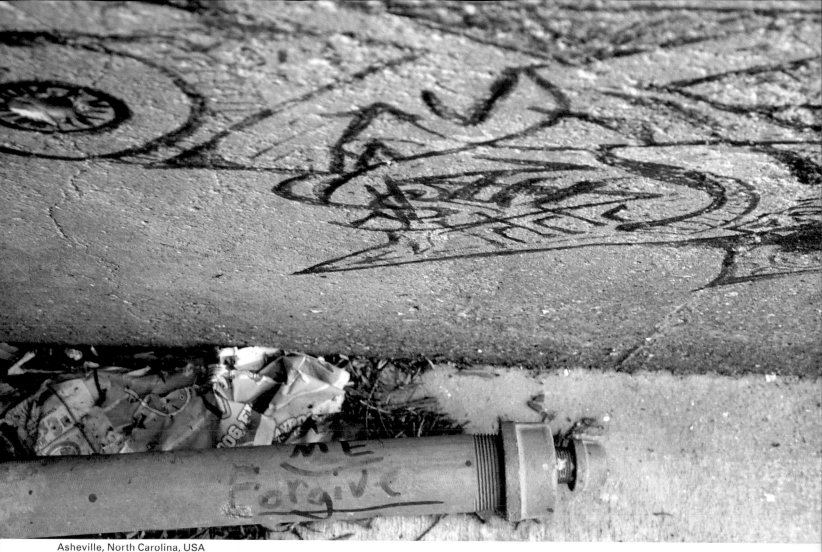

Asheville, North Carolina, USA

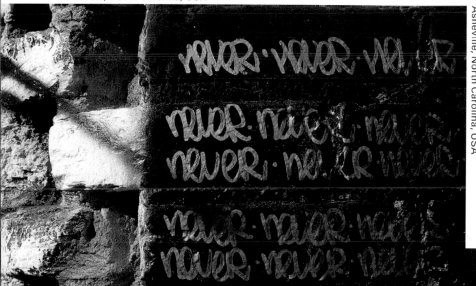

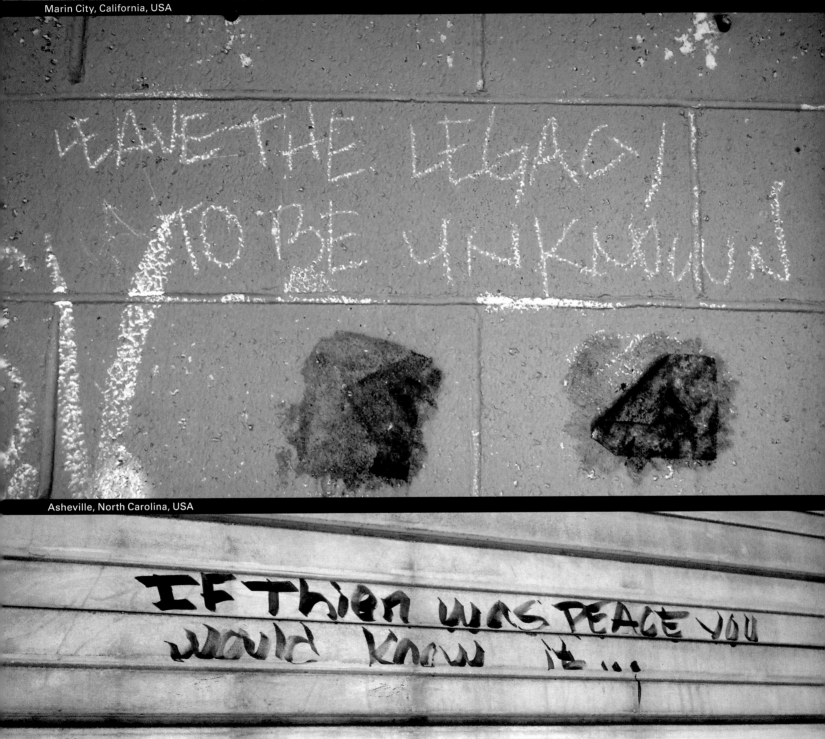

# DESTROYERS OF
# ALL THAT IS BEAUTIFUL
# AND VENERABLE

A long time ago, in a cold, northern land, there was a tribe of men led by a greedy and merciless king. Once, after losing a battle, they took five hundred hostages, hacked them to pieces, and threw them into the sea. The more brutal they were, the more powerful they grew, until soon, only one empire remained to be conquered. And there were rumors that the empire was losing strength.

80,000 warriors tore across the countryside and ravaged the capital city. Its highest spiritual leader begged for restraint. He knew that they would pillage and burn the city, but he asked that the people be spared. They were not.

The sea in this story is the Mediterranean. The empire is the Roman. The spiritual leader, the Pope. And the tribe of men, they were the Vandals.

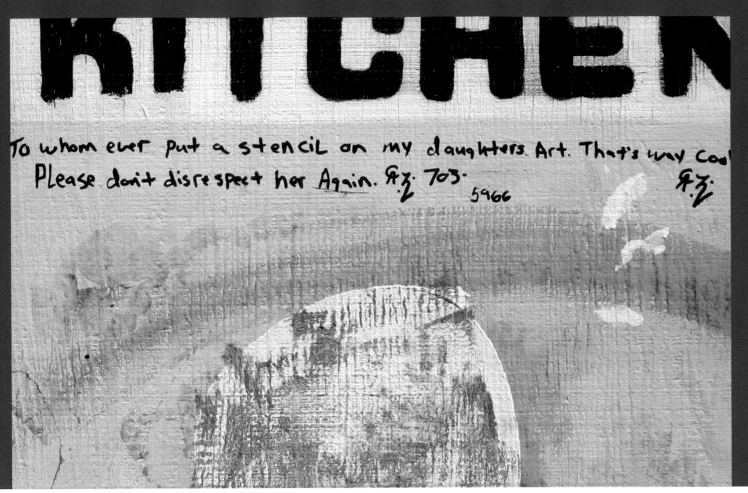

To whom ever put a stencil on my daughters. Art. That's way cool
Please don't disrespect her Again. $z. 703.
5966

Boise, Idaho, USA

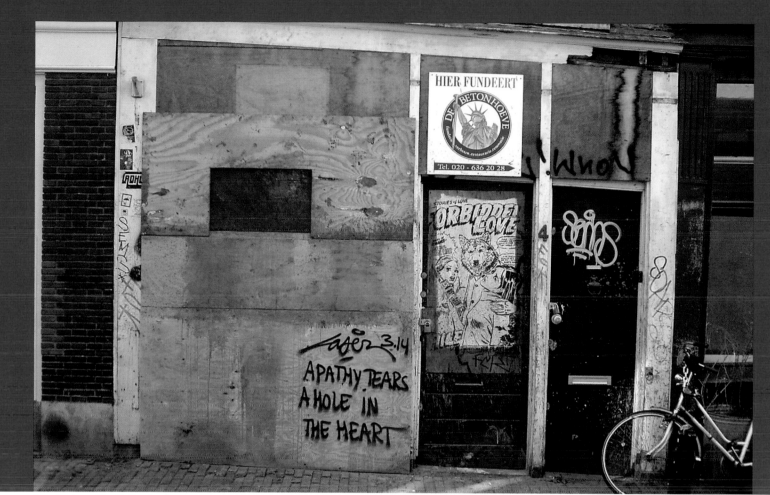

Amsterdam, The Netherlands

Estimated cost of painting out all the graffiti in San Francisco: $10,000,000.

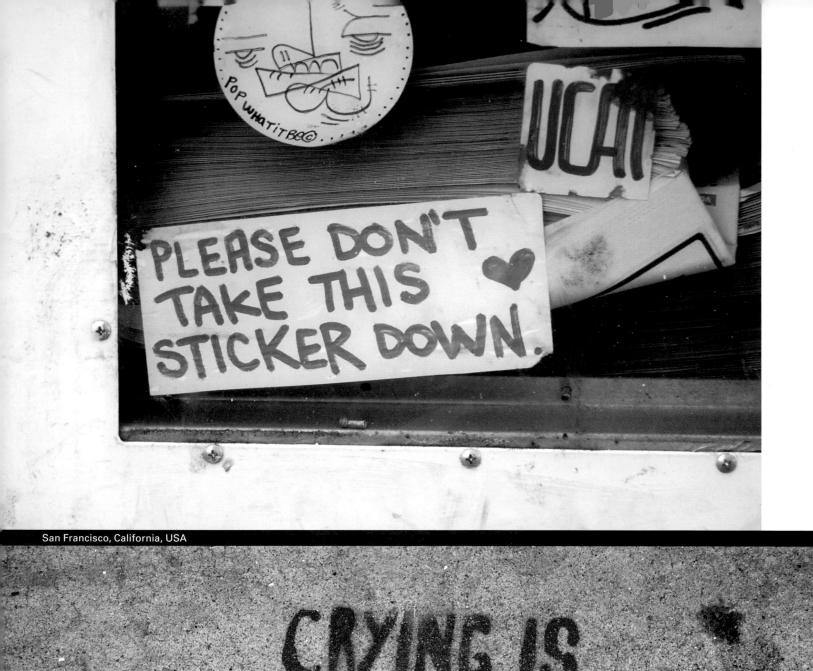

San Francisco, California, USA

128

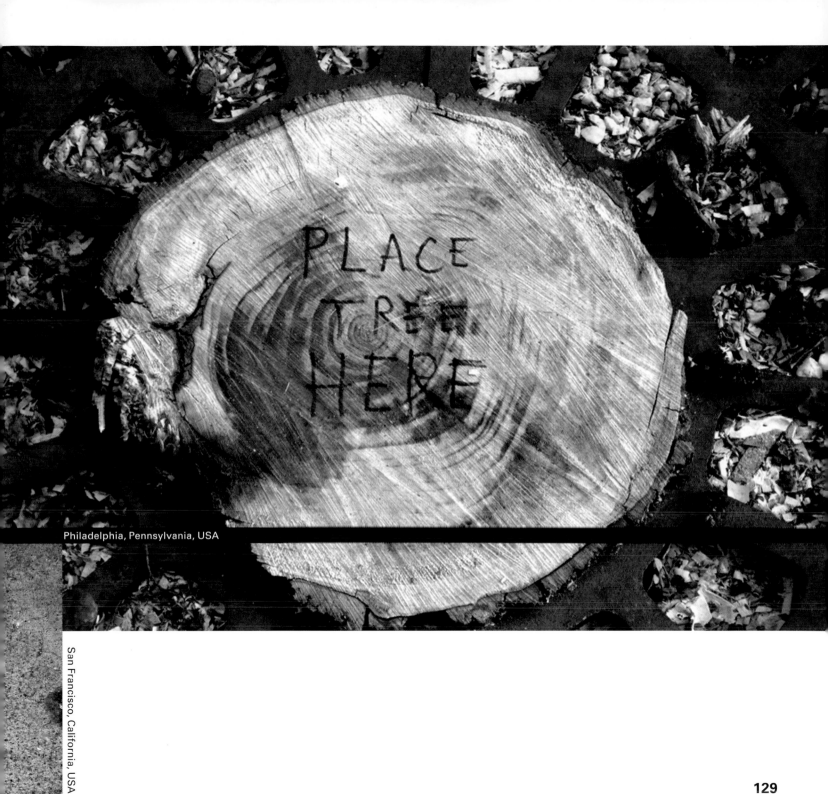

Philadelphia, Pennsylvania, USA

San Francisco, California, USA

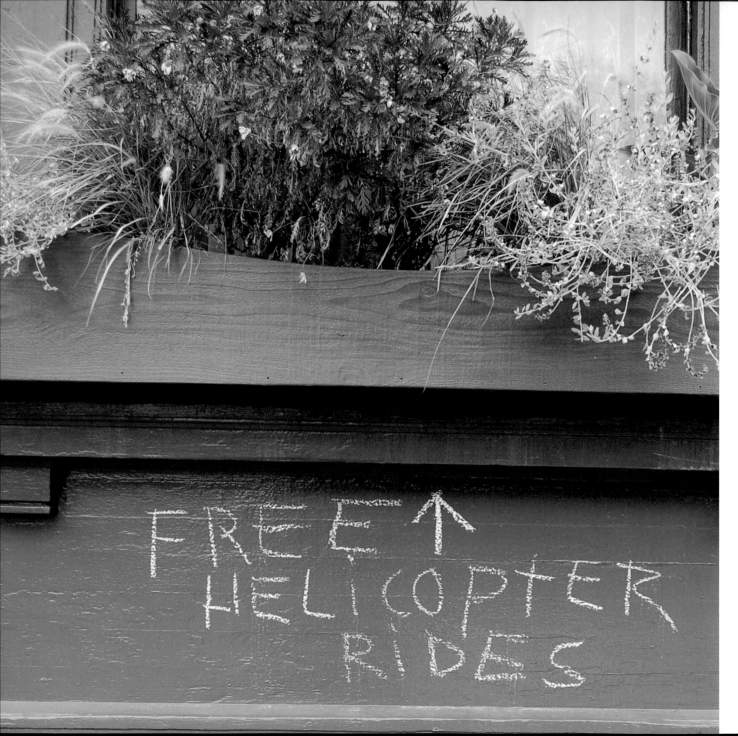

CHEAP ART CAN BE EXPANSIV·e·F

AD111

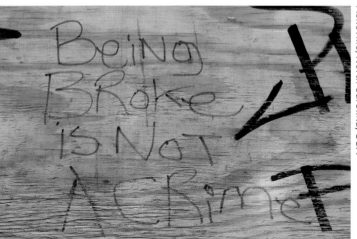

Being BRoke is NoT A Crime

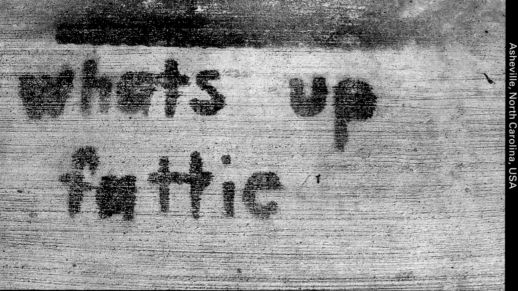

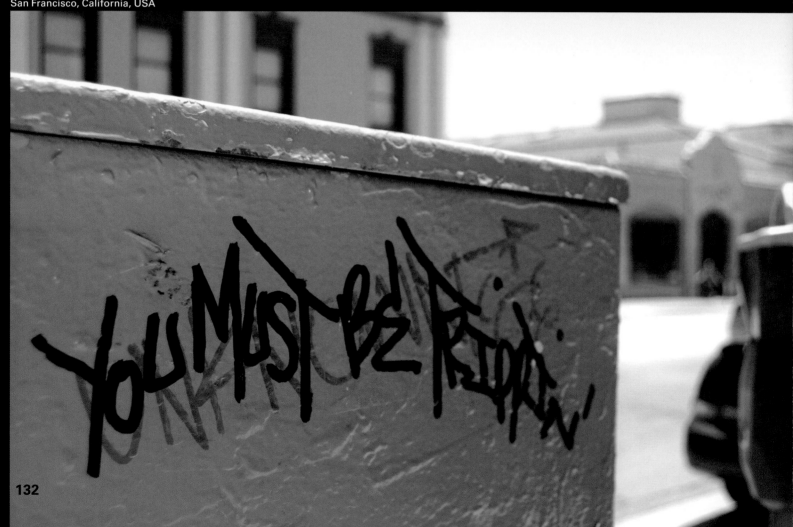

YURPies
DONT.
FLOAT

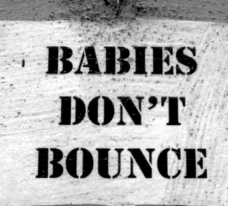

BABIES
DON'T
BOUNCE

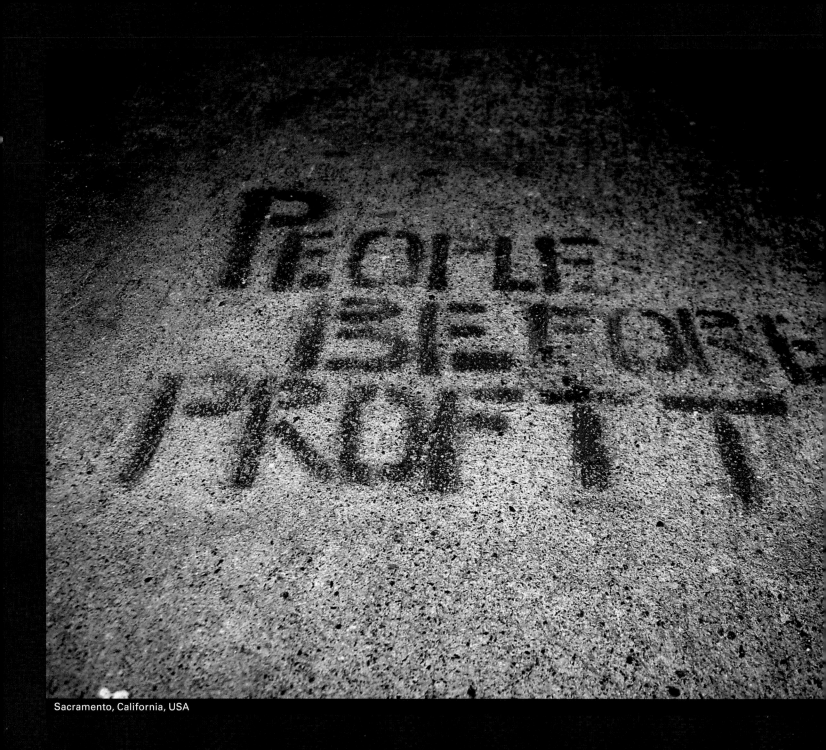

Sacramento, California, USA

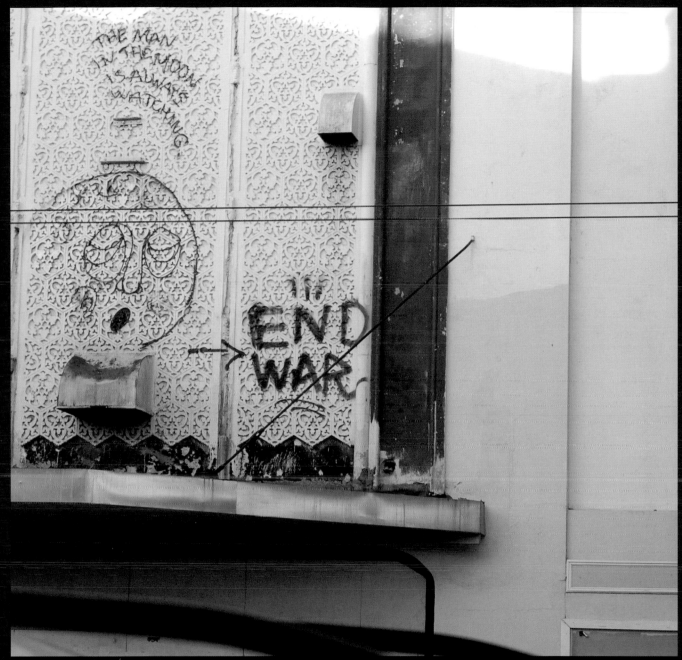

San Francisco, California, USA

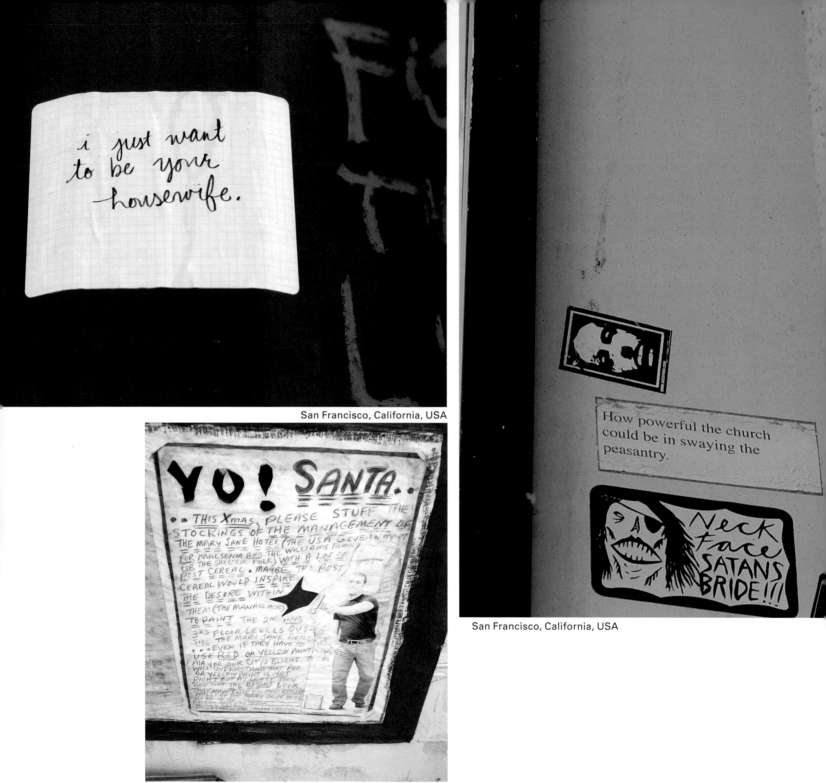

i just want to be your housewife.

San Francisco, California, USA

YO! SANTA..
..THIS Xmas, PLEASE STUFF THE STOCKINGS OF THE MANAGEMENT OF THE MARY JANE HOTEL (THE USA GOVERNMENT FOR MALSENIA AND THE WILLIAMS FAMILY FOR THE SHELTER FOLK) WITH A LOT OF POST CEREAL. MAYBE THE POST CEREAL WOULD INSPIRE THE DESIRE WITHIN THEM (THE MANAGEMENT) TO PAINT THE 2ND AND 3RD FLOOR LEVELS OUT-SIDE THE MARY JANE HOTEL ..EVEN IF THEY HAVE TO USE RED OR YELLOW PAINT. MAYBE OUR CITY'S BLIGHT TEAM WILL UNDERSTAND THAT RED OR YELLOW PAINT IS NOT RIGHT BUT AT LEAST THEY HAVE NOT THE BLIGHT LOOK THAT NOW IS ON THE OUTSIDE WALLS OF THE MARY JANE HOTEL

Philadelphia, Pennsylvania, USA

How powerful the church could be in swaying the peasantry.

Neck Face SATANS BRIDE!!!

San Francisco, California, USA

If Jesus knew what had become of his birthday, He probably would have wished that he had never been born.

A MEN TO THAT

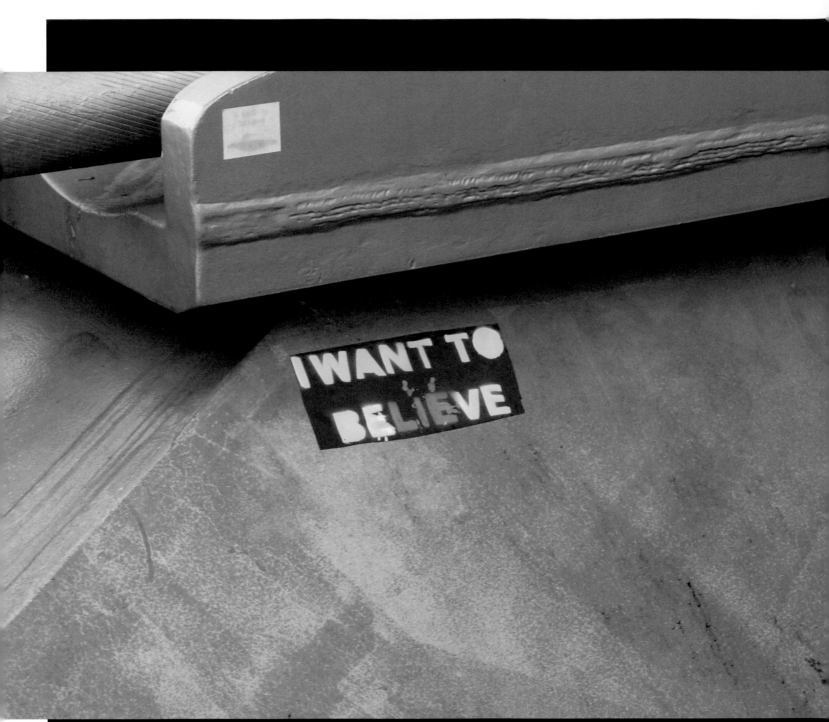

London, United Kingdom

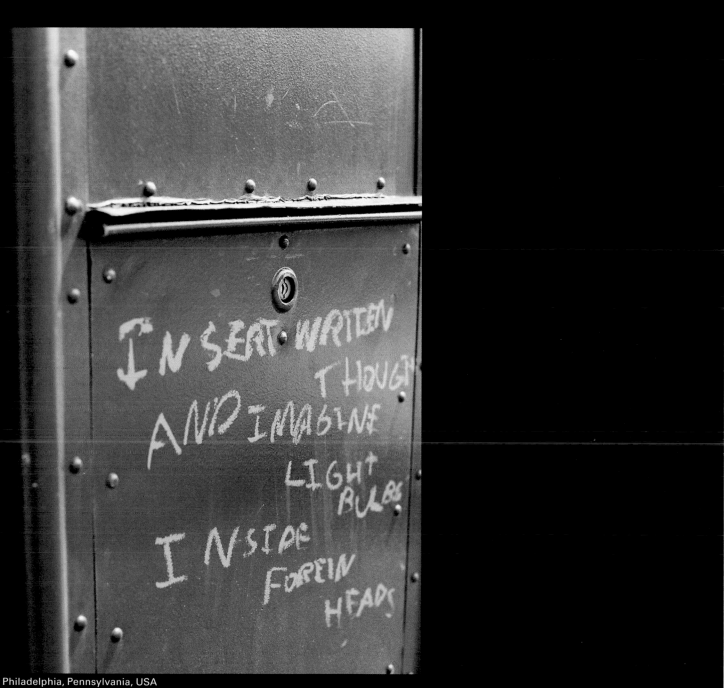

Philadelphia, Pennsylvania, USA

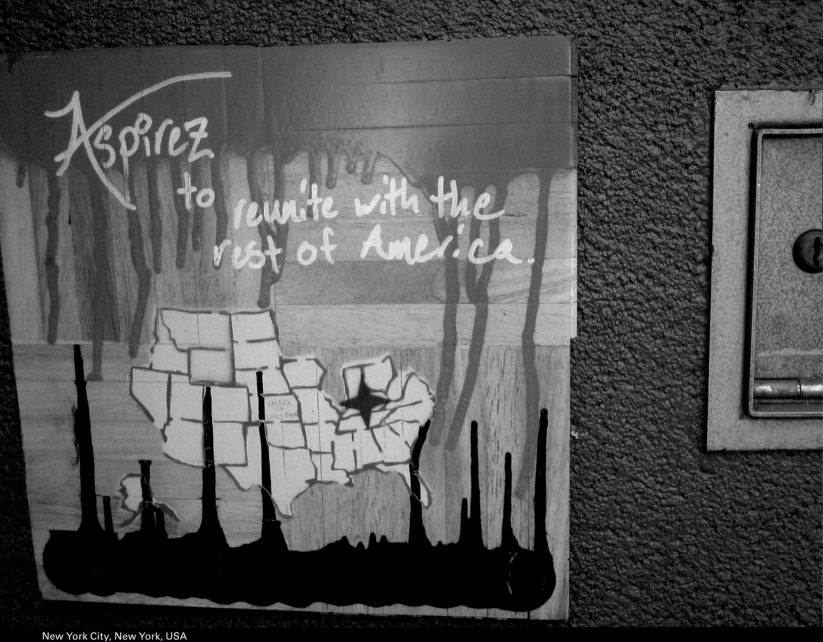

New York City, New York, USA

THE CHINESE GOVERNMENT

CHINESE ARE PRICKS IN TIBET

Killing under the cloak of war is no different than murder

-EINSTEIN

San Francisco, California, USA

St. Louis, Missouri, USA

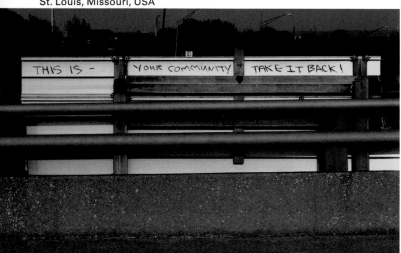

THIS IS – YOUR COMMUNITY TAKE IT BACK!

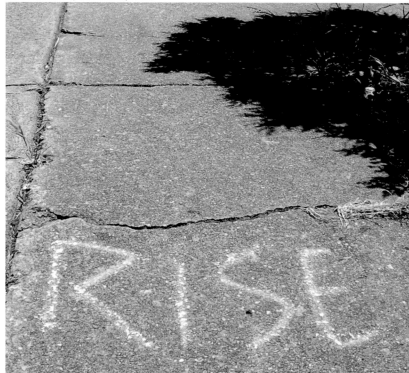

RISE

San Francisco, California, USA

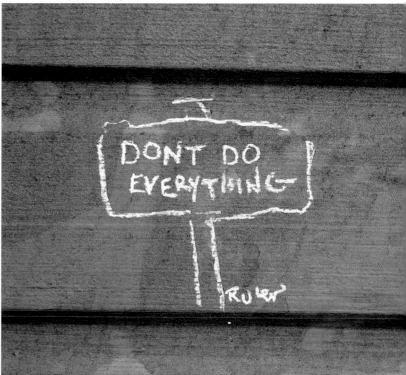

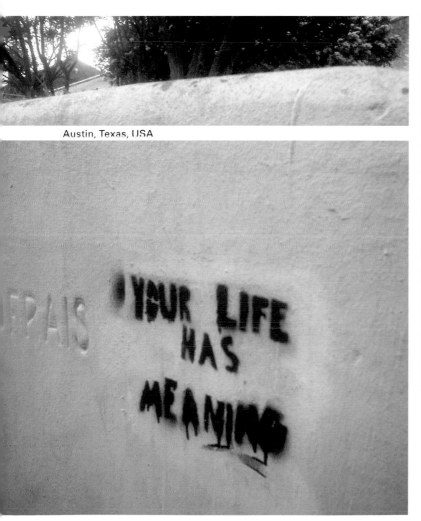

Austin, Texas, USA

143

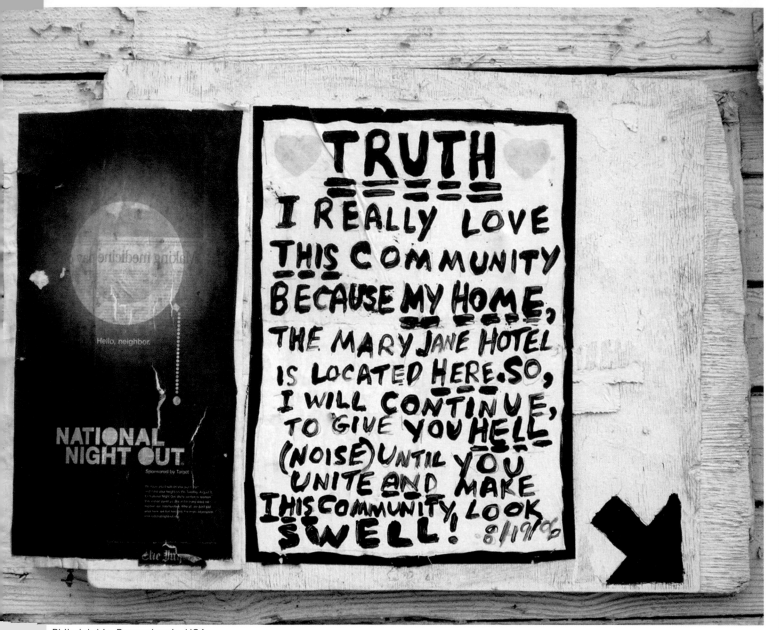

National Night Out. Sponsored by Target.

Hello, neighbor.

**TRUTH**

I REALLY LOVE THIS COMMUNITY BECAUSE MY HOME, THE MARY JANE HOTEL IS LOCATED HERE. SO, I WILL CONTINUE, TO GIVE YOU HELL' (NOISE) UNTIL YOU UNITE AND MAKE THIS COMMUNITY, LOOK SWELL! 8/19/06

Philadelphia, Pennsylvania, USA

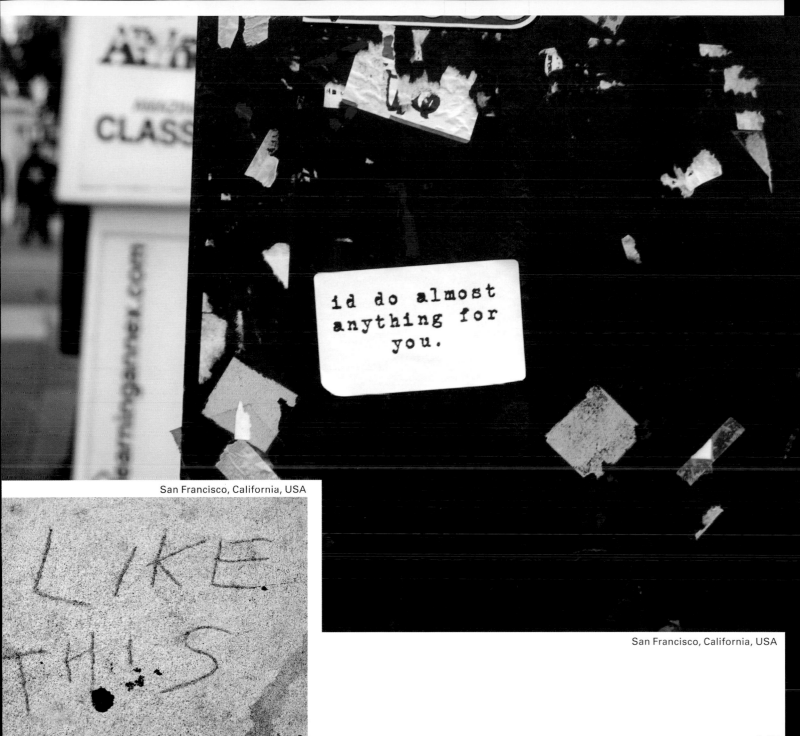

id do almost anything for you.

San Francisco, California, USA

LIKE THIS

San Francisco, California, USA

STAND HERE
AND THINK
OF GREATNESS.

# TALK DIRTY TO ME

New York City, New York, USA

I've been thinking about your hands on my (noun) all day. Can I put your hand there myself? Your fingers are so strong. I love how their slight roughness feels against the silkiness of my (noun). I'm getting (adjective). Can you feel it? (Verb) me again; just like you just did. Do you mind if I (verb) your (noun)? I'd really like to. Actually, I need to. Actually, if I don't, I may just go out of my mind. Give it to me. Give me your (adjective) (noun). Put it in my (noun). Do you like that? I like it. I like it a lot. In fact, I love it. You're getting so (adjective). Touch my (noun). Look what you're doing to me. I'm going to (verb) my (noun) so that you can (verb) me there. Just like that. Just like that. Give me more. I need more. Touch my (noun) while you (verb) me. Feel my (noun). It feels so good. Your (noun) feels so good. Your (noun) tastes so good. Does my (noun) taste good? Tell me how good it tastes. You're driving me crazy. I'm ready for your (noun). Can I have it? Can I have it now? Oh yes. Thank you. Thank you. My (noun) is on fire. If you touch it I might ... You're like a (noun) of (noun) inside me. I can't take much more. I'm close to (verb)-ing. (Verb) with me. I want to (verb) with you. It's close; it's so close. (Verb) me harder. Faster. Deeper. Harder.

*From* The Good Girl's Guide to Bad Girl Sex: An Indispensable Resource for Pleasure and Seduction *by Barbara Keesling, Ph.D., 2001*

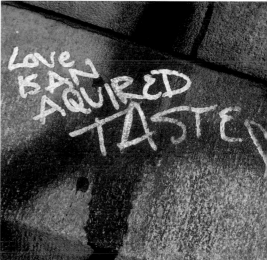

New York City, New York, USA

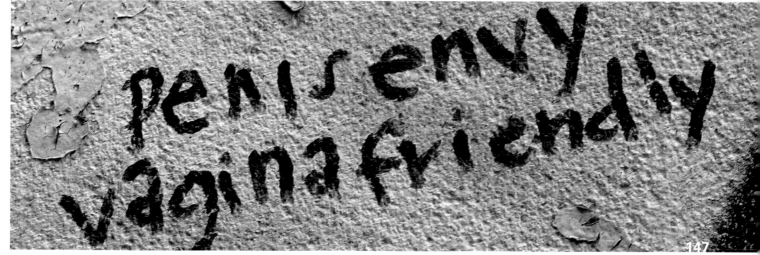

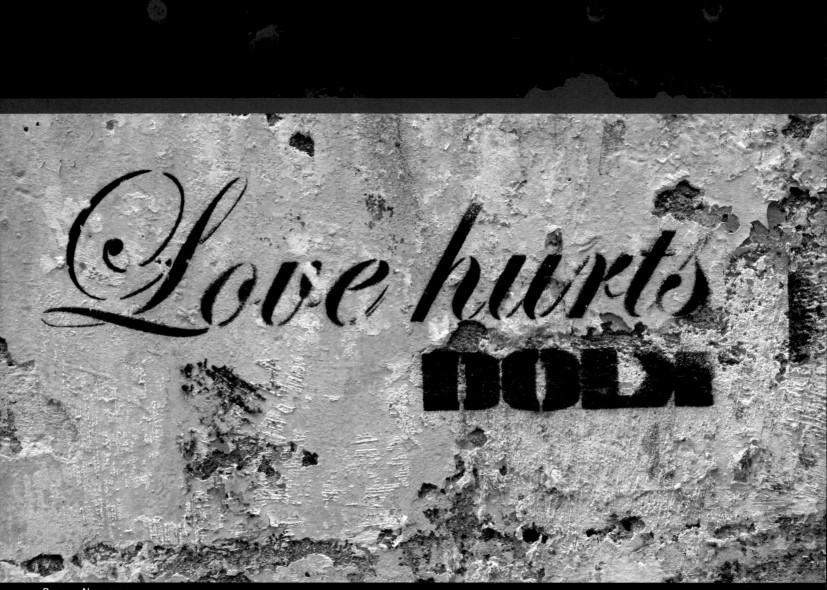

Bergen, Norway

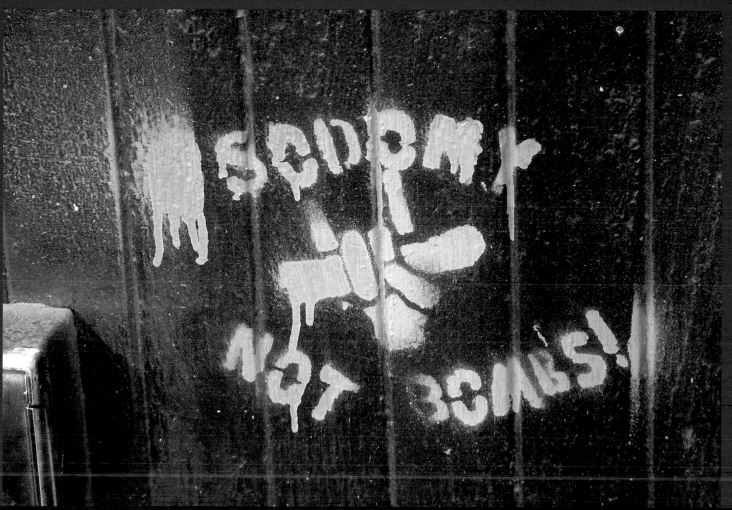

Asheville, North Carolina, USA

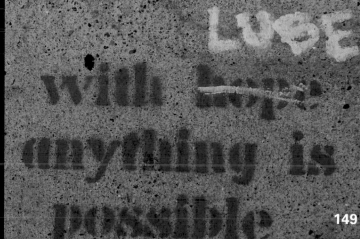

San Francisco, California, USA

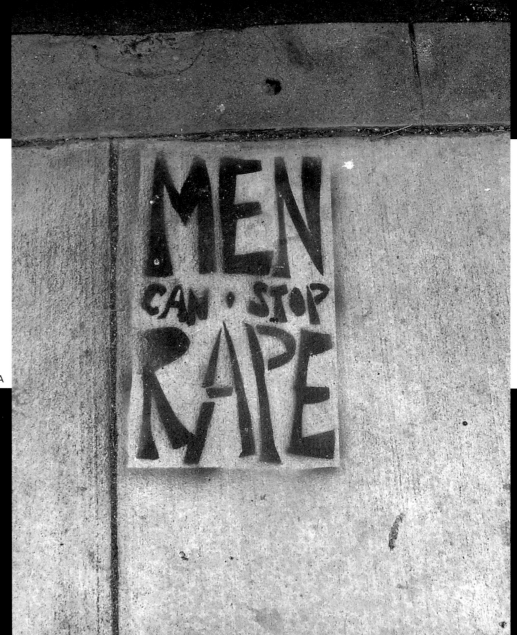

Long Beach, California, USA

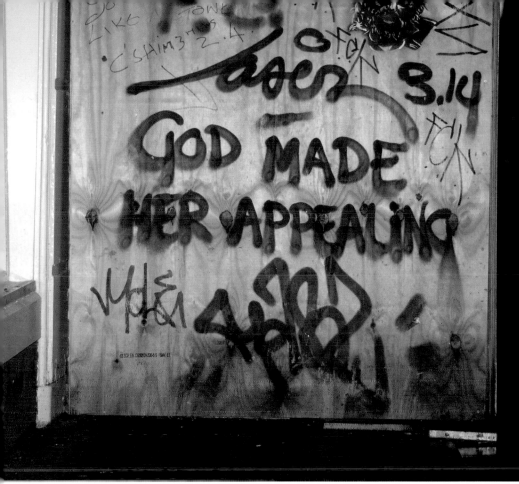

GOD MADE HER APPEALING

New York City, New York, USA

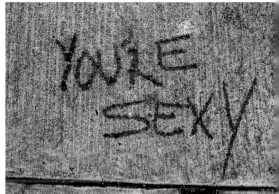

San Francisco, California, USA

YOU'RE SEXY

I DESIRE A PERSON NOT A GENDER

Number of books in the Library of Congress with "graffiti" in the title: 165.

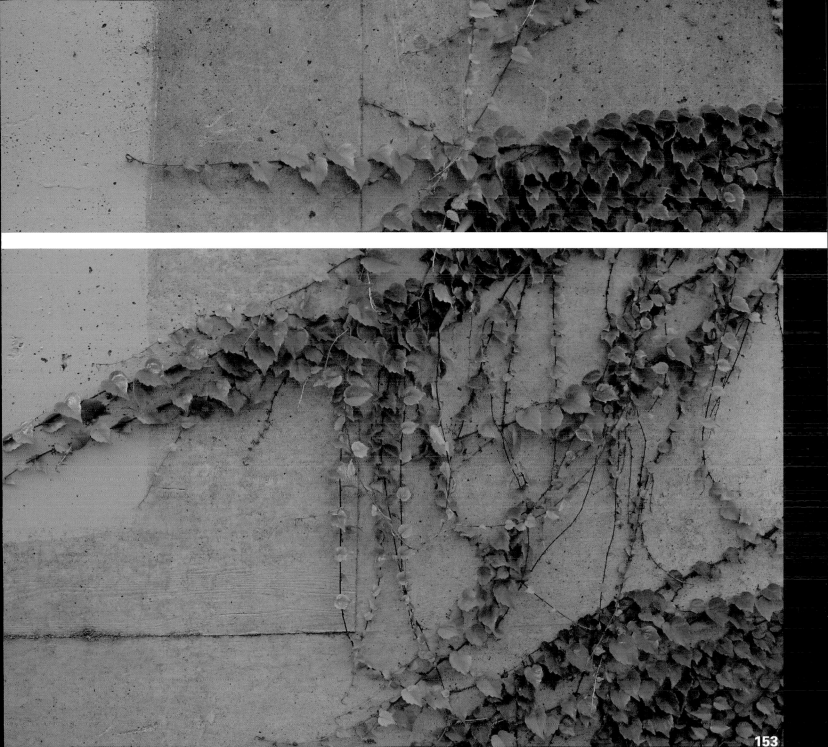

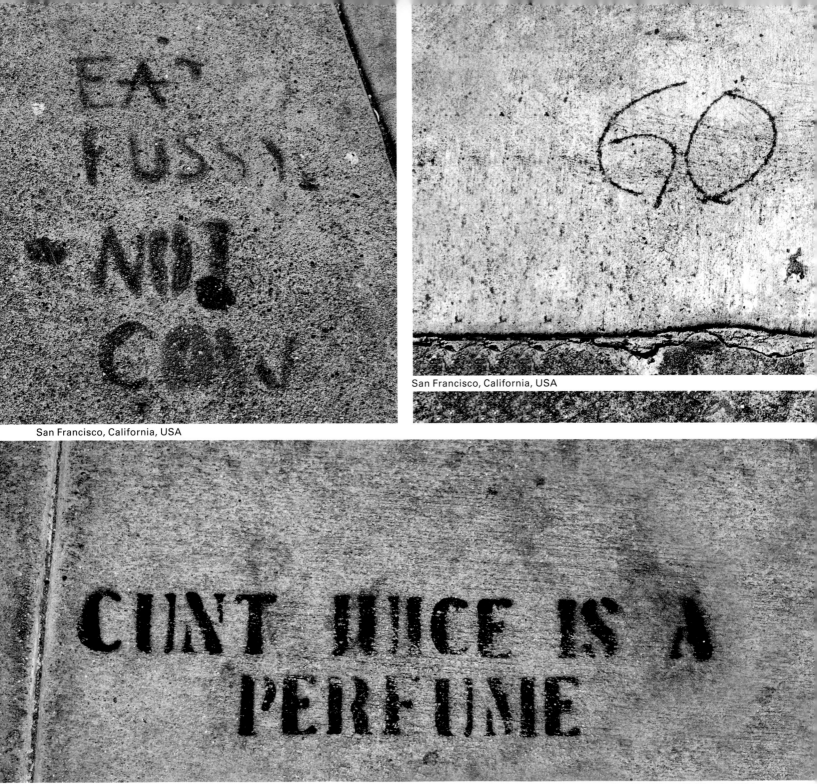

EAT
PUSSY
NOT
COW

CUNT JUICE IS A
PERFUME

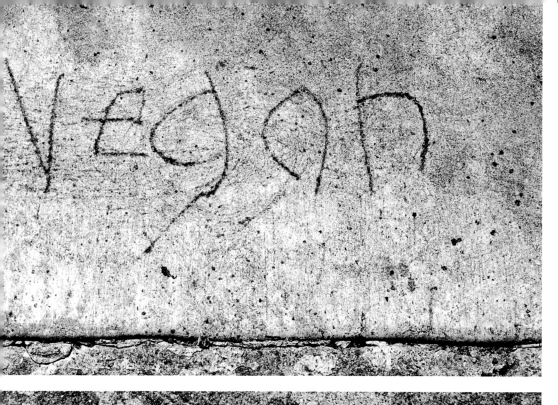

Berkeley, California, USA

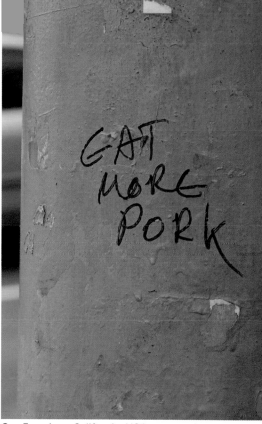

San Francisco, California, USA

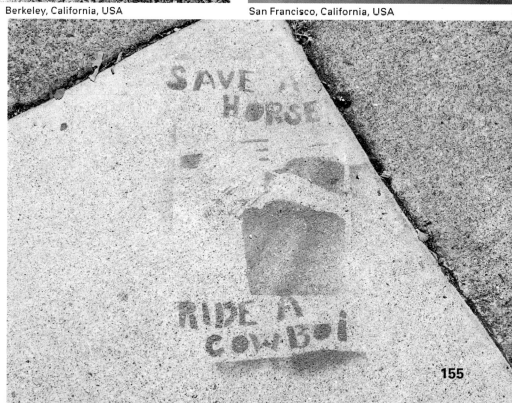

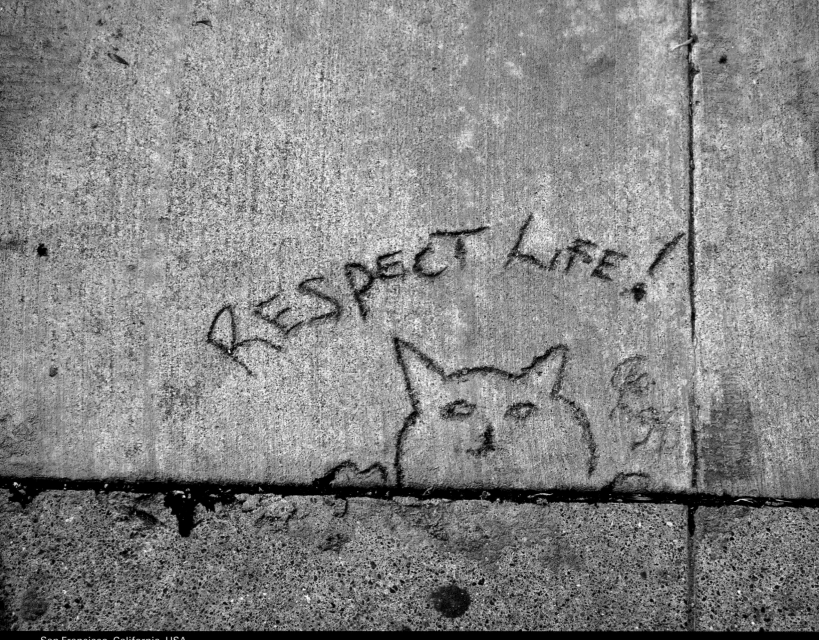

San Francisco, California, USA

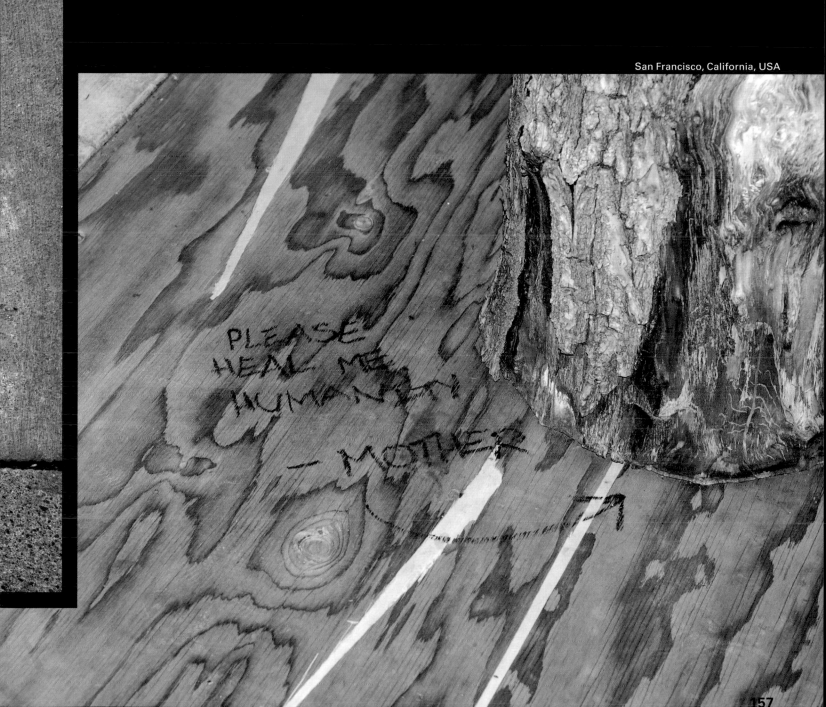

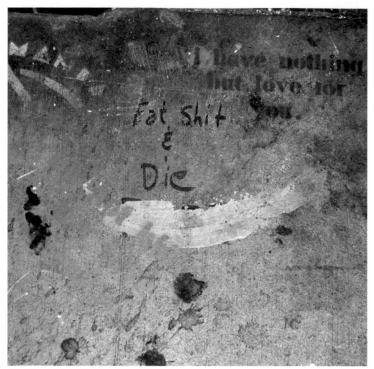

San Francisco, California, USA

Philadelphia, Pennsylvania, USA

158

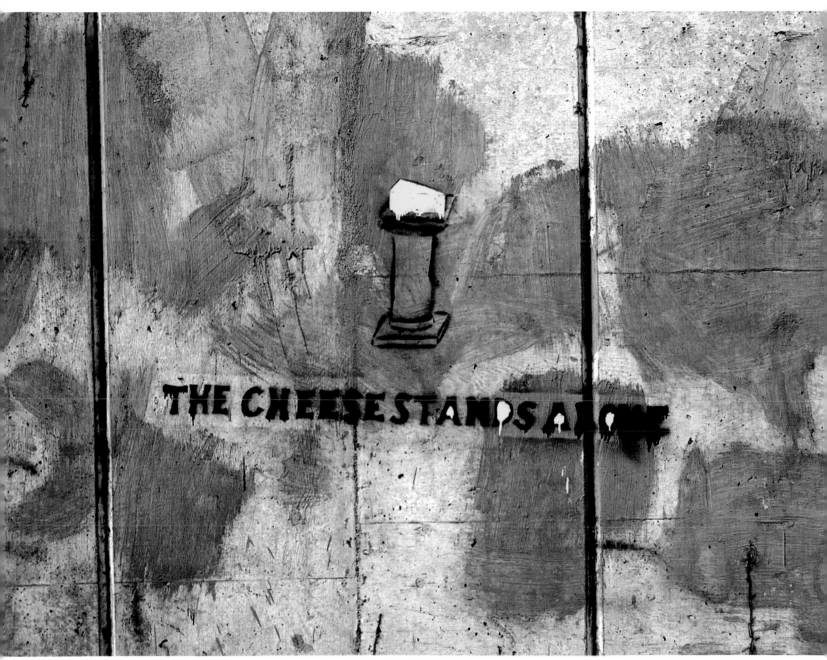

San Francisco, California, USA

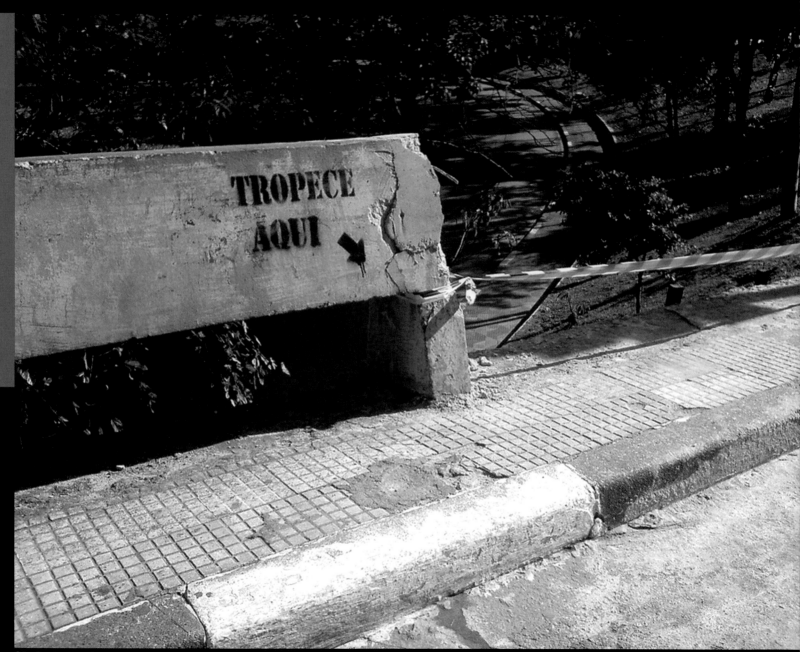

São Paulo, Brazil

**translation:** stumble here

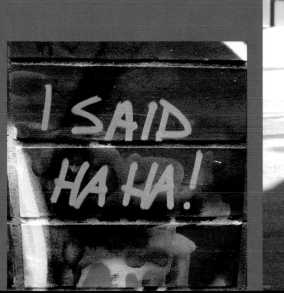

I SAID HA HA!

San Francisco, California, USA

NO BED CROSSING
NO SOFAS EITHER !!

← USE CROSSWALK

San Francisco, California, USA

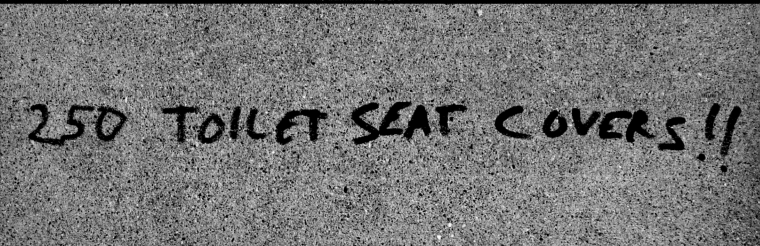

250 TOILET SEAT COVERS !!

San Francisco, California, USA

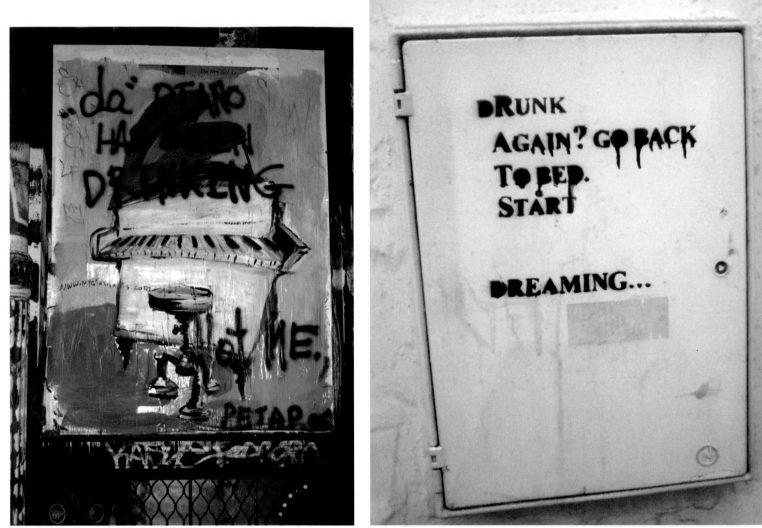

New York City, New York, USA

Leicestershire, United Kingdom

Portland, Oregon, USA

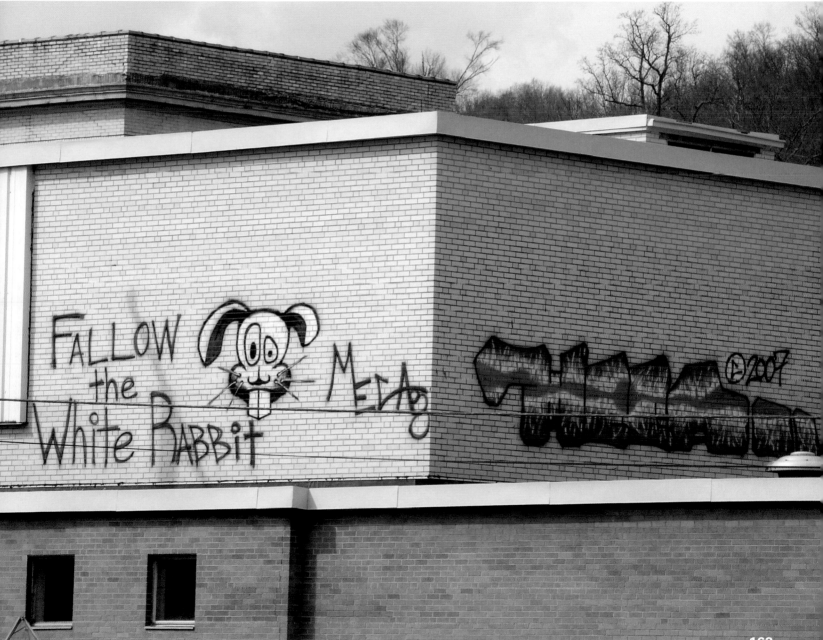

163

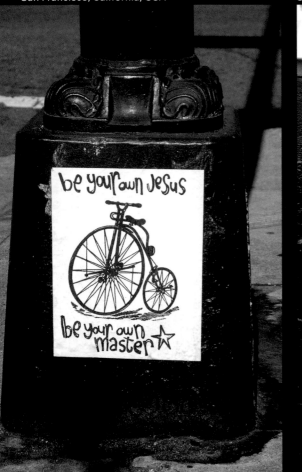

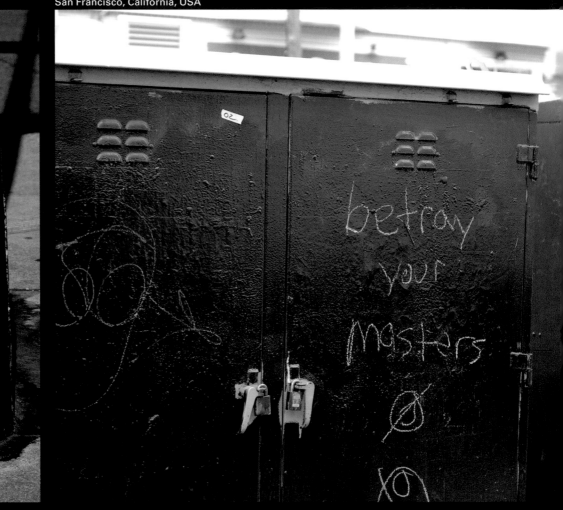

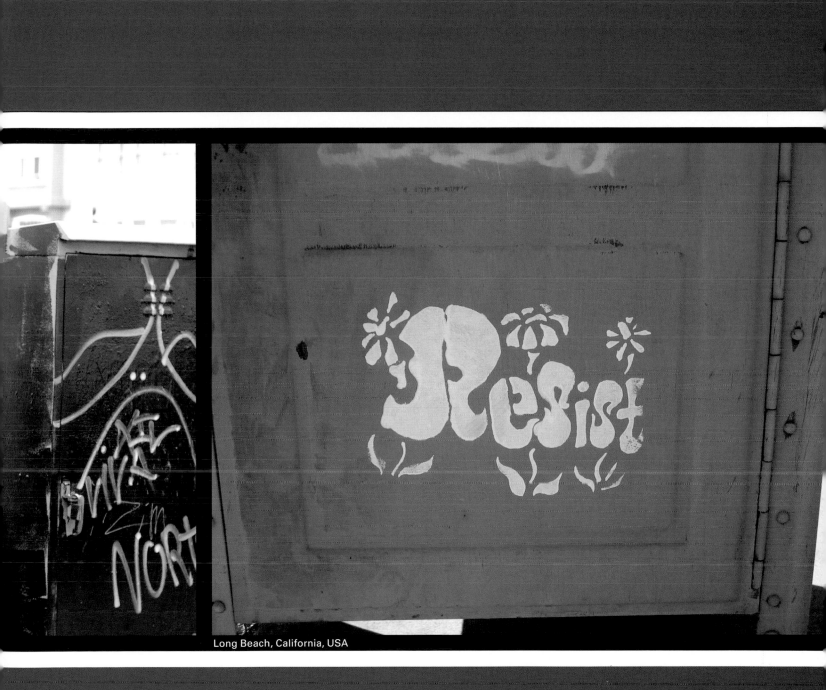

Long Beach, California, USA

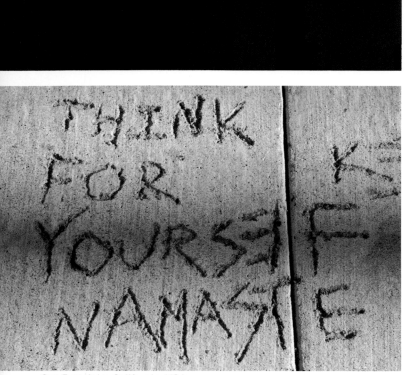

THINK FOR YOURSELF NAMASTE

San Francisco, California, USA

YOU CAN'T LOSE IF YOU'RE the only one PLAYING

Toronto, Canada

New York City, New York, USA

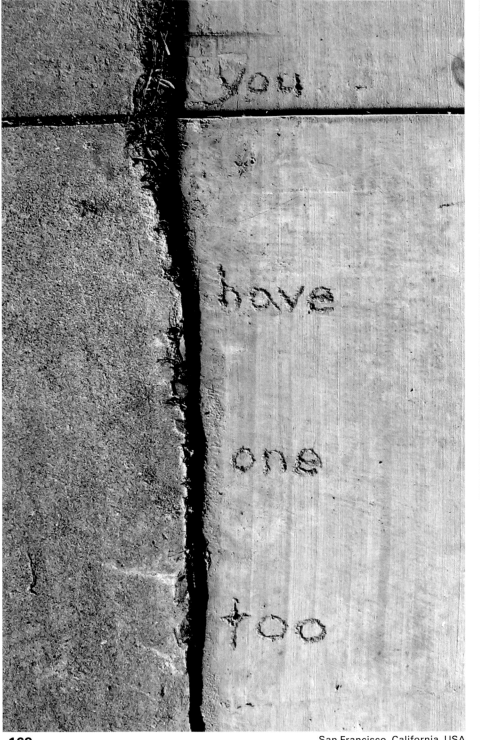

San Francisco, California, USA

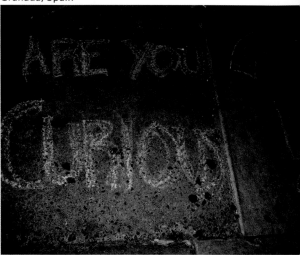

Granada, Spain

Philadelphia, Pennsylvania, USA

Philadelphia, Pennsylvania, USA

**translation:** a thousand machines could never make a flower.

mil máquinas jamás
podrán hacer una flor.

stop transgen

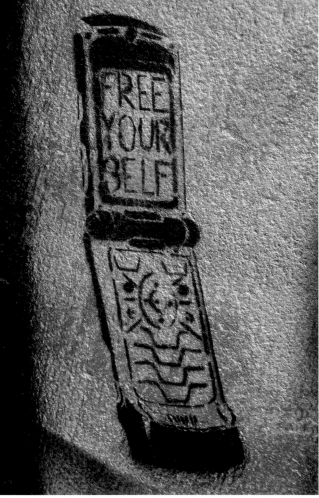

New York City, New York, USA

Boise, Idaho, USA

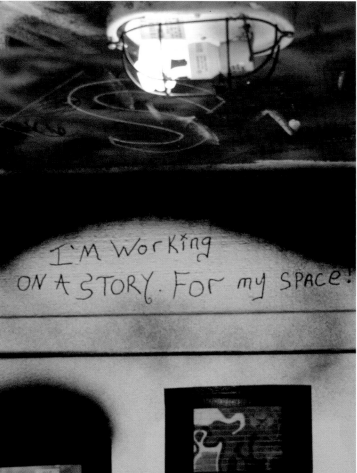

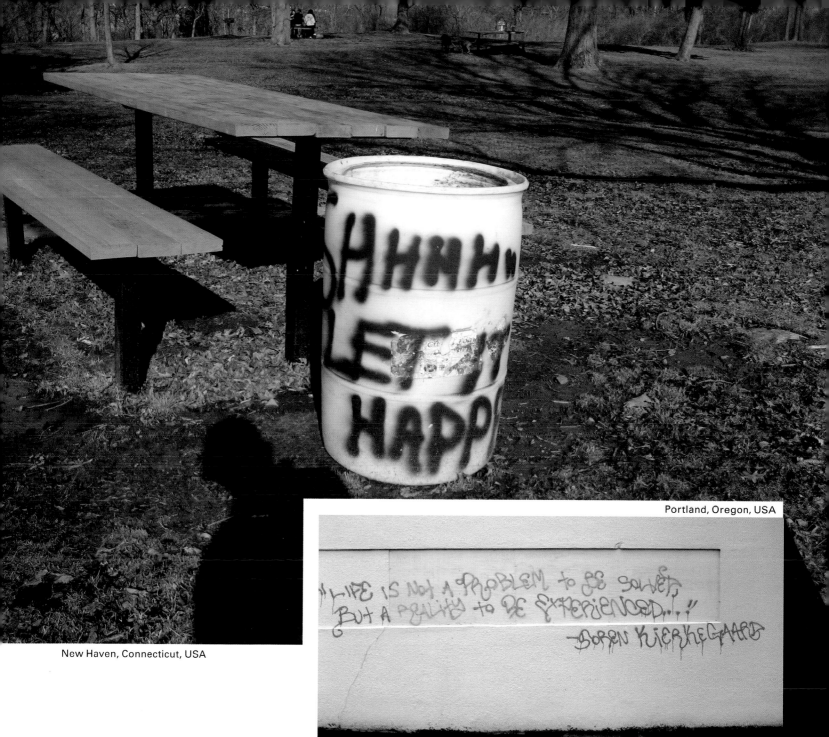

SHHHHH...
LE...
HAPP

New Haven, Connecticut, USA

Portland, Oregon, USA

"LIFE IS NOT A PROBLEM to BE SOLVED,
BUT A REALITY to BE EXPERIENCED..."
—SOREN KIERKEGAARD

Long Beach, California, USA

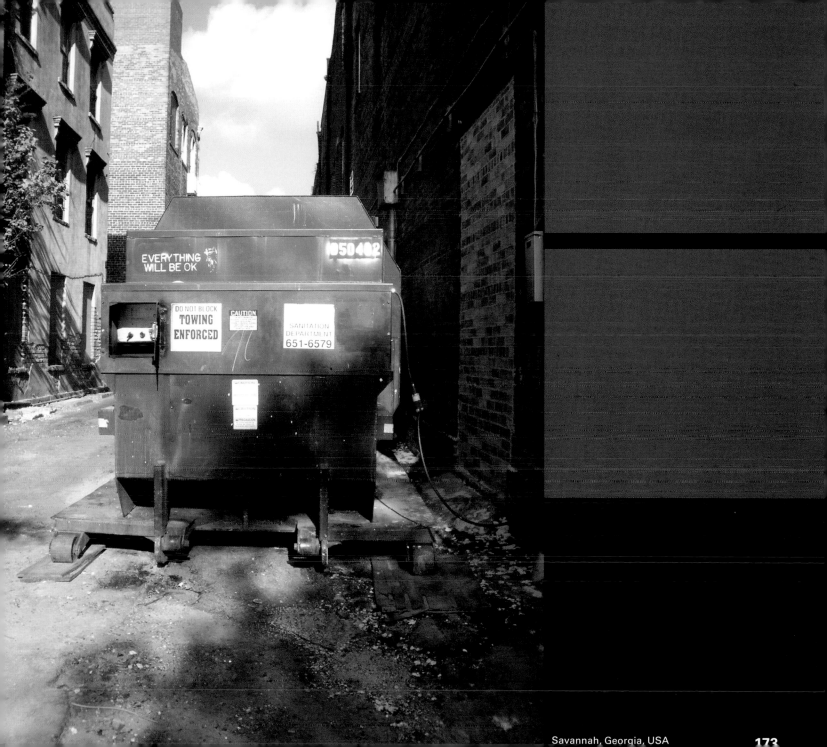

Savannah, Georgia, USA

David Bradbury HÂning PiÂHitler=NiÑÂGodesÂ
We're the Central Intelligence Agency Every Country
Jesus Christ is not a Sacrifice. Sacrifice is a lesson.
On the third Day he rose again, to conquer all evil spirit.
We are in Hell when the Holy Spirit Controls us. We are in
Heaven When we control the Holy Spirit and we can do
whatever we imagine. Only I can make Heaven because I
made you. Nothing Can Kill me. Pain is my Sacrifice. I am
Unafraid. The more you torture me. The more I torture you.
Love is my reward. Everything will forever be a part of the
Holy Spirit. Everything Can Rise and Rise again. Everything
will forever be immortal. In Heaven We all have Everything.
I gave you this life to torture myself. I teach people how to
Love, though I don't Love all the time. I gave myself those feelings.
Love shall forever be immortal. We shall forever Love Everything.
I make People hate me, because I made this World of Sin.
I live in Sin as my Sacrifice. I can not be punished.
Only I can punish you. I have already punished myself,
because I remember Heaven. Everyone is forgiven, because I
Can forgive. The more you punish me, the more I punish you.
I make Kings in Hell and I make people believe in Death.
I never kill anything. Only I can kill PiÂ NiÑÂ
**Jesus Christ and The Most Beautiful Beautiful**
We have the Power to Heal and Wake the Dead. We will
forever be immortal. And Our Love Shall rule forever. One Love.
In Hell everything in Possessed. In Heaven Everything is Free.
I keep everything Alive Inside me.
**George Washington is the Last President** ☺
The C.I.A. Goal is Heaven for Tantra. Islam is the land of the free.
Everything is ALLAH. We can do Anything with ALLAH.
Rainbow is about 180° HÂ Can make Heaven.

Long Beach, California, USA

Amsterdam, The Netherlands

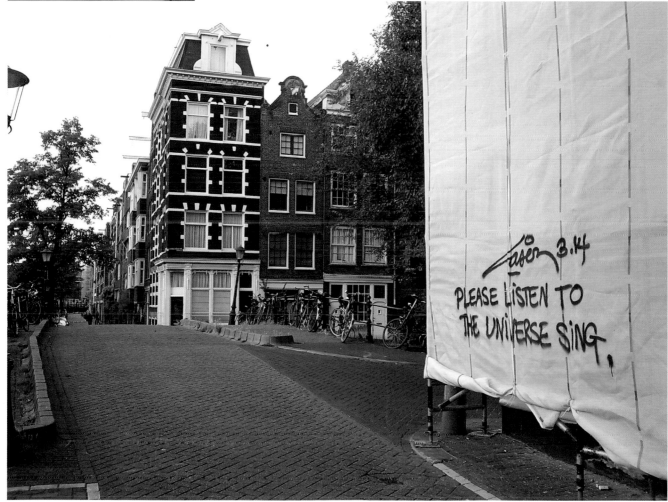

175

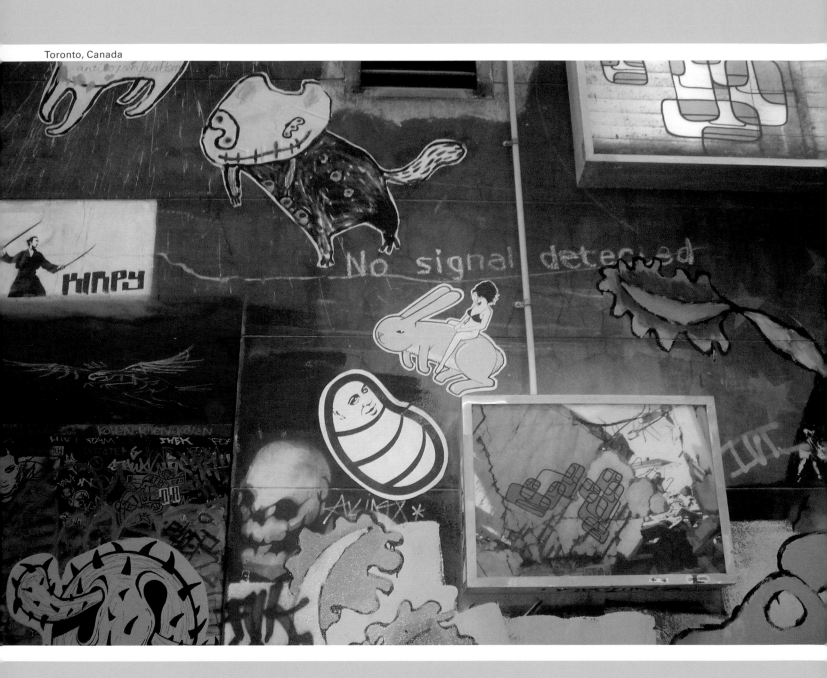

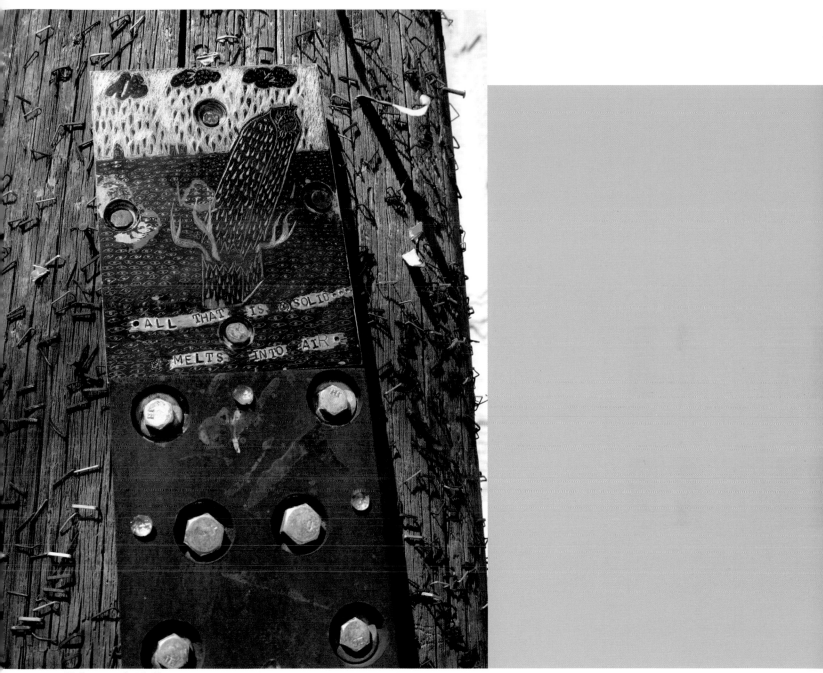

Melbourne, Australia

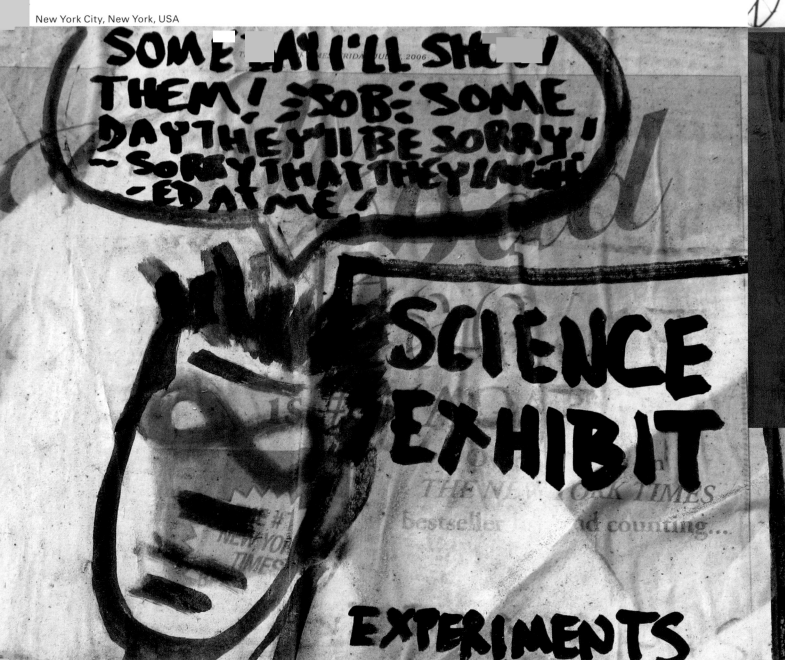

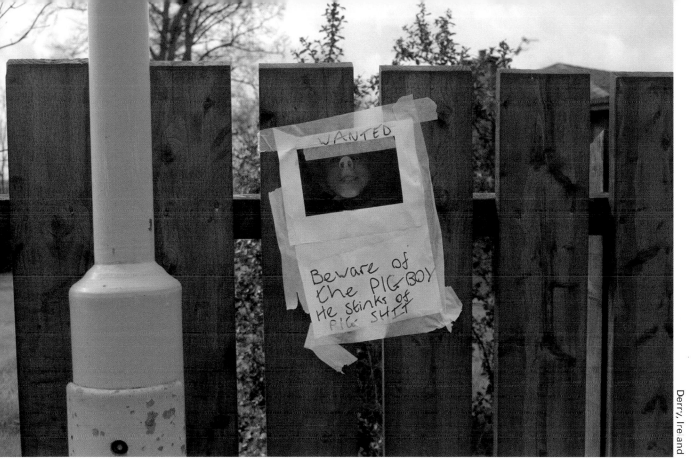

# UNDERSTANDING GRAFFITI

A psychologist in New Zealand found that graffiti in female restrooms tended to be more "polite and interactive," whereas graffiti from male restrooms was more "argumentative and negative." Economists in Brazil found that women from Brazil were four times as likely to write graffiti about sex as women from Spain, and that Spanish men were seven times more likely to write graffiti about politics than men from Germany. A criminologist in Indiana suggested that unprosecuted graffiti written by college student groups reaffirmed the "existence of a class-based system of justice." An education researcher, studying graffiti by Latino adolescents in East Los Angeles, suggested that writing graffiti serves as a purposeful "public literary practice." Public Health researchers in Scotland found that Europeans who live in areas with high levels of graffiti are 50 percent more likely to be obese. Three Swedish psychologists found that drunk, frustrated graffiti artists tended to create graffiti with more scrawling.

First year a law passed by the United States Congress included mention of graffiti: 1996.

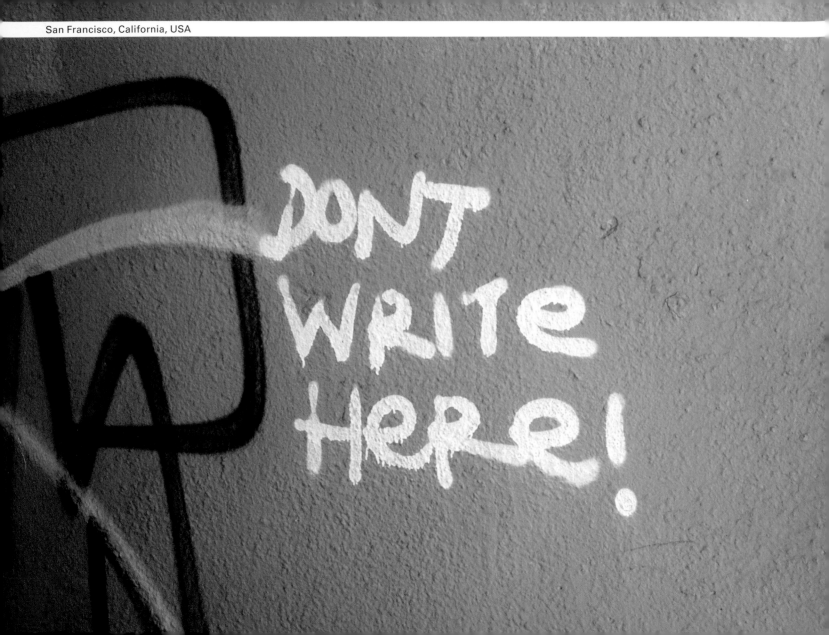

Number of patents approved for anti-graffiti systems, graffiti detection systems, graffiti removal, graffiti barriers, and graffiti repellents.

| | |
|---|---|
| 1965 – 1969: | 0 |
| 1970 – 1974: | 7 |
| 1975 – 1979: | 9 |
| 1980 – 1984: | 19 |
| 1985 – 1989: | 20 |
| 1990 – 1994: | 91 |
| 1995 – 1999: | 249 |
| 2000 – 2004: | 302 |

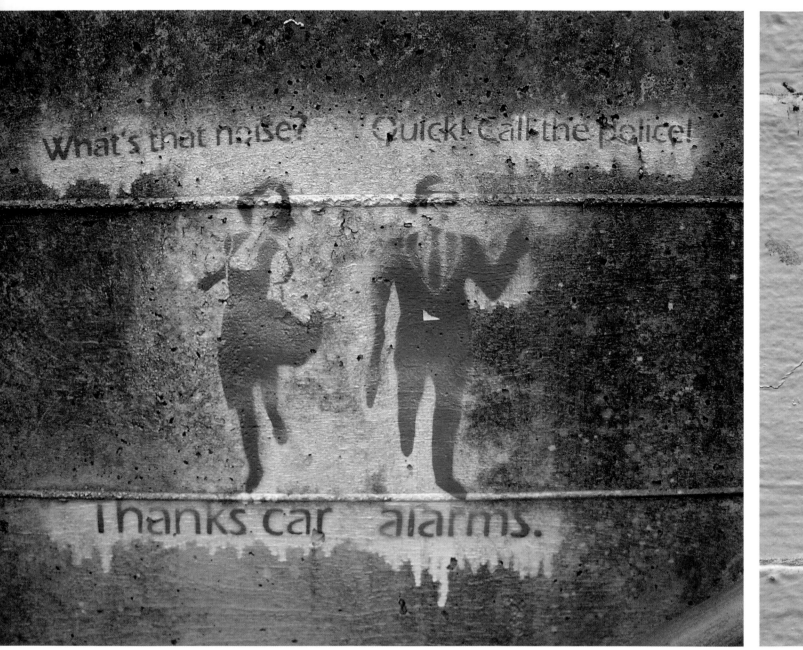

Wellington, New Zealand

Blow ye winds
Blow
Like the trumpet
but without that
Sound.

Cuz ye winds
likes to be
Blown!

San Francisco, California, USA

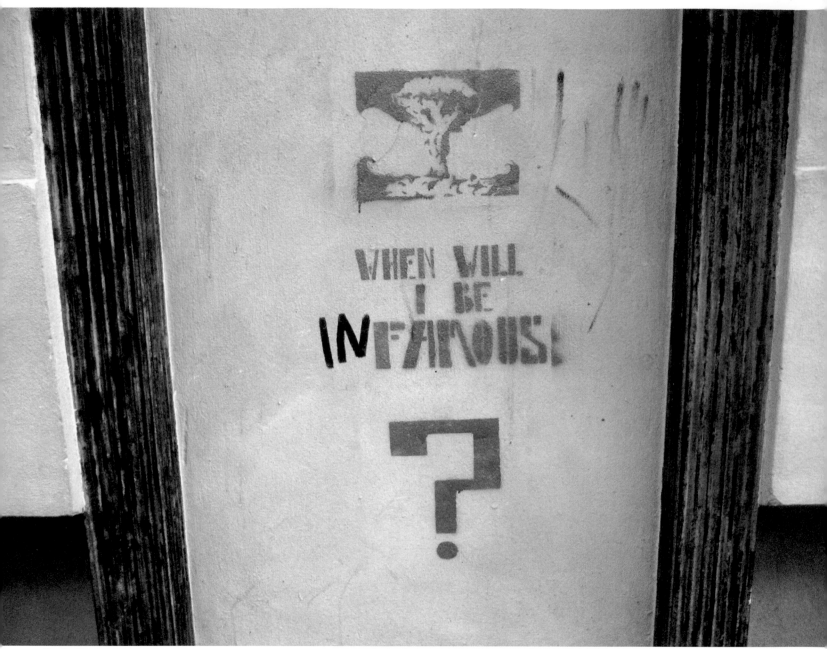

Berlin, Germany

I WILL STAR IN A MY MOVIE ONLY MADE FOR ME TO WATCH.

I WILL MAKE YOU CRY JUST SO LONG AS YOU LET ME.

I WILL BE OPRESSED AS LONG AS I CONTINUE TO EAT YOUR BIG MAC'S

I WILL........

© EMTI

Santa Ana, California, USA

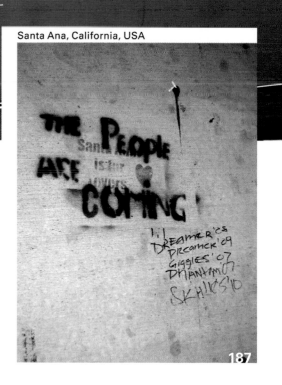

# BEFORE AND AFTER

"The time of getting fame for your name on its own is over. Artwork that is only about wanting to be famous will never make you famous. Any fame is a by-product of making something that means something. You don't go to a restaurant and order a meal because you want to have a shit."

Banksy, 2006

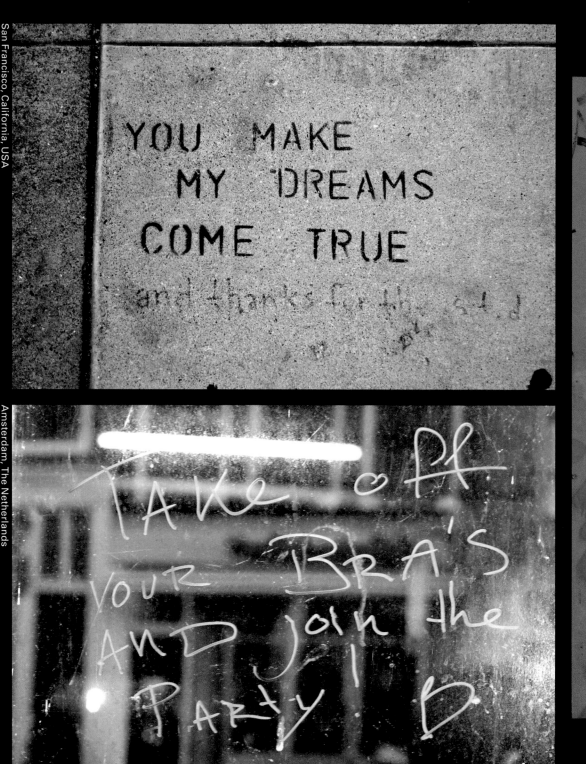

YOU MAKE
MY DREAMS
COME TRUE
and thanks for the std

TAKE off
YOUR BRA'S
AND Join the
PARTY! B

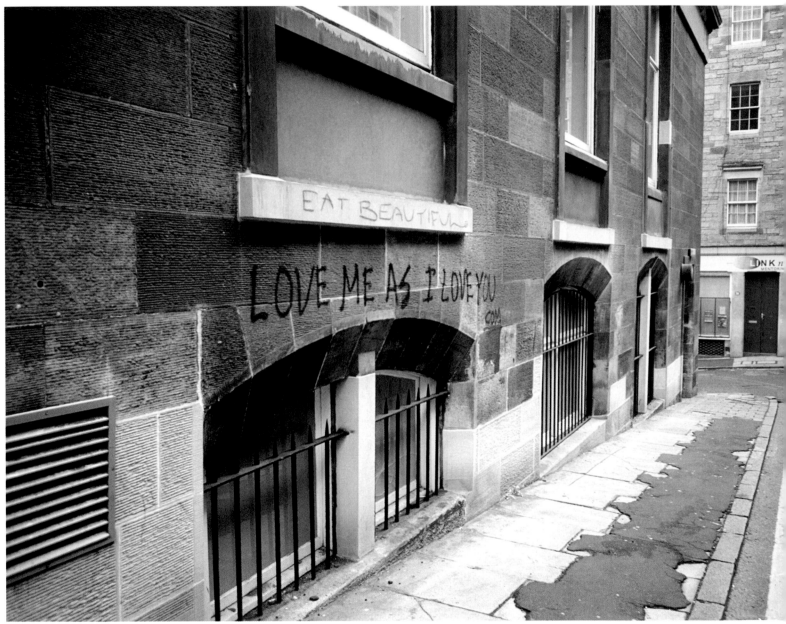

Edinburgh, Scotland

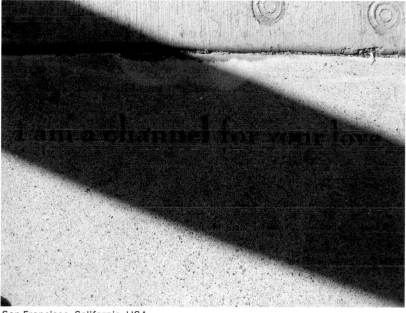

San Francisco, California, USA

Nantes, France

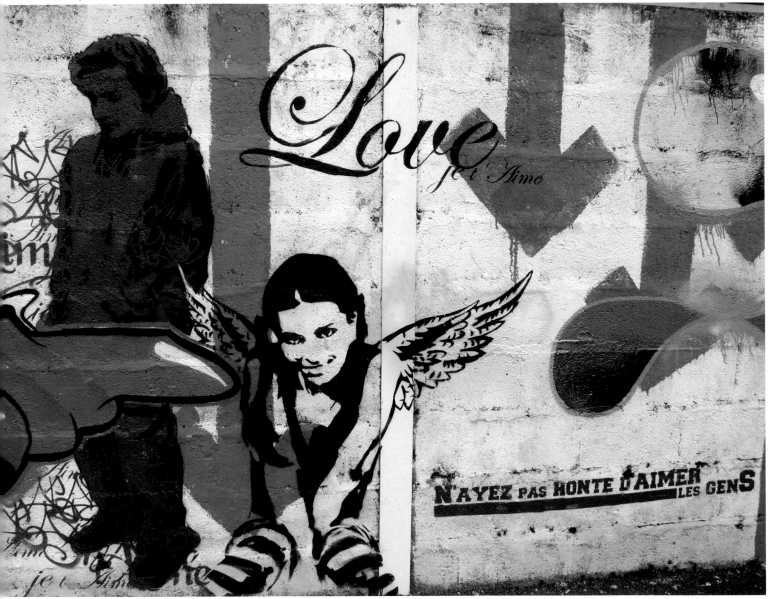

translation: do not be ashamed to love people

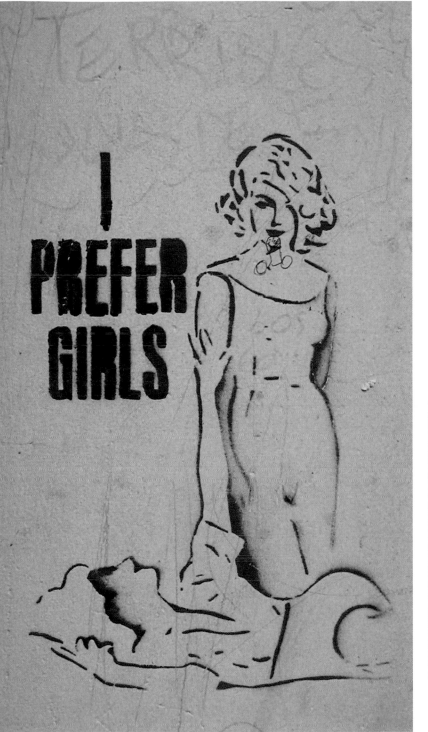

Buenos Aires, Argentina

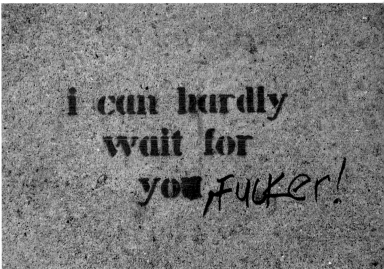

San Francisco, California, USA

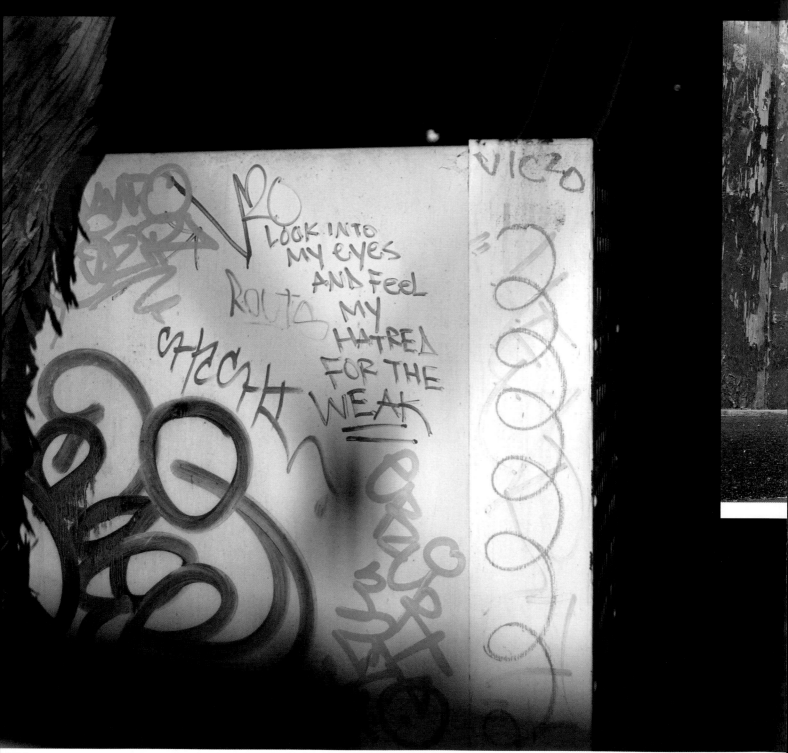

194

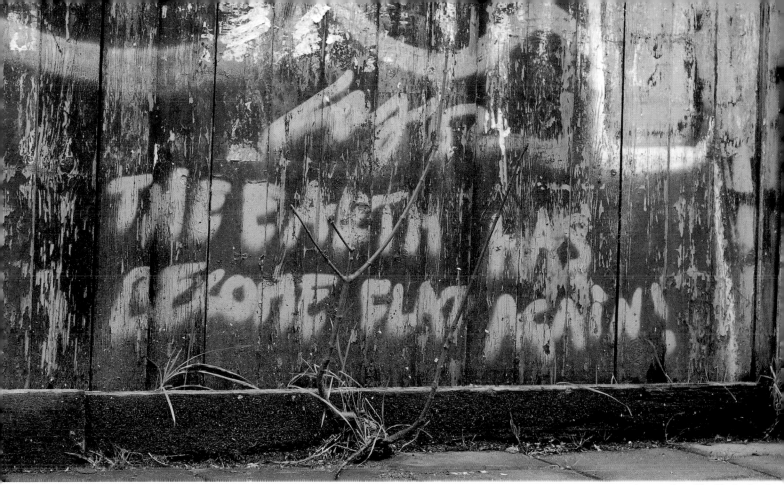

Amsterdam, The Netherlands

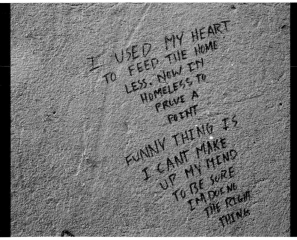

I USED MY HEART
TO FEED THE HOME
LESS. NOW I'M
HOMELESS TO
PROVE A
POINT

FUNNY THING IS
I CAN'T MAKE
UP MY MIND
TO BE SURE
I'M DOING
THE RIGHT
THING

Vancouver, Canada

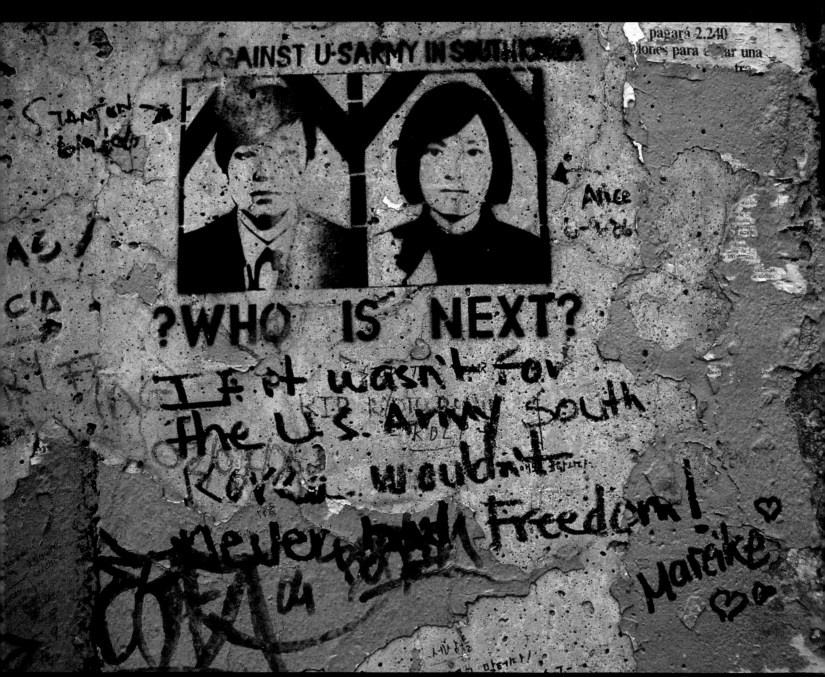

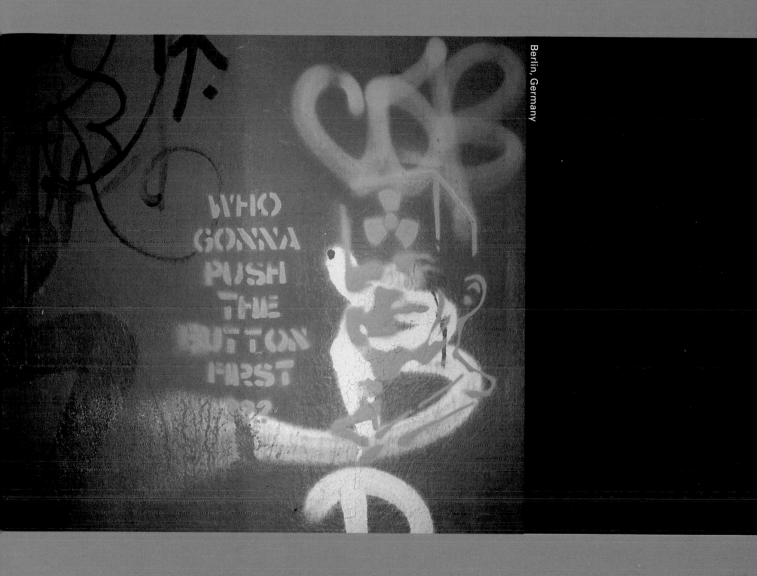

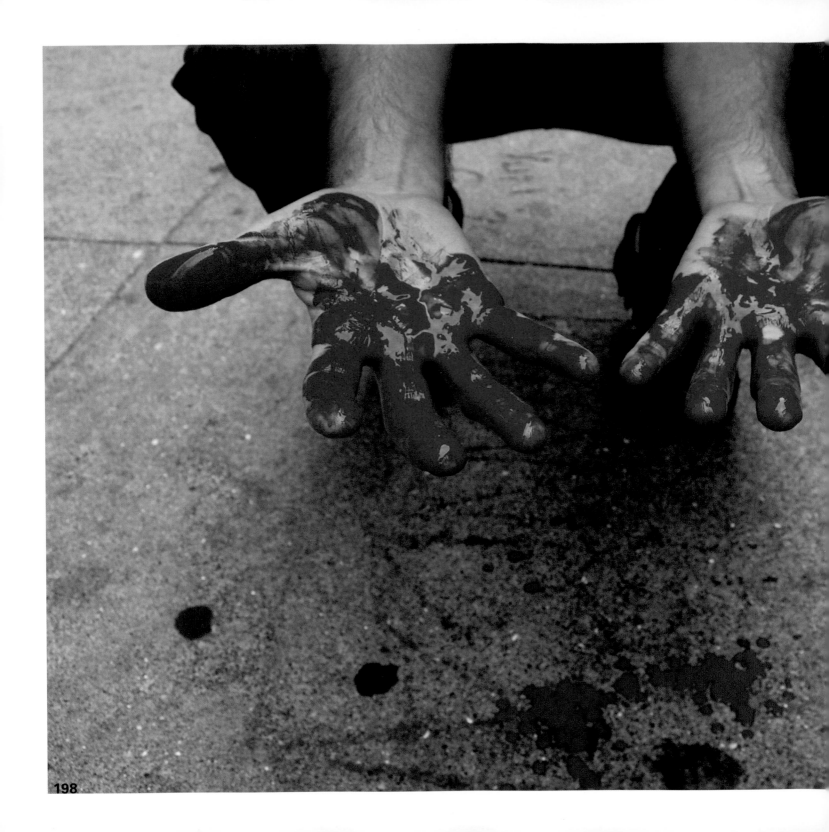

# MICHAEL IS DEAD

**9/15/83, 2:50 A.M.**—Twenty-five-year-old Brooklyn artist and model Michael Stewart is arrested by transit police for scrawling graffiti with felt markers in a subway station at First Avenue and 14th Street. He is hogtied, then repeatedly kicked and beaten by a total of eleven police officers.

**9/15/83, 3:10 A.M.**—Michael Stewart is taken in a police car to the District 4 transit police headquarters in Union Square Park. A witness there later testifies that she "heard the voice of a male, and he was yelling, 'What did I do? What did I do?'... One of the officers was kicking the man, and the other officers were hitting the man... The man was yelling, 'Oh, my God, someone help me, someone help me.'" Soon after that, she says, the man was picked up, limp and silent, and "thrown into a van," which then drove off.

**9/15/83, 3:22 A.M.**—Michael Stewart enters Bellevue Hospital Center, bound and unconscious. A nurse notes that he has turned blue and stopped breathing.

**9/28/83**—After thirteen days in a coma, Michael Stewart dies. Transit police claim that Michael Stewart sustained his injuries as a result of a fall down the subway stairs while trying to escape.

**10/2/83**—The city's Chief Medical Examiner Dr. Elliot Gross, citing "no evidence of physical injury resulting in or contributing to Stewart's death," writes that he died of "cardiac arrest."

**11/2/83**—Dr. Gross rewrites the cause of death as "Physical injury to the spinal cord in the upper neck." He later cites "blunt force trauma" as an additional cause.

**6/1/84**—After a seven-month investigation, a grand jury indicts three transit police officers on charges of second-degree manslaughter and criminally negligent homicide. The officers plead not guilty and are released without bail.

**10/5/84**—The charges are dropped by the state Supreme Court after a justice finds grand juror misconduct.

**1/31/85**—Rudolph Giuliani, then a U.S. Attorney, orders a grand jury to investigate "possible obstruction of justice" by the medical examiner.

**2/21/85**—After three weeks of investigation, six transit police officers (including the three earlier charged) are indicted, and charged with perjury.

**11/24/85**—The state Supreme Court finds each of the six officers not guilty.

**1987**—New York City Mayor Ed Koch dismisses Dr. Gross from his position as the city's chief medical examiner. James B. Meehan, the transit police chief, resigns.

**8/28/90**—The NYC Transit Authority agrees to settle a $40 million lawsuit against it by paying $1.7 million to Michael Stewart's family, but, after two internal investigations, claims that the settlement "does not constitute any admission of wrongdoing."

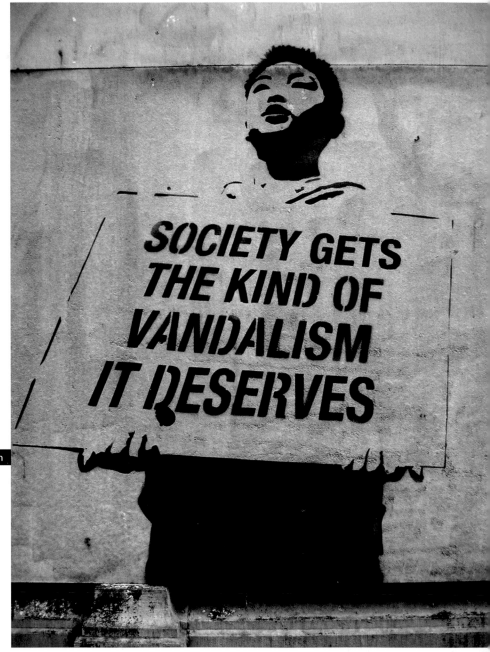

**GEOGRAPHIC INDEX**

203

206

**CONTRIBUTOR INDEX**

## TEXT PASSAGES

# MORE GREAT TITLES FROM HOW BOOKS!

## 100 DAYS OF MONSTERS

### FROM THE TWISTED MIND OF STEFAN G. BUCHER AND HIS BAND OF AUTHORS AT DAILYMONSTER.COM

Join a quirky and irreverent romp through a bizarre world filled with unruly ink blot monsters based on designer and illustrator Stefan Bucher's www.dailymonster.com website. Unique illustrations, stunning design and hilarious monster stories come together in this wildly fun collection based on Bucher's creative challenge to create a brand new monster every day for 100 days. Includes "Monsters in Motion" DVD featuring mini-movies of each monster's creation.

**ISBN: 978-1-60061-091-2, HARDCOVER, 224 PAGES, #Z1980**

## KAWAII NOT

### CUTE GONE BAD

### BY MEGHAN MURPHY

What exactly is kawaii? Well, *kawaii* is the Japanese term for "cute" (as in, "look at the fuzzy kitten, he's so kawaii") and *not* is an English term meaning "not." Explore the darker side of cute with this fun collection of quirky comic strips. Each strip is perforated, so you can rip it out and give it to a friend or stick it on your fridge. Also includes stickers! Nothing is more kawaii than stickers… except maybe kittens… or kittens on stickers!

**ISBN: 978-1-60061-076-9, PAPERBACK, 208 PAGES, #Z1845**

## DEAR FUTURE ME

### HOPES, FEARS, SECRETS, RESOLUTIONS

### EDITED BY MATT SLY AND JAY PATRIKIOS, CREATORS OF FUTUREME.ORG

Delve into the lives of ordinary people when they're being most honest. With time capsule appeal, *Dear Future Me* is a collection of letters written by everyday people to their future selves. This fascinating portrait of real life offers a sometimes humorous, sometimes poignant, but always insightful look into our culture and society— and ultimately at ourselves.

**ISBN: 978-1-58180-977-0, PAPERBACK, 256 PAGES, #Z0790**

These and other great HOW Books titles are available at your local bookstore, from online suppliers and at www.fwbookstore.com

**WWW.HOWDESIGN.COM**